The Darker Passions

Dracula

The Darker Passions Series:
Dracula
Frankenstein
Dr. Jekyll and Mr. Hyde

Coming Soon:
Carmilla
The Fall of the House of Usher
The Pit and the Pendulum
The Picture of Dorian Gray

The Darker Passions

Dracula

Nancy Kilpatrick

writing as

Amarantha Knight

Circlet Press, Inc.

Cambridge, MA

The Darker Passions: Dracula
by Nancy Kilpatrick, writing as Amarantha Knight

Originally published by Masquerade Books
Circlet Edition Copyright © 2001 Nancy Kilpatrick
Cover Design by Hugues LeBlanc

Printed in Canada

First Printing, October 2001
Second Printing, October 2002
Third Printing, March 2004

ISBN 1-88586-34-1

Circlet Press, Inc.
www.circlet.com

Acknowledgements

Sephera Giron, Eric Kauppinen, Hugues Leblanc, Caro Soles, Mari Anne Werier, D.E.H., G. Harrington, M.K. and his golden hands, and Lord Aleric. To the lot of you, for encouragement and inspiration. And to Bram Stoker, without whose Victorian prose the glorious underbelly would not shine through nearly as brightly.

A.K.

"['Dracula' is] a kind of of incestuous necrophillic, oral-anal-sadistic all-in wrestling match [set in] a sort of homicidal lunatic's brothel in a crypt."
Psychiatrist Maurice Richardson's assessment of Bram Stoker's classic.

Part One: Magda

Chapter One

During the months he came for her, night after night, her window exposed to whipping winds from the mountains, the heavy velvet curtain chained aside so that the moon could guide him to her bed, Magda never resented him. Vlad Tepes was a nobleman of the boyer class, stern, a natural ruler. He demanded much, frightening her and thrilling her at the same time. His harsh discipline taught her to submit; she learned to anticipate his desires and to please him. Each night he pierced her, with his teeth and with his fleshy sword. He drained her youthful blood slowly, erotically, through wounds inflicted in her throat and from the crimson patterns he painted across her bare bottom. When she weakened and could only find her strength in his eyes, she still did not hate him, although the word love, as she had known it, no longer lingered in her mind.

Death was like a much-needed sleep her exhausted mind and body embraced. When Magda awoke, his too-handsome face oriented her. Sharp features etched with fierceness and pride burned open her memory. That pale face still held her firmly in its power. They were bound, inexplicably. She understood his commands and obeyed without question. He sensed her every move, as if he tracked her nightly drifts down the mountainside to the village where her gypsy mother had given her birth. Yet this was not so. Since she altered, their physical contact had dissipated. That should have freed her of obsessive feelings, but it did not. Jealousy gnawed away slowly; fungus dining on doomed flesh.

More than ever she wanted to possess him, to be possessed by him, to have him all to herself.

He assured her the others meant nothing to him. When he brought the first over, Magda was shocked. By the second she realized she had become part of a harem, as if they were all Turks, whose religion encouraged such pagan bonding.

The three females lived an uneasy truce. In fact, the other two were natural allies. Both dark haired and eyed, one delicately slim, one fleshy, even in this state. They could have been sisters, and may have been, once. Now these peasant girls clung together like second and third siblings, eternal rivals with the eldest. The onus falls on the first born to mete out strict discipline to guard the rights of privilege, Magda thought. They were two and she one; and although it did not come easily to any of the three, over time she warmed to her role, and the sisters learned to yield.

Chapter Two

Magda often reflected on how two centuries had crawled by, and yet there seemed less time. Existence without sunshine became a bane. Ennui set in. The countryside changed and food was no longer plentiful. The hungers Vlad had bequeathed controlled her and therefore left Magda on the edge of being out of control. Tense. Angry. Eager to lash out, particularly at him.

For a long time now he had seemed obsessed with plans for the future, and with others, leaving her to spend nights alone, or with the rough peasant boys stinking of fruit brandy and strong tobacco, or with the sisters. Silently she blamed him for her state, and resented his preoccupations. And then he invited the Englishman to their home.

"I am Dracula," she heard him say seductively. "Welcome to my house," adding words like "enter freely" and "of your own will."

"Is he now part of the household?" she demanded later, hissing the words at him.

But Vlad let it pass, something he would not have done even one hundred years ago. Then he would have nipped her impertinence on the spot. His inattention wounded her; she hated him.

She also felt invaded. Until she was introduced to the Englishman.

He was soft, so unlike the Wallachians. Blond curly hair. Smooth pink-tinged skin that bred fantasies of blood rushing to the surface at her command. He kissed her hand and met her eye with innocence, not with the dominance that clouded the eyes of the locals, the result of struggling against a harsh mountainous terrain. This Brit smelled fine

and wore tight clothing. His finger nails were clean and trimmed. She saw the picture of his wife, Mina: a serious-eyed well-scrubbed girl who would never fulfil his dark longings, for Magda recognized the desire to surrender burning in his blue eyes. Mr. Harker was his name. Jonathan.

Vlad spent that first evening with this young man. In the study discussing the intimacies of life in England. In the great dining hall, carefully watching him eat and drink. In the bedroom.

And then it was evening again. Jonathan defied Vlad's warning: "You may go anywhere you wish in the castle, except where the doors are locked, where of course you will not wish to go. Did you see with my eyes and know with my knowledge, you would perhaps better understand."

The Englishman wandered the ancient halls alone, looking, no doubt, for trouble. He found it. Magda got to him first, but the others were on her heels.

As he entered the candle-lit room in the tower, his eyes bulged. Apparatus dating from as far back as the early Middle Ages filled half the circular space. A rack, an Iron Maiden, a pillory and whipping post, a wheel and half a dozen other instruments of torture. Along the stone walls hung an assortment of hooks, chains and pulleys, interspersed with well-cared-for tools—paddles, canes and whips of every description, clips, and needles for piercing and stinging rods of several varieties. Vlad's collection spanned six hundred years and reflected many cultures.

Jonathan looked startled then delighted when he saw the three females, dressed for the night. His cherry lips parted and a childlike look spread across his immaculate features. Instinctively, he focused on Magda; she knew her red hair, emerald eyes and full breasts captivated him; gypsy blood made her voluptuous compared to his emaciated Mina, lascivious, rather than properly veneered for polite society.

A sly look spread across his delicate features and she did not miss the bulge forming at his crotch; he had been caught with his hand in the cookie jar and anticipated both the cookies and the consequences.

The other two would have overwhelmed him, but Magda cut them with a glance.

The fleshy one said fearfully, bitter with disappointment, "Go on! You are first, and we shall follow; yours is the right to begin." She recognized her place.

"He is young and strong, there are kisses for us all," the thin one said, an insolent edge to her tone that Magda would see to later.

"In turn," Magda informed them, feeling inexplicably generous.

She removed a long-handled oval wooden paddle from the wall. "Come to me," she teased, opening her arms to Jonathan. He moved stiffly at first, but as his anticipation grew, his steps quickened.

She removed his great coat and his collar and tie. The buttons on his white shirt slid easily through the buttonholes and she yanked the crisp linen down his arms, trapping them. "I have never known an Englishman," she murmured, and his cock swelled further. Magda ran a hand over the warm skin, through the scattering of silky chest hairs. She found a blue vein trailing up over his breast to the throat. She traced it with her finger tip and let her finger rest there in a proprietary way. The throb echoed throughout her body, into her genitals, then back through her stomach, which contracted with hunger and lust.

"Mr. Harker, you've been a bad boy," she whispered.

His body twitched, and the others giggled. He was tall and she forced his face down to her breasts, her crimson nipples swelling over the low-cut gossamer gown.

"Do they punish bad boys in England?"

He nodded. The sisters laughed hysterically.

"We Transylvanians know how to punish bad boys. Severely." The vein called to her, promising warm carnal sensation. The others moved closer and stripped Jonathan of his trousers. A firm, slender body, but there was a softness to him that wanted attention. The thin sister moved a hand to his hairy crotch and the fleshy one rubbed herself against one cheek of his hairless behind. Magda slapped his exposed ass cheek six times with the paddle until it quivered. She could imagine the stinging flesh reddening and that excited her.

Jonathan's lips found one of Magda's nipples. He took it between his teeth and whipped it with his tongue, then sucked hard. Her head fell back and her hand automatically raised and lowered the paddle onto his bare ass. He moaned and writhed against the wall of flesh imprisoning him.

The vein under Magda's finger pumped harder. His skin heated up and sweat seeped from the pores. Jonathan's hands clawed at her satin skirt, lifting it so he could caress her chilled hips, thighs, her well-

rounded buttock. He slid a finger down the crack of her ass until it reached her anus and stopped. She shivered in anticipation. The thin sister guided his other hand to her own mound. He tapped both the pink hole and the pink bud quickly. The plump sister rubbed her crotch against his leg in time. Magda paddled him fast and hard and he groaned, sweat beading across his forehead.

"Lower!" she ordered. He spread his legs wide on command until his thick cock nestled beneath her. The thin sister stroked his shaft from tip to base, guiding him towards Magda's hungry lower mouth.

Magda felt the vein struggling to burst the skin in search of her teeth, eager to meet their destiny. She moistened her lips and lowered them to his neck. Under the soft flesh of her mouth, the vein jumped happily.

The head of Jonathan's cock entered her and her cunt caressed it. The points of her incisors found the vein. It throbbed against their sharpness, eager to be pierced. She worked the paddle in time to the throbbing, against his one cheek only. His body trembled under the combined strain.

"Stand erect!" she commanded. His straightened and his cock plunged up into her, lifting her off the floor, filling her with hot flesh.

Suddenly everything changed. The temperature plummeted. The air reeked with seething anger. A roar pierced her ears. "How dare you touch him, any of you? This man belongs to me! Back, I tell you, or you'll have to deal with me!" Vlad shouted. The others backed away immediately, but Magda held Jonathan to her, in her, refusing to let him go.

Vlad separated them roughly. Jonathan opened his mouth but before he could speak was backhanded across the room. The sisters cringed against the wall, holding each other.

Magda, who many times had tasted Vlad's fury, turned on him. She could not believe her boldness. "You bring him here for your own pleasure," she shrieked. "But what of us? You yourself never loved; you never love!"

Her words stung him, that was clear. She thought she saw a look of regret cross his face, but he closed off to her. "Yes, I too can love; you can tell it from the past."

Magda sneered. "The past! The past for you is the prison where the

Turkish jailors taught you well." The sisters laughed. "Sluts!" she yelled at them. "I'll give you both a licking!"

"So, you are now mistress supreme of my domicile. This is curious."

"Not curious at all. You've simply been too busy to notice."

"Well, I notice now, and from what I have witnessed tonight, your skills are wanting. Perhaps you have forgotten your lessons."

"I have graduated from your tutelage."

"Have you? We shall see about that."

"Master," whined the plump sister. "Are we to have nothing tonight?"

He tossed her a sack he held containing some kind of creature that wailed. The sisters pounced on the bag.

Vlad turned back to Magda and pierced her with his black-ice eyes. She felt him penetrate her soul, baring her secret desires, so long held in check. Suddenly she felt nervous. What had she done? challenging him like this. She had forgotten her place. Instantly she knew she would pay for this indiscretion, and pay dearly. Excitement quivered through her, tempered by dread.

Silently he pointed across the room. She knew what awaited her there and froze in terror. When she did not move, he yelled, "Enough!" He ripped the gown from her body then grabbed her fiery hair and dragged her to the wall.

A colorful leather saddle, the type used in Turkey in the 16th century, had been bolted to a kind of narrow metal horse. He threw her over the saddle, ass up. Within seconds he had her limbs spread wide, wrists and ankles secured to each of the horse's legs.

"To the cellars!" he ordered the sisters. They scurried past him and out the door, carrying the bag with them.

Vlad picked up the stunned Jonathan in his arms and turned to Magda. "I fear I have been remiss in my duties as Master of this castle. You are in desperate need of intimate attention." An evil smile curled his well-defined lips, revealing the points of two sharp teeth. She had forgotten that smile, but instantly remembered. It made her shiver in fear and expectation. "You will, of course, wait for me here. I shall return, have no fear of that. And when I do, all that is amiss will be properly and thoroughly corrected."

He carried Jonathan from the room, on the way out taking from the

wall a fat Moroccan dildo and a handful of willow switches. For Jonathan, she thought jealously, resenting them both.

Chapter Three

Magda lay unable to move, her ass exposed, the skin stretch taut. The horse had been specially designed by Vlad with three rings on each leg, leather thongs attached to every ring, the height of the rings tailored to each of his three wives. Additional straps pulled her thighs wide.

It had been decades since Magda was positioned so. When she had first come here, before the sisters, before he took to bringing home peasants from the village who arrived after sunset and disappeared before dawn, before he brought home Englishmen, she had ridden this animal of pain often. Her undead state had not saved her from the lash that had been applied religiously to her bottom. If anything, after he changed her, he whipped her more fiercely. Sensation had intensified coupled with an increased endurance of pain. Punishments that might previously have injured her beyond repair, she had learned not only to endure but to welcome. The fact that her new state allowed her to heal completely within two days had provided increased opportunity for Vlad to exercise his predilections. At least that had been so until he became too busy for her.

But she had always hated this horse. It not only held her fast, but exhibited her so completely: inverted, large breasts dangling before her face, limbs stretched wide apart, ass flesh primed for paddle or whip, both of her openings offered equally for his pleasure—and he had taken his pleasure with both, regularly. She could not feel more vulnerable than on this dreaded metal beast, helpless, awaiting her master's relentless punishments. And he knew that.

She did not hear him enter, but felt his presence, as she always did. The air in the room became dense, as if the moisture level had increased. Suddenly she had a clear view of him upside down. A tall, powerful man, with long black hair and moustache, and a determined chin. Even from this angle she could see his rigid posture, the tension in his limbs. During his lifetime he had been a famous warlord, hero to some, monster to others, invincible in battle, indomitable in spirit then, and now. After all this time of being with him, and despite his callous neglect, she was surprised to find her nipples firming; she still found him irresistibly attractive.

The wall behind him held a small rectangular window with crimson-tinted glass that could not hide the pitch black sky. He saw her glance at the window. "The sun will not rise for many hours. You will enjoy a long ride on your favorite beast."

"Master, please forgive—"

"Magda, you disappoint me." He stepped towards her. "You have learned nothing from the carefully applied if painful lessons of the past."

"Far in the past," she said bitterly, and immediately wished she'd bitten her tongue.

"Yes, perhaps too far. I see now that sparing the rod does in fact spoil the child of the night. But that will soon be remedied."

He moved close and her angle of vision cut off his head, shoulders and chest to the waist. She could only see him from the hips down. He wore tall polished boots and suede riding breeches, both black; there was never a single speck of color about him. She noticed the massive bulge straining against the suede pants and felt an ache of longing cut through her. Damn him for ignoring her for so long! She would not forgive him.

"I had forgotten your charms," he said. A cool hand rode up one cheek, across and down the other, across the bottom and up again. This soft, circular motion lulled her.

"Magda, do you remember when I first came for you?"

She hadn't thought of that night for a long time.

Her father was away in Buda-Pest, her mother visiting a cousin across the village. Magda was eighteen years old and still a virgin, with smooth creamy skin and flaming

hair. Because she refused to keep her thoughts to herself, she was not popular, although many of the young men would have overlooked this trait. But Magda found them all wanting. They were coarse creatures who only pulled at her in a vulgar manner. She rebuffed them all. Her parents, intimidated by her strong will, did not know what to do with her, and her mother worried she would never marry.

One night, the moon brimming, just at the first frost, Magda had a dream, or so she thought. The sky blackened, as if a thousand bats blocked the light of the moon and stars. The air grew colder and she shivered, although her body began to feel hot in places. She opened her eyes. A man stood outside the window, staring at her. His eyes were red coals, his features dark and sinister. She opened her mouth to scream but then, for some unknown reason, closed it.

Before she could think what to do, he was in her room, beside her bed, pulling the blankets down. She wore a plain cotton nightdress, white, that covered her entire body. He rolled the dress up from her ankles slowly, as if peeling back the rind of a ripe fruit. His hands were icy and she shivered. She really should run out and find her mother...

The thin cotton gathered around her neck, she looked down at her nakedness, at her firm nipples, her flat stomach, the mound of red hair, embarrassed before this stranger. Obviously he was a nobleman, wealthy from the rich clothing he wore. His eyes roved up and down her well-formed body and she could almost feel heat prickling her skin. Those eyes were not red now, but black and mysterious. Eyes that revealed nothing he did not wish to reveal. A face handsome, in a cruel way, especially the mouth. The idea that he would not be easily rebuffed by her proved thrilling.

He reached out a hand. "Come!"

Reluctantly she took his hand and sat up, then stood.

No sooner had she stood than he sat. He captured both her wrists in one of his hands and pulled her quickly across his lap and up one leg so that she straddled his left thigh awkwardly. She gasped, startled, her feet unable to find purchase on the floor without raising her bottom indiscreetly into the air.

"What do you think you're doing, sir?" she demanded, struggling for a balance she could not achieve.

He laughed, a rich sound, harsh around the edges, that rippled through her. "You are impertinent," he told her, "and must be tamed." Her gown had fallen back to her ankles when she stood. This time he yanked the fabric up roughly to her waist, exposing her bare bottom.

He rubbed her ass cheeks, up one side, across the top, down the other side and along the bottom, then around again and again, his touch comforting and sensual.

"My mother will be home soon." She sounded half hearted. "You will leave now, before she arrives, and I shall forget the entire episode, otherwise mother will report you to the

authorities." This was not turning out the way a dream should. His large hand felt soft and warm against her bottom. She grew relaxed, although the skin began to tingle.

He laughed again. "And who might these authorities be?"

"Vlad Dracula himself, the vivode of Transylvania. He who rules these mountains justly, but with a firm hand, that's who!"

"And if I told you I am the vivode?"

"I would call you a liar."

"Your tongue knows no bounds, and neither shall your punishments." The humor had left his voice completely. She became frightened.

Still holding her wrists tightly in one hand, he removed his lamb's wool hat and thrust it before her face. The emblem on the front contained a dragon. It suddenly struck her where she had seen that crest before. "Oh my lord!" she stammered. "You are Dracula, son of the dragon. Vivode of the Carpathians. Forgive me, sire, I did not know."

"And now you do and you will know this also: you belong to me, body, mind and soul, and I intend to enjoy my property."

His hand returned to her buttocks. He slid a finger down the crack in her behind. She felt her face color with embarrassment as he paused at her bottom hole, then moved lower allowing a moment of false relief. Warmth flooded her stomach.

Three of his fingers probed her womanly opening, an area not touched by anyone before, including herself. Her back arched as the fingers entered her. It did not hurt, except when he pushed too far in, but provided a pleasant tickling feeling new to her. His fingers inside her caused her face and chest to flush and made her breath quicken, and she did not know why.

When he removed his fingers, she felt as though something that belonged to her had been taken away, but not for long. Soon one finger returned to the other hole and she tensed. Without delay he entered her anus and explored it as well. She squirmed under his examination, slipping and sliding on his leg, embarrassment giving way to humiliation. Vivode or not, he had no right to invade her like this, and she was about to tell him so.

He removed his finger and again she felt that sensation of emptiness. "You are indeed fresh, fortunately for you, else I would think my time wasted, although time has altered for me."

She had no idea what he meant.

"Answer me truthfully, girl. Your skin is soft and unmarked. Do your parents not liberally employ the whip and paddle to control your rebellious nature?"

She was shocked. "My lord, my parents are kind. They believe in reason over brutality. I have never been physically punished in my life." In fact, her parents, unlike the other parents in the village, refused to raise a hand to their child. It was another reason why the family was looked on with suspicion.

"Intriguing." His voice grew cold and hard, freezing her to the bone. "But that will no

longer be so as the moon streaks the sky this night."

It occurred to her then that she had encountered a formidable wall which would not permit her to pass. There would be no escape yet she did not understand how to submit to her fate.

He balled the end of her nightdress and stuffed it into her mouth so that even if she did cry out, no one would hear her. Rescue now seemed impossible. She was at his mercy and hoped he would show some to one as innocent as she knew herself to be.

His hand came down hard on her bottom, stinging her skin, and she jolted. A muffled sound escaped her lips. The sensation was unfamiliar but not unpleasant. For a moment she felt a hot hand-print on her backside, then warmth radiate out from it. She could still not gain a footing because he held her awkwardly and her struggle only raised her bottom into the air, as though it begged to be spanked. The next smack came quickly, followed by a third and a forth. Soon the spanks rained down on her pristine cheeks.

She buckled and rode his leg, her backside tense, struggling to avoid the hard spanks, but there was nowhere to go. His hand was like rock. It seemed to know precisely where to strike to cause her the most pain. And strike it did. Unpredictably. Continuously. She pleaded with him to stop, but her mouth was full of fabric and he could not or would not understand her. Because external struggle proved futile, she determined to resist him internally.

He spanked each cheek separately, aggressively, the undersides hardest, his palm knocking against her slit. This cannot go on! she thought. The stinging had long ago turned uncomfortable and was becoming unbearable. She must wake from this dream any second! And if it was not a dream, her mother would arrive home soon and put a stop to this. And desperately she thought: surely he will tire!

But she did not wake, her mother did not return, and he did not tire but spanked her more energetically. Her bottom grew hotter, the stinging more severe, forcing tears to her eyes and muffled cries from her throat. She could not stand this heat and the sharp pain that brought it. He spanked and spanked and she sobbed and sobbed, her determination not to succumb crumbling rapidly. And when suddenly the resistance inside her gave way. The moment she admitted to herself that he had mastered her, he stopped.

Her ass pulsed with torturous heat. Oh, if only he would throw cool water on her to dim the sparks!

He lay her on the bed on her back. The rough wool blankets scratched her raw skin and she started to sit up, by his weight pressed her down.

His body was hard and heavy on her young frame. She felt the air would be crushed from her lungs any second and she would suffocate. His lips captured her left nipple and sucked and pulled it up. He tortured the nub until it ached and swelled and she moaned, instinctively grinding her well-spanked bottom into the prickly blanket.

While he held her captured wrists above her head, his knees pried her legs apart. He pulled the cloth from her mouth and his wide lips covered hers. He tasted coppery and male as his tongue plundered into her mouth, filling it with a new sensation. She could not believe that she was submitting to this, and yet she worried now that she would wake, or her mother would return, or that he would stop what he was doing to her.

He reached between them and she felt something emerge from his pants. Fleshy. Large. The end of it was not sharp but round and firm. He used his hand to poke this against her gaping slit.

"Sire, you must not!" she breathed, terrified.

He stopped, obviously taken aback by her words. "If I have not tanned you well enough, you have only to ask for more."

"Oh my lord, you have set my bottom on fire. I meant that I am a virgin, as you know. I will be dishonored."

"And is it a dishonor for the vivode to breach your hymen?"

"Yes, my liege, I mean no, I only mean, I may never marry——"

"Silence! Or tonight you will feel a worse stinging than you do!"

He positioned his rod of flesh at her opening. Before a heartbeat had elapsed, he tore into her, his hard cock ripping down the wall of her childhood.

Magda screamed. The pain from her ass mingled with the pain of her ruptured maidenhead until she ignited, her body blazing under him as he pounded into her, stoking the flames, leaving her no defense against being consumed by them. He punctured her throat when she was least aware, although she felt a sharp pricking that she only identified the next day.

In the morning she stood before her mirror. Her green eyes had never sparkled so, her cheeks had never been so flushed. She examined her body, the full breasts, slim waist and rounded hips. The body of a woman. Her bottom glowed a brilliant red and seeing it made juices she had not realized were inside her flow and her cunt shudder.

She hid the wounds on her neck with a shawl. Over the next few days, whenever she was forced to sit down she was reminded of her night of passion with her demon lover. She feared she would never see him again, never be bent anew to his strong will. She clung to the thrilling words he uttered as he had departed just before sunrise: "We have only just begun, my beautiful Magda, a gentle start to an eternity of painful pleasures that await you. Eternity consists of endless night, and fortunately I am a worldly man, skilled at adapting and applying techniques from a variety of cultures. My imagination has no limits, as will become apparent. You are a raw canvas onto which I shall paint erotic masterpieces for a thousand years."

A finger rammed into Magda's asshole. Startled, she cried out in shock and pain.

"You were always sensitive," he said, thrusting in and out energetically, "but, as I recall, eager for your lickings.

"You have disobeyed me, Magda. And you will be punished. What is your preference?"

It was an old game. A game of foreplay. He encouraged her to believe she had some control over her fate. Pinioning her to the horse of pain was his way of assuring her she did not. The idea of again being controlled completely sparked a memory too exquisite to bear; she realized exactly what she had been lacking. A shiver of desire rippled through her for the first time in a long time and involuntarily her rectum contracted around his finger.

"You have become a cold woman. Your flesh wants warming. A warmth that only I can administer effectively." He slid his finger from her anus and she felt empty.

"I shall whip you, Magda, more thoroughly than you have ever been whipped. You need discipline. You will receive a taste of it tonight and plenty more in the nights to come. Do you understand?"

"Yes, sire," she said, her voice quaking.

"What is your preference?" he asked again.

She dreaded each of the cruel instruments. The walls were crammed with leather and wood paddles, thick and thin straps, single strand whips and whips with many knotted strands, metal rods and clamps, and objects from the Far East, made from the rubber tree. Each, she knew from experiences that were rapidly returning to memory, created a unique pain. Each could be used convincingly and creatively by a master disciplinarian. Vlad was such a master. But she had waited too long to answer.

"Is your silence a cry for help or stubbornness? Either way, your need for chastisement is greater than I had suspected. Perhaps something intimate will speak to you most forcefully."

He stepped back so that she could see him from the chest down. She watched him unbuckle the thick ebony belt he wore and slip it out through the loops on his pants. The belt was made from the tough skin of an African animal and stained black. Short coarse hairs still lay imbedded in the leather here and there, like stubble from a beard. The belt was

so stiff it could not be bent in half lengthwise, and would barely double.

He waited. "Have you forgotten the words, Magda?"

He paused, then sighed, his voice resigned. "You are wilful and full of resentment. I see now that I have failed you. Perhaps I have been preoccupied, but as of tonight all that is changed. You will repeat: Master, punish me severely."

It was difficult. Very difficult. Her lips could barely form the words. "Master, punish me severely."

"How shall I punish you, Magda?"

"Well."

"And for how long?"

"As long as you see need to, my lord."

"And how hard?"

"Until my pride is broken."

Leather smacked her ass. Her body tried to jump to safety, but the restraints kept her from moving. He strapped her again. And again. Heat seared tender flesh no longer accustomed to such kisses. Because she was so spread, the leather licked her gaping asshole, and the sensitive fleshy folds of her cunt opening. She howled in pain.

Crack! Crack! The rigid strap burned her, adding fuel to the growing fire. He brought the heavy leather down harder than she remembered from previous strappings, but then those had been so long ago it was as if this was her first time.

Tears gushed from her eyes and cries from her lips as the leather cracked mercilessly.

"Do you wish more, Magda?"

To answer 'no' would doom her. "As you see fit, Master," she wailed.

"I do see fit."

The strap whipped across the top of her ass cheeks. He had been an excellent marksman in life and eternity had only refined his aim. He lay on the leather, snapping at the top of her ass cheeks until she thought the skin would split. She screamed for mercy but, as always, her cries did not deter him. And just when she knew she could take no more, he shifted to her undercheeks, where the strap cooked her cunt opening as well and caused the flesh of her ass to boil.

Magda screamed out her agony as he flayed her; only her upper body

was able to writhe beneath the stinging blows that seemed endless. Her red hair whipped about her face and her full breasts bounced wildly, the nipples achingly hard.

He moved to the side of the left cheek, beating there until she was screaming anew. Then he chastised the side of the right cheek, letting the stubbly belt mark his displeasure into her flesh. When he returned his attention to the middle of her ass, he whipped first from one side, then from the other, making sure that neither cheek escaped for long and that her bottom hole was well attended to. Finally he used just the end of the belt to skilfully snap down the length of her crack, lingering over her bottom hole until she shrieked, and then again at the soft folds that led inside her feminine hole. Her screams echoed around the circular walls. Memory assured her that nothing she could say or do would make him stop. She was completely at the mercy of a merciless being. The moment she accepted that truth, the leather stilled.

Sheets of tears blinded her. She could hardly see him. Her ass blazed as if flames shot from the fiery flesh. Her ears rang from her own screams and her throat was raw, but she knew he was far from finished with her.

Through blurred vision she saw him now naked. His cock stood erect, longer and thicker than Jonathan's. And far more experienced. Rock hard already, despite her agony, Magda felt proud that she still had this affect on him.

"Take me, my lord." Her voice was almost gone, but sincere. "Anywhere that pleases you."

"You have learned well."

His scalding cock found her burning cunt hole. As it touched the scorched outer flesh, she gasped. It had been so long since he had entered her that it felt as though her opening had closed up and she was once more a virgin. His cock head nudged, like a firm, insistent knock on the door. Before she could open to him, he broke into her, the long sturdy rod penetrating its full length, pushing her walls aside to make room for him. Slowly he pulled out of her completely then re-entered quickly, burrowing deeper, ripping moans from her throat. Each extreme thrust caused her extreme pain, and pleasure. He slid a finger into her smarting asshole, then two, then three; her moans increased in volume. "My master, anything to please you. Anything!"

He squeezed one of her sore ass cheeks hard, sending her into another spin of pain; her cunt contracted around him. Her body rippled with pleasure as his fucking speed increased. Her walls gripped him, working with him, sending waves of delight rushing through her hot pussy and along her rectum until she felt she would go mad with the sensation. The fucking seemed eternal. Each time he entered, her folds parted submissively, as he withdrew, they accompanied him to the door, her tunnel tightening for his next thrust. He rode her hard and she rode the dark horse of pain, her ass cheeks an inferno, her cunt exploding. Their gallop became a pounding run, bodies working together towards the moment when pain and pleasure inextricably tangled and they merged.

Magda cried out her ecstasy as he shot into her scalding body a cooling stream.

Chapter Four

She must have fallen asleep; pain pulsing from her ass woke her. She was alone, still strapped securely to the metal horse. The burning skin of her bottom warmed her like fire on a cold night and reminded her of how he had taken her. Her pussy and bottom hole felt raw from his fucking. Thinking about his hard cock controlling her made the juices inside her break.

If he did not love her, would he have bothered punishing her so soundly? Would his cock have driven her beyond her anger and resentment? He still cared.

Magda felt this knowledge swirl through her. She could endure any pain. She longed for her next lesson, for hadn't he implied there would be many more to come? She would present herself over and over to him to be thrashed into a frenzy of pain and lust and ultimately surrender. This is what she had been missing, what she longed for. Jonathan seemed like a child, her attempts to act the mistress a naive game. Her Master's no-nonsense discipline had corrected her course. The end justifies the means, she had often heard it said. Now she understood that truth to the core of her being. She laughed suddenly, feeling her burning end, the justification for his means.

Suddenly her Master returned. And with him the Englishman, naked but for what appeared to be leather suspenders running from his groin up his stomach and chest to a studded leather collar around his neck, where they were attached.

Jonathan stared at her ass. His jaw hung open, his eyes widened.

Why had the master brought Harker here? To humiliate her? To show him how the dominator had become the submissive? Magda felt her face color with shame before this stranger. And yet, was he not part of the means toward the end she had hoped to achieve?

Vlad turned to the Englishman. "In one of your English books there is the story of a school master from Amsterdam, a firm believer in corporeal punishment, who claims to have 'cracked the seat of a student's rebellion'. Tell me Jonathan, did you attend a boarding school?"

Jonathan, still gaping at Magda's ass, nodded.

"Prior to coming here, had your seat of rebellion been cracked?"

Jonathan shook his head.

"I thought not. Unlike Magda, you are unfamiliar with the virtues of the strap. We are an old and backward people, in this part of the world, and hence must glean knowledge from many corners, including yours." Vlad walked to the wall and removed a willow switch, imported from England. He whipped it through the air and Jonathan jumped. The sound set Magda to shivering. Surely he would not whip her again! Not in the presence of the Englishman!

Jonathan, looking pale and exhausted, said nothing. Magda could tell from his face that her behind was a fireball, redder than a poppy. As red as the blood seeping from the two wounds at his neck. He was not changed, but from the pallor of his face she could tell Vlad had taken much of his vital fluid.

"Sit there, Mr. Harker," Vlad ordered, pointing the switch. "Observe and learn of our simple Transylvanian ways."

Jonathan sat gingerly on a low leather ottoman the color of a persimmon. It was an ottoman that Magda had been laid across many times in the past and well whipped on by means of a switch like the one Vlad now held. It was also the seat where Vlad had sat when he ordered her onto her hands and knees before him, her head down, her ass up. As he flogged her bottom raw with a switch, or sometimes with the Turkish horsewhip, she took his magnificent cock deep into her throat. Those delicious times had died long ago and yet what occurred tonight had rekindled her hopes for the future. As if reading her thoughts, Vlad said, "Magda, Mr. Harker wishes to see

you submit to the willow."

He walked to the horse of pain, swishing the flexible branch back and forth in the air. The sound made her bottom twitch in anticipation yet sent a cold quiver through her chest.

"Shall I whip you before Mr. Harker?"

"As it pleases you, my lord," she whispered, embarrassed, terrified that he would, afraid that he would not.

She heard the switch cut the air a split second before she felt it cut across her ass on a diagonal. Her wounded flesh perked up at this new pain. She watched her nipples harden and felt the liquid within her cunt flow. He lashed the willow across her backside from left to right, then right to left, then cut into her thighs a dozen times. She bit her lip but could not keep from wailing.

Harker watched spellbound.

"Tonight, Magda, I have a treat which will please. A Master must execute discipline regularly and creatively for the edification of all concerned. Clever new pastimes are required. You see, my dear, Mr. Harker does not appreciate how bored you have become, but I do. I have allowed this to happen and it is my responsibility to correct the error by insuring the frequent administration of rigorous punishment. This situation must not be permitted to continue. You have suffered my neglect."

"My lord, I suffer no longer."

His lips under his dark moustache turned up into a slight smile, revealing the sharp points. "We will see."

Behind him, through the tinted glass of the little window, the only window in the room, she saw that the sky was lightening. The sun would rise shortly.

"What are you thinking, my dear?"

It was useless to hide her thoughts from him. "We must return to our rest soon, sire, before the sun rises."

"And?"

She hesitated. "And I am too tender for further punishment tonight. I must heal so that I may offer you a fresh canvas on which to paint your exacting pictures."

"I agree with the former, but only with the latter in theory," he said. "You see, Mr. Harker has agreed to continue painting into the

day, when I am unable to wield the brush."

The idea of Jonathan using the willow on her turned her sick with humiliation, and yet she felt oddly titillated. But how could she be punished in daylight? Maybe Jonathan would be brought to their secret sleeping chamber.

"Magda, both your need for and capacity to enjoy pain has always impressed me. As the sun rises, you will impress me still further. You will endure even greater agony. Pain beyond your wildest dreams. Suffering inflicted by me through the hand of my servant."

The light through the window was growing intense. Something in Vlad's tone frightened her. She wanted to beg him not to do whatever he was contemplating. But she knew from the past that pleas would only increase her misery.

"I leave you now, in good hands. Alas, I must hear most of what will occur from afar. However, I will be on hand for the initial moments, for a glimpse or two, and will carry a sweet image with me to sleep." He walked to the door and stepped out. The door closed but not all the way. Through that pencil-line opening, Vlad commanded, "Mr. Harker, proceed as instructed."

Magda looked at Jonathan. He went to the window. As he opened it, she turned her face away and squeezed her eyes closed to the light filtering into the room. Light that heated the air. Suddenly she felt as if she were trapped in a Turkish steam bath. Her terror increased. "Why are you letting in the light?" she cried.

"Patience, my dear, a creative undertaking requires time for proper execution," Vlad called. His deep voice was tinged with amusement and excitement.

Through her closed eyelids she saw the sun cut above the top of the window sill. Instantly she knew where those rays fell; they seared her ass like a whip of fire. She screamed. Jonathan closed the window and all light was blocked. The temperature fell everywhere but where the sun's rays had licked.

Magda smelled burning flesh, her own. Across her bottom she knew a thin line had been scorched. This she could not stand. It was beyond even her endurance.

"You sell yourself short," Vlad said, once again reading her thoughts. "You can endure much, and will. Mr. Harker, proceed."

"No! Please! Master, I shall never disobey you again. I will do any-thing—"

Jonathan threw open the window. Heat welled around her, fire tore across her bottom and into the folds of her wide-spread open-ings. The window closed.

Through her wracking sobs she heard Vlad say, "Alas, my love, it is well past my bedtime. I am old, as you know, and need my rest. Nothing would please me more than to witness your full initiation by fire, but this cannot be. The light affects me too. Mr. Harker has been directed to open and close the window until the sun rises above it. Have no fear; the rays are focused. Your seat of rebellion will be evenly cooked and your temperament far more tender by tomorrow evening."

As the door closed, the window opened, and Magda screamed.

Chapter Five

When the sun set the next night, Vlad came for her. Magda could hardly move. Her flesh was in shock.

He freed her and she braced herself against the horse of pain and looked over her shoulder. Hundreds of blood-filled blisters covered her bottom. Blisters that came to life as Vlad threw her over his shoulder and carried her over to where Jonathan lay naked but for the leather suspenders. His English cock stood erect, as if waiting for her.

Vlad positioned her on top of Jonathan; her slit over his member. She braced herself on her hands and knees. Vlad entered her from behind.

They moved in a strange rhythm, she up and down Jonathan's shaft, while Vlad impaled her asshole. His hips banged against her swollen cheeks, pressing on the blisters, reviving excruciating pain that awakened fierce pleasure. Magda slid along the cusp of ecstasy, edging towards it, then away. Each time she felt she was in control of her orgasm with Jonathan, Vlad forced her to a new rim of sensation. The moment her pace became comfortable, he quickened his and she was compelled to follow. Soon she gave herself over to fucking and being fucked. As she slid to the edge of Jonathan's prick, Vlad's cock withdrew. As she collapsed down onto Jonathan and was filled with him, Vlad impaled her anew. And just when she was lulled into that pattern, he changed again, thrusting his rod deep into her rectum only when she reached the head of Jonathan's penis.

She did not notice the sisters enter the room. Suddenly the plump one straddled herself over Jonathan's face while the thin one stood over her sister, getting her sensitive mound tongue- whipped. The fleshy one grabbed Magda's nipples between her thumbs and fingers and pinched and twisted them. Her sister above reached down and did the same to her.

The first orgasm rocked Magda. Her body shook as if the earth had quaked. And while she came, cunt and anus contracting as ripple after ripple coursed through her, the motion continued, pumping, grinding into her backside, pinching her tender nipples, hips slapping her blistered behind, cock throbbing in her cunt, her pleasure exquisite. Magda came many times before the others exploded into her and each other.

They lay in a heap until Vlad order, "Magda, get up!" She stood immediately. He opened his arms and she willingly entered his embrace. His teeth found the throat wounds from when he had scarred her that first time, so long ago. There was no blood in her to be taken. In fact, she needed blood. But she also needed this piercing. This ultimate surrender to her dark lord and his indomitable appetites.

As he impaled her with his long eye teeth, she felt cherished. Loved. By Vlad. By her sisters. How could she have felt apart from them all?

"You may play with him, my dear," he said, nodding at Jonathan, "until my return. Come," he told the sisters. They joined him, each on one side. As they left the tower room, Vlad selected a Chinese braided horsehair whip from the wall and several metal clips.

Magda was alone with Jonathan.

He looked up at her with those innocent blue eyes. She pitied him. Soon he would return to England, to his frigid wife Mina, never to actualize his darkest fantasies. His brief attempt at mastering her with the sunlight had been dismal. He had succeeded in the physical task but the man himself was lacking. He'd been doomed to failure. He had never learned to submit, how could he possibly hope to dominate.

She reached out a hand. He grasped it and stood.

"To the rack," she said.

"Why, whatever for?" He sounded shocked.

"So that I may bind you and stretch you and whip you until you bleed."

He sputtered. "That's... that's ridiculous, Magda. I refuse..."

He was still mortal and she had not been so in a long while. Her strength exceeded his. Within moments she had him locked against the metal bed frame.

The suspenders he wore soon showed their true purpose. Thrust into his rectum was the large Moroccan dildo Vlad had taken with him the night before. Magda had worn it herself, in both of her holes, and knew that by now the giant leather penis threatened to split him in two. The end had a ring attached and to that ring a rounded strip of leather, which ran up between his ass cheeks, along his backbone and was finally secured to the studded collar circling his throat. This clever arrangement held the enormous dildo firmly in place, meanwhile leaving his bottom and back exposed for her pleasure. His asscheeks were crisscrossed with dozens of angry red lines—the marks of the willow. Magda smiled and thought: the Master was busy last night!

She twisted the handles at the four corners of the bed until he was stretched wide and long and begging her to cease. Then she pulled a lever and the frame lifted upright.

"Stop! This infernal machine will tear my limbs from my torso!"

"That is entirely possible."

His tone changed. "Hadn't you enough punishment for your actions of yesterday evening?" His attempt to threaten was weak. Futile. "When Count Dracula finds out about this—"

"He will be pleased. Why do you suppose we're alone here together." His eyes followed her as she selected a Spanish bullwhip. The oiled leather was rounded and darkly tanned, except for the flat length at the end and the distinctive white cord, dotted with splatterings of dried blood along it. It was a long whip—a good ten feet, thick at the tooled handle and braided, but narrowing to the tip. She had never wielded it before but remembered its nasty sting. She knew she would use it naturally.

His cock, half firm, had sprung between the slats of the rack. Isolated from the rest of his body, it reminded her of a young boy

poking his head out a window to see what the world had to offer. His prick quivered at her touch. The large vein protruded along the shaft, inviting her. She reached in and brought his balls through the opening too. The position assured he would not release anything until she permitted it. With the tail end of the whip, she flicked his cock until it rose higher and seemed firmer and the vein darkened from the pressure of the stinging.

"Magda, we should discuss this in a civilized manner. I don't believe you want to—"

"But I do want to, Jonathan. I do want to whip you. Violently. Until your flesh cracks open and blood bubbles from the tears in your delicate English hide. Blood that I will lap up to give me strength to whip you again and again, until you learn the art of submission."

She took a jar from the shelf and massaged fat mixed with crushed stinging nettles into his back, his ass and the back of his legs. She left his cock clean, though, because she didn't like the taste. Animal fat, she recalled from those sessions long ago, increased the heat created by good leather. His skin would welt sooner and burn longer. The nettles were already increasing his discomfort. It was as though she could read his thoughts. "Oh, you will no doubt see your precious Mina again. And when you do, she will hardly recognize you; you'll be a new man. She'll feel the difference soon enough, though, likely on her precious ass."

She grasped the handle firmly and threw the long whip behind her. "Now, Mr. Jonathan Harker, you will repeat after me, 'Please, Mistress, punish me severely...'"

Part Two: Mina

Chapter Six

I arrived at Whitby, a seaport town on the coast of England's North Sea by train from London. The train was dirty, both the interior and exterior, indecently loud, and reeking with foul odors, all of it made worse by the fact that I was obliged to share my compartment with an odious man—I shall not call him a gentleman—who persisted in staring at my breasts. I only made this trip to visit my dear friend Lucy Westenra, for I have not seen Lucy since my marriage to Jonathan.

"Mina, oh Mina, how I've missed you!" Lucy, embarrassingly exuberant in her affections as always, raced down the steps of the manor house to the carriage, her golden ringlets bouncing in the sunlight. She grabbed me about the waist as a man would and lifted me to the ground. She smothered my face and lips with her warm wet kisses, holding me tightly against her soft bosom; I had not before appreciated her strength, for indeed she is a small girl.

Behind her, in the doorway, stood a severe-looking couple, servants no doubt, from their drab attire. I wondered if in fact this was the famous Hodge and his wife Verna, who had been in the employ of my rich friend's family since she was a child and had remained since her parents were accidentally killed on a trip to India several years before. Whether they were common household help or in fact kind folk who nurtured Lucy, I knew not. What I did know was that this emotional display in front of them was unbecoming.

"Lucy," I said, taking her firmly by the shoulders. I would have

spoken sternly, but the girl has such a mischievous look about her, the twinkling in her violet eyes, an impish grim; she never ceases to bring a smile to my face. Instead, I told her sincerely, "It's wonderful to see you as well."

"Oh, Mina, you aren't embarrassed, are you?"

Even as she said it, I felt my face color.

"Come, you silly goose." Her arm circled my waist, snaring it almost, and hip knocking against hip, she guided me to the front door.

"Mina, you've heard me speak of Hodge and Verna. They've been like parents to me, tutoring me in the ways of the world."

Hodge was a lean man, nearly hairless, and bespectacled.

His wife was equally slim, with greying hair pulled back severely into a bun. The ways of the world? I wondered what these two cross-looking people could teach Lucy. I cannot say why, but I distinctly felt jealousy coming towards me from both of them.

After the introductions, Lucy dragged me into the parlor, unbuttoning my jacket en route as I unpinned my hat—Verna took both away, reluctantly leaving the room, it seemed to me. Once we were alone, I seated in the winged armchair and Lucy on the footstool before me, our knees touching, her hands clutching mine, she said, "Mina. You are a woman now, while I'm still a girl. Tell me, what is it like to be married?"

Married. That is a word to ponder. It is certainly not the joyous state I had anticipated. "Jonathan is a decent man," I said carefully. "A good provider."

Lucy giggled and jumped up to kiss me. "Oh Mina, you can't know how funny you are! I'm hardly interested in his business acumen. I mean in the bedroom, of course."

My friend Lucy had always been more than forthright. As girls at the finishing school for young ladies where we met, Lucy had never ceased to find trouble for herself, including the headmistresses' paddle against her backside at regular intervals. All because of her quick tongue that refused to bow to convention. The girl had not a tactful bone in her body and the constantly reddened state of her fanny attested to that.

But Lucy was a dear and it was her directness that appealed to me.

Besides, we had confided in one another it seemed like all our lives; I saw no reason to hide anything from her now.

"Well, you're to the point as always. What would you like to know?"

"Does he fuck well?"

"Lucy! Your language is shocking. Wherever did you learn to talk that way?"

"Why, from Hodge and Verna, of course."

These two obviously had not been a good influence. "You must not speak like this in public. What if anyone would hear you?"

"But I'm not in public. I'm in private. Alone with you."

With that she leaped up again and snuggled onto the seat next to me. Both of our bodies did not fit into the confined space so she draped her leg over mine and slid her arm behind my shoulders. With her free hand, she played with the pearl buttons down the front of my silk blouse.

"Is it warm in here?" I asked, feeling flushed.

"Ummm... Now, Mina, share your secrets with me. How is Jonathan as a lover?"

Staring into those exquisite iris-colored eyes, I knew I could only tell her the truth. "Wanting."

"In what way?"

"He does all the right things, if you know what I mean, and yet..."

"The pond does not ripple."

We both laughed until tears came to our eyes.

"Oh, Mina, I've missed you," she said, kissing me again on the lips, hers sweet and fleshy.

Suddenly she jumped up. "Come along. You must be tired and dirty from your trip. I'll have Verna draw you a bath and we'll chat while you bathe, like we did at Miss Whippet's Finishing School for Young Ladies." The last she said in a haughty tone, ending with a giggle.

Within the hour Verna had emptied a dozen buckets of water into the wooden tub in Lucy boudoir. I unbuttoned my blouse and let my heavy wool skirt slide down my body. The servant untied my petticoats and, before I could stop her, slid my bloomers down my legs,

leaving me bare-assed. Lucy insisted on unlacing my corset. "You have a lovely figure but this undergarment is so unflattering," she chided me. "No wonder Jonathan can't perform to his potential."

"Lucy! Really!" Saying this in front of Verna embarrassed me mightily and my cheeks flared crimson. I turned my back on Verna, only to feel the eyes of that woman glued to my exposed bottom. All of a sudden I was aware that my nipples had hardened.

The dour servant stood at the door with my clothes in her arms, just watching as Lucy slowly unhooked the whale bones that confined me. My lungs began to expand to their full capacity and air reached my skin. Soon I was naked before the two women and the full-length mirror.

Standing next to the petite Lucy, I was surprised to find myself attractive in my own eyes. Whereas she is short and very curvaceous—a classical hour-glass figure—I am far taller and slimmer, although I, too, have a small waist. Our breasts are equally full, it seems to me, although her derriere is perhaps a bit higher and rounder than mine.

"Lovely," Lucy said from behind me, staring at my form in the mirror. She ran the palms of her hands up my hips and waist, her fingertips swelling over the sides of my breasts. Then her hands went back down. "Poor, exhausted Mina." I felt myself lean back against her. Her hands moved down my belly and her fingers tangled with the hairs between my legs, then up, past my belly again to my breasts, then back down.

I have no idea how long I stood thus, Lucy soothing me, murmuring sweet sounds in my ear, my head back against her shoulder, my eyes closed.

"I've brought the birches."

Verna's voice startled me and my eyes snapped open. I saw her in the mirror, my clothes no longer in her arms, in fact, nowhere in sight. Instead she held a handful of short green birch switches, tied neatly with a pink ribbon. Somehow she must have gone into the garden and returned without me hearing a thing.

"Oh goody!" Lucy exclaimed. "Mina, my darling, you must try the hydrotherapy from Scandinavia. It's all the rage this year."

"Hydrotherapy? Whatever are you talking about?"

"I'm talking about stimulating your skin. So you'll have a fresh look, as they do in the Alps."

"I'm not in the Alps, I'm in Whitby."

"Oh, Mina! You've always been such a prig. Stop it!" She stamped her little foot and it was such a pretty, endearing sight, her golden curls tossed petulantly, that I had to smile.

"All right, Lucy. If inflicting your hydrotherapy on me will make you happy, you may. What do I have to do?"

Again Lucy grabbed me and kissed me full on the lips, a moist kiss, hot and dark. It was a lifelong habit of hers, apparently, and had not died out with childhood but had taken on intricacies, yet I didn't mind. Jonathan was the only other person who had kissed my lips and that was entirely different. His lips were soft in a pointless way, while Lucy's held a plumpness that felt like an invitation.

"Verna!" Lucy ordered. The servant went to the wall. A thick pink braided cord, like the type pulled to summon the maid, rested against the wall. Now I noticed that it ran along the ceiling and hung down into the middle of the room, ending in a loop.

"You won't be wearing these long," Lucy said, as she tied a pink wrist collar to each of my wrists. She connected the collars together with one curve of an S-shaped piece of metal. "Now, lift your hands high above your head."

I did as she asked and she hooked the other end of the S-shaped metal over the loop of the cord, then nodded to Verna.

Immediately Verna yanked on the rope. Before I knew what was happening, I was lifted off the ground so that only the tips of my toes brushed the Oriental carpet.

"Lucy!" I demanded, "what are you doing? Lower me at once!"

"Patience, my love. You have always had plenty of it, now's the time to bring it to the fore."

Verna handed Lucy the stark bouquet of birches then wrapped the cord under her armpit and around her shoulder several times. Lucy circled me, swishing the branches in the air, a lascivious play on her full lips. The entire time she ran a hand over my breasts, up the inside of my thighs, here and there. "Your skin is like an old dried apple! You don't take very good care of yourself. This stimulation will open your pores so that the bath waters might do their

work and penetrate more fully, enabling you to relax completely. The Finns do it in their Saunas all the time. Verna has taught me. It's an ancient technique."

Verna! So this was from where the perversion stemmed. As I spun on the cord, and I could not help but spin, my eyes locked with Verna's.

The audacity! I thought. A servant, having the impertinence to look me in the eye. But all I said was, "We're not Finns," and that I said breathlessly, for the fear I felt had coupled with not only embarrassment but excitement.

"No, we are British and our heritage deems that we claim the ways of the world as our own and adapt them to our special needs. Anyway, Mina, I know you hate new things, still, perhaps you'll enjoy this. But even if you don't, I will."

She lifted her arm high and brought the birches down on my bottom. The switches stung right across both cheeks. Particularly where the ends had struck, it felt as if half a dozen bees had a go at me. I'd hardly time to gasp before the next blow came, this time along my hip.

Lucy could not have weighed more than 7 stone, but she did not spare those deciduous rods. They landed on my stomach and I looked down to see six red streaks welling from my skin. The stinging reached my other hip, then moved up my back and over my shoulders then back down to my bottom, which received the birches again. Then she moved down my thighs.

I had, in all my lifetime, never been birched. Unlike Lucy, who suffered that and more at the hands of our headmistress, I had been a good girl and the rods had not sought me out. But they found me now, lashing the front of my thighs, the back and front of my calves, making the skin quiver and my body jerk as I spun helplessly. I moaned and protested mightily, to no avail.

Despite the sharpness of the thin branches, there was something pleasurable in such heat. My body did feel as though it was opening, but to what, I knew not.

She finished, or so I thought, with the undersides of my feet. But that was not to be the end.

"Spread your legs!" she ordered.

The servant Verna stared at my groin.

"Oh, Lucy, I cannot," I pleaded.

The willows struck my breasts, one at a time, and twice as hard as she had been using them. I yelped like a puppy.

"Obey me!"

I opened my legs, which meant that I now had not even the minor support of my toes brushing the floor.

"Wider!" she commanded, the switches reiterating that command against my stinging bottom.

"I'm spreading them as far as I can!" I cried. "Lucy, for God's sake, have mercy!"

Instead of mercy, she showed me the Devil's tortures by whipping the delicate inside of my thighs, the right, the left, the right, the left, and then she brought the birches up from below and switched the vulnerable place between my legs that only Jonathan had ever touched, and he barely. He had never set me on fire so. Hot fluid broke within me as she whipped and whipped. I could do nothing but shriek in pleasurable pain.

Tears streamed down my cheeks as I was lowered to the floor.

I do not recall the wrist cuffs being removed. Suddenly Lucy and Verna stood one on each side of me, lifting me up. "Bend your legs," Lucy said.

I did as I was told.

They lowered me into the steaming water and pushed me down until my hot skin was covered with hotter water, to the neck, ripping another moan from my throat.

Lucy pulled my head back and kissed me full and hard on the lips, her tongue sliding inside my mouth.

I jumped to a seated position, alarmed. "No, Lucy. You must not! I am a woman, not a man."

Gently she pressed my shoulders down so that the back of my head rested once more against the tub. "Of course you're a woman, which is why there is nothing illicit in what we do. If I were a man, now, that would be another story, wouldn't it?"

Lucy washed my shoulders and chest with a soapy sponge, an unusually rough variety. The dried sea creature rubbing my nipples reddened them more than they already were, forcing further moans

from my lips. She washed my back and had me kneel so that she could rub the sponge over my hot lower cheeks, very fast and hard, making them burn, then she slid it down under me, where it scoured spots I had not known existed. After she washed my hair, both she and the servant Verna dried me with thick towels and led me to a canopied bed in a room nearby.

The linen felt cool against my hot, tingling flesh, and the old-fashioned feather-type mattress allowed me to sink into it.

"Drink this," Lucy said, handing me a small Waterford crystal sherry glass. I drank the amber liquid in one gulp.

"Sleep until dinner," she said, kissing me on the forehead.

She pulled the covers up to my neck and tucked them tight under my body so that I felt encased, then she closed the curtains at the window and left.

I lay in the quiet darkness. My body danced with sensation. Never had my skin felt so alive. Not an inch of me had been ignored by Lucy's thorough hand, for which I was grateful.

With each breath, I felt my nipples strain against the starched linen, pressing, demanding to be paid attention to. The heat between my legs was intense and the flesh pulsed with each beat of my heart. My bottom against the linen-covered mattress felt so hot I imagined steam rising from it. For wasn't it those areas that had received the most attention?

Part of me wanted to find a way to answer the call I heard and yet I did not know how. Until this day, only Jonathan had roamed my flesh and I felt that he had taken but a quick tour and missed the most important sites along the path. Lucy, sweet Lucy, had managed to spend time admiring each natural point of interest, tending it with loving concern.

I drifted into a deep warm sleep in which I dreamt of myself as a wild animal, both riding and being ridden under the sweltering African sun. The yearning for release became unbearable. My heart pounded throughout my body and my breath quickened as the heat of the day and the heat within combined. I thought I would incinerate and cried out.

Suddenly a dam burst between my legs and cool water flowed.

My entire body trembled uncontrollably. I lay exhausted, then cooled.

My eyes popped open. Verna was lighting the lamp. The covers lay clumped at the foot of the bed; my naked body exhibited before her, legs spread, nipples hard and swollen, and she examined every inch of me carefully. I felt liquid seep between my legs and Verna noticed.

"The mistress awaits you for dinner," she said, a strange smile on her lips, and left.

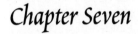

Chapter Seven

Lucy and I had a fine meal of roast pork, apple sauce, and new potatoes from the garden that Hodge tended. We laughed and talked and I ate as if I'd not eaten in a year.

Immediately after dinner, Hodge came into the parlor and announced, "Doctor Steward."

"Send him right in," Lucy said, jumping to her feet.

A tall man with reddish-blonde hair entered the room. He looked annoyed and preoccupied. Lucy stood on tiptoes to kiss him on the lips. He removed a pocket watch from his vest pocket and checked the time. Then he pulled on his waxed moustache.

"Mina, I'd like you to meet my friend, Dr. Steward. John, Mrs. Mina Harker."

Dr. Steward took my hand, although it was obvious he was distracted and anxious to be elsewhere. "Mrs. Harker," he said, then, "Miss Lucy, I'm afraid I cannot stay long. The hour is late and my patients need my attention, particularly Mr. Renfield, of whom I have spoken. If we could attend to our business sooner—"

"John, do sit down," Lucy said in a light but firm voice. "You're being rude to my guest, and I shan't forgive you for that. Mina has traveled all the way from London and her husband is on the continent in some dreadful country called Transylvania. Mina has a problem, a martial difficulty."

"Lucy!" Now she had gone too far.

"Oh, Mina, for heaven's sake, John is a doctor. He knows about these things."

My face burned crimson. Embarrassment flooded me and I could look neither of them in the eye. "I believe I shall retire," I said coldly. "The trip was arduous and I am exhausted. Please forgive me." I did not wait for a reply but raced from the parlor.

Once safely in my room, I felt too upset to sleep. The air was warm and dense, as if a storm were approaching. I paced for a time, then decided to compose yet another letter to my husband.

Jonathan had been gone several weeks now, off selling real estate to an old baron in the Carpathian Mountains. I had written daily, as my wifely role dictated I should, and yet had not as yet received one reply. Of course, Transylvania is a backward country and I did not expect the mail service to be what it is in England. Still, I felt angry at Jonathan and, when I was honest with myself, realized my ire was based more on feeling failed by him when it came to his husbandly duties. Still, we were married, and I must write.

I picked up a fountain pen and dipped it into the inkwell, about to touch it to paper, when I heard a tapping on the wall. As it did not cease, I stood and hurried across the room. It seemed to be coming from behind a portrait. On impulse, I pushed aside the framed oil of some stern Westenra ancestor and was startled to see a large hole in the wall, the size of an eyeball. The tapping had not ceased but the sound of Lucy's voice clearly came from next door.

I hesitated but a moment, then placed my eye to the hole.

Within I saw Dr. Steward stark naked, his hairy bottom facing me so that I viewed his genitalia dangling below. His hands were bound behind his back and he was kneeling at Lucy's feet, licking the soles of her laced hobnailed boots. Lucy lounged in a Queen Anne chair wearing only the boots, a black leather corset and black wool stockings, held in place by red garters. On her lap rested a black wood paddle, long and rectangular in shape with a short handle, much like a cricket bat.

I could hardly believe what I was seeing. I noticed my breath had quickened, and that I was pressed close to the wall.

Suddenly Lucy kicked out sharply, sending the doctor sprawling onto his back. I gasped when I saw his erect member.

Lucy looked at the wall as though she saw me and smiled, and I jumped back. But it was not possible that she could see me—the

hole was too small. I told myself I should go directly to bed else I would be privy to some vice I would be better off not knowing about. And yet within seconds I was again peering through the peephole.

Lucy was now out of the chair and the good doctor in it, not sitting properly, but kneeling on the edge in an upright position. His bound hands were resting at the small of his back and I could clearly see his white bottom cheeks with the reddish blond hairs. Lucy stood to one side of him, the menacing paddle clutched in her right hand.

"You must be taught civility, doctor. The next time you visit, if I deign to grant you a next visit, you will wait patiently until I am ready to begin our session. I am the Mistress here, you my slave. Do I make myself clear?"

Dr. Steward mumbled something I could not hear and apparently Lucy could not either.

She hauled off and whacked him a good one with the paddle across his rear end. His body jerked and he nearly lost balance. The cricket bat, being so wide and long, reddened the whole of his bottom.

"Do I make myself clear?"

"Yes, Mistress Lucy!" This time he virtually shouted.

"Good," she said. "Assume the position."

Doctor Steward bent forward so that his head touched the back of the chair. He lowered it until his head rested where the chair and seat connect. This forced his derriere high into the air and, to keep his balance, he spread his knees wide apart. Again, those testicles hung down between his legs and I felt secretly thrilled at seeing them thus exposed.

"When I am finished with you, doctor, you will be interviewing your patient Mr. Renfield from a standing position. If you think I will spare you humiliation and pain, you are quite mistaken. You deserve all the punishment I will inflict on you and more. You have been arrogant, rude and impatient and I intend to paddle your behind until those traits are no longer in evidence."

"If it please you, mistress," he said quite loudly, "spare me the largest paddle tonight, as I have work to do at the sanatorium which

requires sitting."

Lucy was obviously furious. "Sparing you anything does not please me, Doctor. For that you shall have an extra half hour."

She swung her arm far back. The paddle rushed forward and landed on his behind hard—even from where I stood, the whap sounded as though it had done damage to the skin. Dr. Steward cried out, "Mercy!"

Lucy's reply was to bring the paddle across his bottom again and again. Each time she swung back I was given a clear view of that poor derriere. It quivered as it brightened, the color of the skin surpassing the red hairs in hue and going on to a far darker shade that I would call crimson.

As Lucy paddled him, my head swam. I could hardly breath. My entire body quivered with the tension I felt. My palms were sweaty as I watched, and moisture slid down between my breasts.

Lucy worked the paddle as if she were a lifelong cricket player. After a time she switched sides so that she might evenly tan him, his shade having gone from crimson to scarlet. I heard him groaning, begging for mercy, but Lucy only increased her efforts. Wherever she got the strength was beyond me.

Eventually I felt so weak I could not stand. One last, longing look at those maroon cheeks nearly made me faint. I staggered to my bed and fell upon it. Outside the wind howled, as if the coming storm was about to break.

My pulse was dangerously fast, my body tingled. I could do nothing but lie there, listening to the exquisite sound of paddle cracking against flesh over and over and over, interspersed with the pathetic cries of the now contrite Dr. Steward.

Finally there was silence, except for the thunder, yet it did not help me. My body burned, and I longed for a cool breeze to temper my fever. I did not know what to do for myself.

Suddenly my door opened and Lucy appeared looking fresh as if it were morning, carrying a glass of sherry. She wore a white cotton nightgown decorated with white ribbons and her feet were bare. Her long golden hair flowed prettily over her shoulders.

"Oh, Mina," she said, jumping into bed with me, "I'm so glad you met John. You do like him, don't you? He's proposed to me, you

know. Tonight for the third time. He's desperate to marry me. What do you think? Should I take the plunge?"

All this in her breathless girlish way while I could only lie there pulsing.

"You're still dressed!" she cried, as if I were indecent. Immediately she pulled my blouse down off my shoulders and lifted my skirts up my steaming body.

I allowed her to do it, unable to stop her, not really wanting to. Soon she had me stripped nearly naked before her. She sat back against the lacquered headboard and gathered me into her arms.

"Mina, you're freezing," she said, and giggled.

She ran her hand down my hot left breast to the burning nipple, which was plump as was the circle of paler flesh surrounding it.

"This is outrageous," I managed to mutter.

"Is it?" She circled my nipple with her finger tip and my body trembled.

"Lucy, I am a married woman. We must not."

"You worry so, Mina, but you always have," she reminded me. She took the nipple between her thumb and forefinger and pinched hard.

I cried out, arching my back as a hot charge passed through me, wanting her to stop, wanting her to do it again, feeling helpless to do anything but receive what she decided to give me.

"Remember the time at Miss Whippet's when we snuck down to the pantry in the middle of the night to peep through cook's keyhole?" she said.

"Oh yes!" I gasped. "She was in the bed with the gardener's son... but I don't remember what they were doing."

"You don't remember because that's all you saw before I shoved you aside so I could get my turn. But I saw them. He was mounting her from behind, like a dog, and..."

She bent her head and sucked my swollen nipple into her wet mouth. The sensation proved so delightful I could hardly bear it. My head fell back and I panted like an animal, feeling completely weak. "Oh, Lucy, you must stop..."

As she lifted her lips, she pulled the nipple up with her teeth, driving me insane.

"I saw him cook the cook's cherry pie," she whispered in my ear.

We both laughed. Another of our 'episodes' as we'd called them, except, as usual, I hid in the shadows while Lucy had all the fun.

She slung a leg over mine, trapping them, and moved her hand to my other breast, treating that nipple in the same rough manner. I writhed and groaned under her ministrations.

"Mina, remember how afraid you were that cook would hear us and tell the headmistress? You were always afraid of catching a licking from Miss Whippet."

Indeed, I had been terrified. Miss Whippet was renowned for her stern chastisements and I'd seen the effects of a session with her on the flesh of more than one student. "Poor Lucy, you spared my hide and took the blame alone when she found out; it was your bottom that paid the price."

Her hand alternated from nipple to nipple, pulling, twisting, pinching. I could hardly concentrate on what she was saying. My legs under hers struggled to spread of their own volition. My breasts thrust towards her dexterous fingers, begging for more. I felt like a hussy.

"Saved you? Nonsense. Besides, she didn't find out, I confessed. I just didn't want to share, that's all."

"Lucy, I swear, half the time I don't know what you're talking about. Share what?"

"Miss Whippet's paddle, of course."

I sat up abruptly, to the extent I could. "You aren't saying you enjoyed being spanked?"

She grinned at me.

"You can't be serious!"

"But I am, Mina. Do you think I'm dim? I knew how to obtain a licking and I knew how to avoid one. I just didn't want to avoid them."

This gave me pause. Lucy had been punished by Miss Whippet more than any other girl over our entire four years at the exclusive finishing school. The idea that she had elicited it... But then, I'd had a mild taste myself this very day of the pleasures of stinging flesh. Could it be that Lucy knew something I didn't? For once, I decided to be cagey. "But, then, you wanted the paddle?"

"The paddle, the birch, the palm of her hand. Even her riding crop on occasion. I wanted it all and got it all. Those were the most enriching years of my youth."

"But what did you get out of the pain?" I blurted. She pulled me back against her and this time each of her hands took a nipple and teased and played and punished them to her heart's content, and to mine.

"Pleasure. Intoxicating pleasure."

I felt as if my world was upside down. All these years I'd felt sorry for Lucy, being punished so, and yet now she was telling me that she craved it. And if I had not myself today experienced what I had, I wouldn't have believed her. But I did.

"Would you like to hear about the first time? It's a story I've told no one." Her eyes twinkled with that mischievous look.

"Oh yes. Tell me," I said breathlessly.

"Well, since you've been such a good girl today, I believe I will." She pulled me close and kissed me full on the lips, her tongue sliding into my mouth. I met her tongue eagerly with my own. She shifted me so she could easily slip a hand down inside my bloomers from behind. She passed the crack in my bottom and my bottom hole until she was between my legs. Shamelessly, I let her do it.

Her fingers rested at my opening, pressing against it only slightly. At the same time her lips found one of my nipples again; she nibbled on it with her teeth until I bucked and jumped and cried out, my exertions forcing her fingers slightly inside me.

Finally she licked my nipple and I shuddered. Then she began telling me the story.

"The evening after we arrived at the school, just as dinner had finished, Miss Whippet sent for me.

"You never knew this, Mina, but behind her office was a small room, no bigger than our woodshed. In it was a table long enough to lie on, three straight-backed chairs, a bed and a small dresser. The moment I entered, she locked the door, pocketed the key and ordered me to sit, although she remained standing.

"'Miss Westenra,' she said in her sharp voice, 'you are eighteen years old and have been deprived of parental charge for the past two years.'

"'Oh, no, Miss Whippet,' I said immediately, 'I have two servants who have been with me all my life. They take care of me since the death of my parents.'

"'Indeed, Miss Westenra, taking care of you and being in charge of you are hardly the same thing. And this is not what they have told me.'

"She handed me a letter written by Verna in her poorly educated scrawl. The gist of it was that although they had tried their best, I had always been spoiled and had now become incorrigible. It was, Verna said, not their place to discipline me. She went on to talk about how my parent's had wanted me to attend Miss Whippet's Finishing School and that Verna prayed that Miss Whippet would not be too lenient with me or she feared what would become of the young mistress of the manor. Needless to say, I was appalled.

"'Miss Whippet, this woman does not know what she's talking about. And anyway, I am eighteen and an adult. In charge of my own life.'

"'You are in error, Miss Westenra. I am in charge of your life for the entire time you are enrolled at my school which, if you will recall from the provision in your parents' Will, is for the term of four years.'

"I was angry at this. Who was this woman to think she had authority over me? Regardless of my parents' wishes, I was free to come and go as I pleased and I told her this without hesitation.

"She sat in an armless chair opposite me and just stared at me for the longest time. Oh Mina, you remember how chilling her grey eyes could be? As though her mind was made up and nothing would sway her? It wasn't long before I began to feel uncomfortable. Such a penetrating look. I sensed she could read my mind and all the nasty little things I was thinking about her.

"As you know, dear Mina, patience is a virtue you were blessed with, but the same cannot be said of me. Soon I was on my feet, demanding, 'Unlock the door at once!'

"But Miss Whippet only continued to sit there, watching me, studying me, I now believe.

"Over the next hour or so I threw fit after fit. I threatened her. I pleaded. I apologized and promised her anything, if only she would

let me out. At one point I picked up one of her precious antique Chippendale chairs and bashed it against the door, nicking the back and shattering one leg, all to no avail. If she hadn't been so much larger than me, I would have attacked her physically—the thought crossed my mind. Finally, exhausted, I fell into the remaining free chair and waited. Surely she would release me by morning when classes resumed.

"We sat another long while in silence, her staring, me fidgeting. Just when I'd decided that she was quite mad, she said, 'Miss Westenra, if you wish to leave this room, you will do as I say.'

"Of course, by that point, I was willing to do anything, and told her so.

"'Go to the dresser and open the top drawer.'

"I did.

"'Bring me the hairbrush.'

"Inside was an ordinary boar's-hair brush, only rather large, with a flat smooth back made of oiled mahogany. I carried the brush to her and she took it from my hands, examining it with great affection in her eyes.

"'This brush belonged to the mistress of the school I attended as a girl, when I was about your age.'

"'It must be very old,' I said, not really caring, more trying to humor her.

"'Very old and very reliable.'

"'I suppose it's a good brush,' I said, growing more bored by the minute. 'I imagine it does an adequate job on the hair.'

"'It does an adequate job on more than hair, Miss Westenra.'

"With that she looked up at me and I did not like the look in her eyes. It was wild and dangerous. And yet compelling. Something unrestrained spoke to me and I was mesmerized.

"'Clasp your hands behind your back,' she ordered, and for some reason I did as I was told.

"In a second she reached behind me, grabbed my wrists and yanked me across her lap. I was too stunned to realize what was happening and in those moments of my confusion she lifted my skirts and stripped my bloomers to my knees, still holding my wrists captive.

"I lay helpless, my bare bottom completely exposed before her. I kicked and screamed, trying to bite the woman and scratch her hands, demanding to know, 'How dare you! I shall have your school closed down on the morrow! Release me at once!'

"To Miss Whippet's credit, she did not release me. 'You want discipline and you want it badly,' she remarked. 'And you shall receive it. This, Miss Westenra, is the way things will be. I shall paddle your virginal ass with my trusty hairbrush from now until sunrise, at which time I will send you to your bed to sleep for one hour, although by then I should think sleep will be farthest from your thoughts.'

"It could not have been later than midnight. A quick tally resulted in the mind-boggling awareness that I was about to receive a five hour spanking!

"'In the morning,' she continued, 'you will attend classes and you will behave yourself. My instructors have been informed of your inclination towards disobedience and the necessity for swift correction. They have been ordered to overlook nothing. At the slightest transgression or infraction of the rules, you will to be brought to me immediately, whereupon you will be put across my knee as you are now. I intend to mete out punishment as often and as severely as you have need of until you clearly understand who is in charge of whom.'

"Of course, her words sent terror careening through me.

I had never been spanked and the thought that it should happen to me now, at the age of adulthood, and when I had finally become independent, well, I could not bear that easily. But at the same time another feeling coursed through my body making me quiver in anticipation. The idea of being slung bare-assed across this woman's warm lap, of being completely at her mercy, the thought of her hairbrush imposing limits—and for five hours!—well, I was excited.

"'One other thing, Miss Westenra. Regardless of how perfect your behavior is in the days to come, I will see you every evening after supper, here, in my private office, where we will continue these important if hard lessons for the next three days.'

"'Three days!' I yelled.

"'A week, then.'

"I was stunned into silence and would have stayed silent had not the back of the hairbrush forced a cry from my lips. The brush smacked one cheek, then the other. Back and forth, the wood stung my behind harder each blow. I had never felt anything like it. Pain rippled out from what felt like the one tiny spot she spanked on each cheek. My bottom warmed very quickly.

"Soon my rear end jumped at each crack as the wood found its mark, but I suspect my increasingly sore bottom was not so much seeking escape as rising to meet the occasion. For you see, my womanly nub knocked pleasantly against the intimacy of her lap with each fall and to fall, I was required to rise. But then, the spanking itself titillated.

"Miss Whippet was nothing if not thorough. She spanked all sides of my bottom, paying particular attention to the underside where I would be forced to sit, as well as the middle. To my amazement and agony, she kept finding new areas that had not yet tasted the hardwood. She paddled me well, never tiring, a natural disciplinarian. I must have received a hundred on each cheek before she even paused, and then it was not to rest but only to inform me, 'From your response, Miss Westenra, I see a fortnight of paddling would suit you better.' And then she was off again, spanking me powerfully and energetically, as if she derived energy from her efforts.

"As I bounced the night away across her lap, I cannot say that my first session was entirely enjoyable. I was terrified, and my tears knew no limit. My bottom was shocked by such rude and direct training. Still, by the time the cock crowed and Miss Whippet sent me to bed, I was looking forward to my next lesson. And Miss Whippet, true to her word, administered all the ones that followed in the same no-nonsense manner, every night for the next fourteen. My bottom glowed like a ripe red apple. For two weeks I could not sit and being at a school desk was agony, causing me to squirm, thus earning me further licking. The brief sleep I was permitted, I could only lie on my stomach, suffering as my ass raged like a roaring inferno. But through it all, I experienced delicious new sensations that I knew her training was awakening."

Lucy paused for a drink of sherry. All this had been going on under my nose, as it were. During the years I'd pitied Lucy, I should

have been pitying myself. To never feel a wooden paddle against my bare skin. To never meet a striking hand that would not be halted by my cries. To never endure pain, exquisite pain, that would drive me down paths I had not explored.

Her throat once more lubricated, Lucy concluded. "At the end of my initial private instruction with Miss Whippet, I had learned respect for our head mistress. I also knew by then that she demanded a great many things from me, including an insistence that I employ her expertise often so as not to waste my time at the school. At least once a week I found occasion for a private session with Miss Whippet, who never failed me. Of course, our head mistress, being a true educator, employed a variety of training methods and I discovered them equally effective under her firm hand. What I learned from her has proven invaluable; she made me the woman I am today."

As Lucy finished, I became aware of her fingers deep inside me— how had they gotten in so far? I felt like a puppy, warm and fuzzy, waiting to be stroked.

"This will be our little secret, won't it Mina?"

I nodded languorously. The heat coursing through my body had built to the point where I knew if I moved even an inch that delicious pulsing fire would engulf me. My dilemma was: how to stoke the flames until they rose higher and yet delay the inevitable crumbing to ashes.

But my problem suddenly vanished. Lucy withdrew her fingers quickly. She stood. Outside rain pounded on the eaves.

I lay sprawled like a cast-away doll, aware of my near nakedness and my awkward position. My mouth gaped in utter disbelief.

She walked across the room and turned the knob on the lamp until the room faded to darkness. "I trust you are warm enough, Mina," she said. I could hear the humor in her voice. "Sleep well, if you can."

Chapter Eight

The following day Lucy was not to be seen. Verna, who served the first meal, answered my inquiry that, "Miss Lucy is volunteering at the sanatorium and will be away all day." I breakfasted alone, after which Verna suggested a ride.

I mounted Rosebud sidesaddle, a skittish chestnut mare that took off immediately, although I struggled to rein her in. She galloped along quite rapidly, I bouncing hard against the saddle, until I gained control of the beast. From then on we trotted at a reasonable pace. The brilliant sunshine of the English countryside combined with cooling breezes from the sea and the large animal beneath my legs lulled me into a kind of erotic stupor. I found myself daydreaming.

The events of the night before had fired my imagination as well as my body. I felt a strange confusion, not unpleasant, as I conceived myself in both roles. Rather than Lucy, it was me who stood behind my absent husband with the long paddle in hand. Oddly, I could feel the vibration as the wood struck home and the ever sorer flesh submitting to it. And then the next moment it was me receiving the paddle across my backside, the stinging increasing and my control chipping at the edges. An hour of the continuous bouncing of my womanhood against the saddle coupled with my vivid fantasies caused a great wet spot at the crotch of my riding breeches. When I returned to the house and dismounted, the servant Verna noticed.

I hid my face in embarrassment and became harsh with her.

"Has Miss Westenra returned?"

"No, Mrs. Harker, she has not."

"Fine. I will lunch on the veranda. You may serve me there, and you will do so within the next half hour."

"Very good, madam."

Frankly, I was annoyed with Lucy. I was her guest; she should have told me she would be away. More to the point, I felt toyed with. Used in some way that was as yet a mystery to me. Brought to a pitch and then left dangling. As the day passed and most of the evening, my frustration grew and I resolved that Lucy would hear of it directly.

It was early and I was not yet tired, but decided to retire to my room and write that letter to Jonathan. I'd just begun the salutation when suddenly I heard a commotion through the wall. I hurried to the portrait and eased it aside. What I saw through the peep hole shocked me.

Lucy stood in a powder blue silk corset and matching shoes and stockings. Her hair flew about every which way as she swung her arm back and forth. A God-awful swishing resounded, the effect of the thin bamboo cane she held cutting the air. The cane was not, however, only cutting air, but lacerating the flesh of a dark-haired bottom. A man—and it was definitely not Doctor Steward—lay across the side of the bed, his torso on the mattress, his knees on the floor. The bottom being cut to ribbons was hairless except at the crack where the cheeks met, where the sable brown hairs led down to his rather large testicles. He howled as the cruel reed whipped back and forth across his flesh with wild abandon.

Lucy was having a wonderful time, by the looks of her. The corset exposed her triangle of blond hair at the front and her plump little buttocks at the back. It also held up her pert breasts, the rosy nipples riding the cusp. Those nipples were hard and pointed and glistened from the most unladylike sweat she had worked up. My mouth felt dry; I imagined sucking on them and the delight that might bring. The room suddenly felt steamy.

A large smile had spread across Lucy's face. As she swung the cane, her body twisted girlishly from side to side as if she were showing off a new dress. Her sweet breasts bounced in their cups like two Vanilla puddings. Her creamy bottom cheeks quivered.

Suddenly she paused and turned her head sharply to stare straight

at me, or so I thought. She smiled again, and pursed her lips as if sending a kiss, obviously for my benefit. I was annoyed and angry and yet I could feel that my bloomers were wet in the crotch again, and the liquid refused to quit flowing.

Lucy turned her attention back to her victim. "Into the middle of the room, Arthur!"

The poor fellow, obviously in pain, fell to the floor and crawled along it on hands and knees, Lucy using the cane to guide him. "Stop!" she yelled. She prodded him to turn so that I could see his behind, which was fearfully red. She inserted the tip of the cane into his anus, then slid it in farther than must have been comfortable.

The man named Arthur threw his head back and wailed like a dog as she pumped him with the bamboo, although I had the distinct impression the sound mingled pain with pleasure.

I watched his bottom cheeks tremble and his diaphragm suck in and out faster as she increased the thrusting pace of the natural rod. From where I stood, I could not get a clear view of his penis, yet what little I did see told me it stood erect. Something in that shadowy view excited me.

Without being aware of it, my fingers had gone to my nipples some time before because I realized I was twisting and pinching them through my cotton blouse in time to the cane's thrustings.

The man was on the verge of some sort of conclusion when all of a sudden Lucy withdrew the pale rod. The groan that he emitted sounded pathetic, and it was one I understood well. Lucy had escorted him to a door but would not open it that he might go through.

She swung the cane briskly again, whipping his bottom anew, increasing the number of flaming streaks across the once white skin until they could not possibly have been counted.

Indeed, it was a dreadful sight, the man writhing in agony, and yet I found myself pressed to the wall, rubbing myself against the flowered wallpaper, trying in vein to find relief. Tonight another storm rode in off the water, this one greater than the night before. The air pressuring my body felt unbearable.

She made him squidge around on the carpet so that his head came close to the wall I hid behind. "Turn over!"

Arthur did as she commanded. Now that he was on his back, I

could see his handsome, cultured face, the long dark brown side-
burns that spread across his jaw, the clear blue eyes, the rims as red
as his bottom. I also saw his enormous manhood.

Never had I seen the like. Of course, I had not seen many.

Dr. Steward's member may have been as long but was certainly
slimmer. Jonathan's I'd never seen, although I had felt its half-heart-
ed attempts to greet the woman in me.

This man, however, showed what manhood could aspire to. The
shaft was not just long, but thick, the tip a dignified polished head,
proud, arrogant, masculine in every way. Beneath the shaft his testi-
cles stood on duty, large and bright colored and tight. The sight took
my breath away and sent a new surge of wetness sliding down
between my legs. Outside the window, lightning flashed.

"Lift yourself up by your hands and feet."

Arthur pushed from the floor with his hands and feet until his
body became convex. His head hung down between his arms—I
now saw that Oxford face upside down—and his glorious manhood
stood proudly on call, jutting from his groin into the air. He looked
like a gymnast about to perform an amazing feat.

Lucy went to the desk and returned with a round brass ring. She
slid it over his member and pushed his testicles up through it as well
so that the ring seemed to lift his marvellous tool higher. She
appeared to be tightening it, which only lifted him higher. Whatever,
I wondered, could that be for? But Lucy answered my unspoken
question.

"You will keep your ejaculations to yourself, Mr. Holmwood, so
that I may enjoy you without worry and you will enjoy only what I
permit."

Lucy straddled that enormous creature. She lowered herself onto
it until the fleshy rod disappeared inside her. The smile on her face
spread and Mr. Holmwood moaned.

I could barely stand. The craving within me, the emptiness
longing to be filled and filled again and again made me shake uncon-
trollably. The heat was tremendous. Frantically, hardly knowing what
I was doing, I untied my skirts and let them and my bloomers drop
to the floor. My fingers intuitively found my dark forest, a thicket I
had never entered.

Lucy pushed herself up and then slid down onto him again, over and over. Arthur's face became crimson, his breathing strained in the control that was demanded of him.

My fingers became sticky as they slid along a tender hump in that secret jungle. Rubbing it caused me to jump and squirm. Thunder clapped and my legs parted. I bent forward so that access was easier; my rump stuck out into the air.

Lucy lifted and lowered herself, bouncing, writhing on top of him; my heart pounded in time with her movements and my fingers danced inside me. The fierce storm was approaching, I felt that throughout my trembling body.

Finally I found the source of my wetness and entered that moist hidden cave. My eyes closed and my head fell back. My knees bent as I slid most of my hand inside the wet grotto, exploring.

I opened my eyes for a moment. Lucy moved faster and she pumped him harder. Arthur's face turned purple. With each entrance, Lucy's nipples thrust higher and her back arched.

My breath came in ragged pants. My hand was soaked with my own juices. I felt the ripples of flesh within me and brushed and tickled them up and back, up and back. It was divine, this sensation! My inner flesh tighten as my hand worked faster in and out.

Swish-Whap!

I nearly jumped out of my skin.

Swish-Whap! Swish-Whap! The sharp searing across my bottom stunned me so that I could not even cry out. Pain burst through my flesh like a tinder catching a spark.

I spun around. Verna stood behind me gripping a dread cane similar to the one Lucy held. She swung it again and the rod landed smartly across my thigh. I screamed.

"Into bed with you, Mrs! I have my orders from the Mistress."

I could not even think about how absurd that sounded for the pain made me compliant. In my haste to obey, I tripped over the clothing caught at my ankles and for my clumsiness felt the bamboo cut my bottom again.

Despite the tangle of clothing, I stumbled to the bed and fell across the duvet, face down.

Helplessly I lay there as Verna applied the rod. The cane criss-

crossed my derriere from both directions. I howled as I'd heard Mr. Holmwood howling just moments before. And yet I now completely understood that strange mingled sound ripped from his throat. With each whip of the cane, I wanted another, needed another. I cried uncontrollably, lust for the cane spreading through my secret forest like a wildfire. As my cheeks fried, the liquid within me bubbled, threatening to boil over any second.

All of a sudden Verna stopped. "Miss Westenra ordered a baker's dozen, no more, and that's what I've delivered."

I lay sobbing. My bottom throbbed. My insides throbbed. Violent rain crashed against the window. My agony begged release. But there was to be no deliverance tonight.

Verna turned out the lamp and closed the door as she left.

Hours raged by, the swelling heat leaving my entire body pulsing. I was terrified to try to fulfil my longing, afraid the rod would magically appear again and renew our acquaintance. And yet the fear was greater that I might end this delicious torment which I suffered, and that I could not bear either.

And so I suffered, floating in and out of dreams that had me caning Arthur and Dr. Steward and, most delightfully, Jonathan, and being caned in the worse way by Lucy and Verna, all as the storm raged.

The night had been scrumptiously tormenting and I was grateful that when I awoke near noon the next day, my bottom still bore the angry red stripes, assuring me that everything had not been a dream.

At breakfast I was relieved to find that I must sit gingerly, for my cheeks were sensitive to the hard chair seat. The rawness of my fleshy seat sent little quivers through me and I found myself fantasizing about another licking, and how I could prolong it.

Lucy entered the room bursting with energy, her face full of color. She pecked me on the cheek and sat beside me, flicking open her napkin.

"Oh, Mina, I had such a wonderful time with Arthur! You haven't met him, of course, but he's a dear old friend of the family. He's proposed."

"What, another?" I blurted.

Lucy giggled. "Mina, don't be so silly. I have more men than I can shake a stick at."

"Well, which one are you going to accept?" I asked.

She gave me a sly smile. "Perhaps you should meet the third before you ask me that."

Now I was shocked. "You have three gentlemen asking for your hand? Is that decent?"

"Decent?" She jumped up to hug me, inadvertently pressing me harder against the chair. A little gasp came out of my mouth, a comment from my sore bottom.

"I sent Verna to see to you last night, as I was not available. I hope she did as she was ordered. Did you sleep well, or were you uncomfortable?"

My cheeks colored. "I slept... enough."

Lucy had but a nibble of toast and a gulp of orange juice and then she was out the door, calling, "Mina, dearest, I must attend to some boring legal business about the estate. Be on hand, won't you, for a late supper tonight with Quincey. You two must meet. He's exactly the type you should get to know intimately."

My day was spent nursing my wounds, which titillated me no end, although by late afternoon I wished them freshened rather than on the mend.

Verna appeared at regular intervals to offer me tea and then lunch. Her eyes stared into mine, not the way a servant looks at a mistress, more the way a maid carefully examines a carpet in order to ascertain how severely it needs be beaten in order to remedy it's imperfect condition.

I decided on a late afternoon rise. Mounting Rosebud reawakened the worries of my bottom and the bouncing reminded me of the rhythm of the cane in all its myriad uses. Today the nub beneath me was red hot, sending ripples of pleasure throughout my body as it rode the living flesh beneath me. I only wished I could be free and ride bareback.

I traveled to the East Cliffs and dismounted for a break. Below a crowd of men—workers by their muscles—unloaded all that remained of a ship that had run aground during the night. Large boxes were being carried to the shore. Even as they bent and lifted the crates over the sides, waves slammed the bow of the ship against the rocks. Everywhere today, the rhythm of the cane repeated itself.

Life ebbing and flowing, lifting and rising, pain and pleasure.

Rosebud was anxious to return. Secretly I removed my bloomers and stuffed them into my jacket pocket. I mounted the mare by straddling her, and spread my riding skirt in a way that permitted me to ride home bare assed if not bareback. I galloped her, taking the long route, dreading that anyone would witness my impropriety and yet the sensations were delicious. The hard polished leather slapped steadily against the crack between my spread legs and, at the same time, paddled my bottom. By the time we returned to the house, I felt well spanked, thanks to Rosebud's steady rhythm. Quickly I slid to sidesaddle, not yet brave enough to withstand disapproval.

Verna held the reins while I, breathless, dismounted. From the look in her eyes, I suspected she caught a glimpse of the nakedness beneath my skirts. The tan saddle was wet and a sweet tart odor came from it.

"The ride has brought needed color to your sweet cheeks," Verna declared, and walked away.

Chapter Nine

I dressed carefully for dinner, borrowing one of Lucy's beautiful dresses for the occasion. It was a pale green brocade with a low neck—far lower than was decent, to be truthful—with tulle trim. Jonathan would be scandalized, but Jonathan was not here.

I felt distress at the thought of my husband. He had failed in his duty to me. Recently I had tasted of the erotic and I wanted more. But Jonathan was a moralist. A land and estate agent by trade, a stamp collector by hobby. I felt certain he could not comprehend such desires.

Lucy had left a pink powder on my dresser. I applied some to my lips and also colored my nipples and the area surrounding them. The red looked healthy and bespoke of the yearning I felt.

Perhaps this Quincey, whoever he may be, might at the least deliver entertainment. This rest by the sea had in many way been far from a rest, and yet I seemed to be spending substantial hours alone. Perhaps a bit of masculine input would do the trick.

Lucy and a tall broad-shouldered man stood by the French doors in the dining room. They turned as I entered.

The man had black hair, swept back and pomaded. It told me immediately that he was an American. His dark eyes locked onto me and I felt a shiver of fear and delight ride up through my thighs.

"Mina, dearest." Lucy kissed me on the lips and shoved me forward, presenting me like a present to this man. "Mr. Quincey Morris. Quincey, my best friend, Mina."

"Ma'am," Quincey said, kissing the back of my hand. His lips were full and wet and I felt the imprint of them as if I had been tattooed.

"Isn't he delightful?" Lucy exclaimed, adding, "He's from Texas."

"Really?" I said, hardly knowing what to say.

We dined on roast beef and Yorkshire pudding, with a whipped chocolate dessert that Verna had created for the occasion. While we ate we chatted.

I learned that Mr. Morris was a rancher by trade. Horses.

"You must ride frequently," I said.

"Every day, Mina. Gets you mighty sore in certain places, if you know what I mean." His dark eyes laughed.

"Oh, Mina does," Lucy said, and I felt my face color.

He had come to England on business and would not be staying long. Still, during that time Lucy had managed to meet him and he had managed to propose marriage.

We spoke of many things while we ate, including Jonathan, at which point the meal became tasteless for me.

"Mrs. Harker, how long has your husband been gone?"

"Far too long and yet not long enough," I said, an unusually candid and witty remark for me.

"Mina is recently married, Quincey," Lucy told him. "They're still sniffing their way around one another."

Quincey laughed, a hearty laugh that did not feel mean-spirited yet I knew he was making fun of me. "Hell, in Texas folks take a lesson from the horses. When a stud sees a mare he wants and she's willing, well, they just do it on the spot, no ifs, ands or buts about it. That's the way we do it in Texas."

"An interesting approach, Mr. Morris," I said. "I suppose in England we are rather more formal."

"Some of us," Lucy corrected. "Personally I think it's refreshing. If men and women want to explore their animal natures, I for one do not believe convention should stand in their way. These acts are perfectly natural, after all."

"I suppose so," I said, feeling that sentiment was against me yet not really understanding how I'd managed to assign myself the role of official opposition. After the last few days, I was no longer certain

just what I did believe. But one thing I knew for certain: my life had altered. When Jonathan came home, he would not find the woman he had left behind. The idea of that both frightened and excited me.

Jonathan. I had been so hard on him in my mind. Since I'd arrived, I hadn't written him even one letter. Of course, I'd received none either, although the mail would needs be forwarded from London.

I looked at Lucy and Quincey. What a fine couple they made. Whatever had I been thinking? I was still Mrs. Jonathan Harker. Nothing had changed that. Perhaps I'd had certain experiences that awakened my sensibilities, still my allegiance was clear.

I excused myself, much to the protests of Lucy and Quincey, and retired to my room, determined that tonight I would write to Jonathan. For good or for ill, he was my husband and I at least owed him my loyalty.

Half a page had been written when I heard sounds through the wall. I kept my back to the portrait of the staid relative, determined that tonight I would ignore Lucy's lascivious behavior. She had her life and I mine. We could be good friends but that did not mean we must share everything.

But the racket continued and I could not concentrate. Despite all my willpower, I found myself sliding the portrait aside and peering through the hole.

Quincey was on all fours, naked but for the bridle he wore over his face and the bit between his teeth. Lucy, also naked, pert breasts jiggling with each movement, sat astride his back. Her bent knees allowed her pretty little bottom to plump out behind her. In her left hand she held the reins high and tight, forcing his head this way, then that, as if he were a horse. In her other hand she clutched a riding crop which she flicked smartly against his rear end.

The scene transfixed me. As Quincey galloped about the room, Lucy cropped him repeatedly, bouncing merrily on his back, reining him left and right, yelling "Giddyap!" and "Whoa!" as they say in the American Western novels.

Quincey pranced about like a fine steed. His dark hair had fallen into his face so that it resembled a mane. His well-defined muscles gleamed from sweat and rippled under the tension of Lucy's direct-

ed movement. At one point, when she pulled the reins, he reared back on his knees and I glimpsed a penis so steady and hard I gasped out loud.

Both he and Lucy turned to the wall.

"Mina!" Lucy said.

I would have hidden, but something in her voice held me.

"Mina, come in here right this minute!"

I could not move at first, but then suddenly found my legs propelling me towards the door, down the hallway and into Lucy's room.

"Take off your clothes!" she commanded. Her amethyst eyes and Quincey's dark orbs glittered as they locked onto me.

I did not move a muscle.

"Remove them or I shall." Lucy's tone was sweet, but it did not invite discussion.

Slowly I unbuttoned my borrowed dress. The fabric rustled as it drifted down my body to the floor. Next I unrolled my stockings to my ankles and slipped them off after my shoes. My bloomers embarrassed me. They were plain, unadorned cotton, the utilitarian kind, not the beautiful undergarments that Lucy wore, and I peeled them off quickly. Because Lucy's dress was a size smaller than my own dress size, I'd had to tighten my corset more than I normally would. It held in my waist and plumped my breasts up high, meanwhile pushing my derriere out so far that it appeared to be as round as Lucy's. My fingers fumbled in nervousness and I struggled with the hooks; the task seemed to take forever, although apparently neither Lucy nor Quincey minded. Their eyes roamed my exposed parts and I was reminded of hungry predators.

Once I stood naked before them, Lucy vacated Quincey's back and pointed to it with the crop. Shamelessly I sat astride him, taking the warm spot Lucy had so recently sat upon and where her sweet slippery juices still lingered. Two small stirrups had been harnessed to his sides and I bent forward in order to slip my toes into them. They kept my body thrust forward and my derriere jutted out behind me like a jockey at Ascot.

Lucy handed me the reins and a second crop. "Well," she said sweetly, "he is a stubborn beast and will not move unless you whip him soundly."

"Whip him?" I said stupidly. I had never whipped anyone. The idea of it frightened me.

"Whip him properly or I shall whip you." I glanced at her and she smiled, but I knew she meant business.

I flicked the crop lightly against his rump.

Lucy's crop lashed my buttocks and I yelped.

Determined to do better, I struck him harder and felt him tremble beneath me. The feeling was a delicious sense of power. Between my legs was an animal. A beast that needed taming. A beast I could learn to control.

The leather crop stung me again, once on each cheek in quick secession, so I would get the point.

I cracked mine against Quincey's bottom and nudged his sides with my knees.

He moved around the room slowly at first, my crop lapping at his ass, Lucy's flailing mine. Soon Mr. Quincey Morris from Texas galloped over the carpet like the fine American breed that he was, responsive to my every whim.

His cheeks had been pink when I arrived. A quick glance over my shoulder assured me they had brightened considerably, as had my own sweet seat, which plumped red against the white skin of his back.

Each gallop tossed me up into the air a bit, there to receive the precisely timed cropping, then plunging me down so that my tender nub bounced against his hot sweaty skin.

We rode this way for a good hour, I on Quincey whipping him, Lucy's crop licking me madly, until at last Quincey collapsed onto the carpet in exhaustion.

"On your knees!" Lucy ordered. Quincey, like a horse that had laid down, struggled to obey his mistress under the smart cracking of the thin leather punishing his hide.

"Get up!" she told me, "and on your knees too."

I did as I was told, the stinging leather tongue encouraging me to make haste.

Lucy mounted him and rode him in a circle until they were behind me. I felt tense with excitement. All the little lash marks on my bottom pulsed in unison with my swollen little button. I was out

of breath, waiting, excited, fearful.

Lucy nudged him forward. I heard the crop cracking against him. "Mina, spread your legs," she ordered, and I did.

Within moments I felt something close to my opening. Warm breath. A wet tongue slid from the front of my crack all the way back to my anus, there to linger. I quivered at the contact. Fleshy lips sucked and chewed on my anal opening, forcing moans of pleasure and embarrassment from my throat. A firm tongue entered me. I groaned again and the crop cracked against him and I felt him shudder. The tongue licked my bottom hole clean then moved back down to my sensitive womanly slit.

The pleasure was so intense I could hardly stand it.

Instinctively my chest lowered and my bottom thrust back into his face. He slurped the juices from me, swabbing the layers and folds outside, nibbling my tender swollen nub. Tremors passed through my body. The crop whipped me anew, increasing my pleasure.

Then his tongue entered me. No man had entered me before but Jonathan. I felt indecent. Dirty. Vulgar. Thrilled.

I begged, "Lucy, whip me, I beg of you!" She complied, raising and lowering the crop quickly, lashing both cheeks, forcing me to lose all decorum and moan and beg them both to continue.

Quincey's tongue darted in and out of me and his lips sucked skin, shooting sparks of sensation through me.

I groaned and cried as they kept time with tongue and whip.

Tongue, whip. Tongue, whip. Both brought torturous pleasure and exquisite pain. I wondered if I could go on this way forever. Could I build and build and never reach the top? And yet I had a sense of escalating, nearing a mountain peak that would show me sights I had longed to see.

Suddenly, Lucy jerked the reins.

Quincey's tongue and lips were gone.

The crop disappeared.

I was left on my hands and knees, my burning derriere sticking high up in the air, my insides pulsing, the cool air of his absent tongue tempering the heat.

I looked over my shoulder. Quincey lay on his back with Lucy

astride, riding him, his fine manhood piercing her.

Suddenly Verna appeared at the door, riding crop in hand. She came straight towards me.

"No!" I screamed.

Her crop found my bottom without delay. I was whipped out the door, back down the hallway and into my room, all on my hands and knees. The blows were many and she laid them on heavily.

Once in my room, Verna yanked me up by my hair and threw me onto the bed. Then she gave me the crop good, striking my already swollen cheeks, the backs of my thighs, my calves, using the leather tongue and the cane part. In no time I was pleading for her to stop. My body throbbed like a heartbeat. If I could get no release I would die.

She stopped, as I had asked, but now it felt too soon. She switched off the light and left. Again I lay till morning, my body steaming in an agony of not-quite-ripeness.

I lay in my bed on my stomach sobbing. Would I never be fulfilled? Would I never taste the magic others took for granted? Lucy and her multitude of beaus. Verna and Hodge. And I? I would be leaving soon. What had I to look forward to? The moral Jonathan. A good man. A righteous man. A man who would not even use a riding crop on a horse!

I wept in bitter disappointment, feeling like a new bud that would never flourish but die on the vine.

Chapter Ten

The following evening was to have been the last of my visit. Again, I saw almost nothing of Lucy during the day. I had only my wounded bottom to entertain me.

Lucy arrived while I was eating supper, but did not join me. Shortly thereafter the doorbell chimed. Dr. Steward was led into the living room where I was enjoying a glass of cognac while I sat upon a soft cushion.

"Mrs. Harker."

"Doctor. I'm afraid Lucy is in her rooms. I'll send Verna for her."

"That won't be necessary." Lucy stood in the doorway. She was dressed in a satin gown and a black velvet cape with a hood, as if she were ready to attend the opera.

"It was good of you to come, John, but I'm afraid I cannot see you tonight. Perhaps Mina would be kind enough to entertain you."

I was speechless once again. Was Lucy now offering my services as a paddler to this man who was virtually a stranger? The gleam in his eye told me he was not opposed to the idea, although I had the distinct impression that he felt as annoyed at Lucy as I had become.

"Don't wait up for me," she told both of us. "I've met a fascinating man from the continent. A lord. Count Dracula. He's escorting me to the theater and I shall be home late. Very late."

Chapter Eleven

Someone must have carried me to my bed for when I awoke I found myself in my bedroom in Castle Dracula, unable to move. Alone.

Magda did a job on me, that is certain. Every limb and my entire torso had been cut by her harsh whip. She suspended me on the rack for hours—until just before sunrise. The woman is a fiend, gleaning pleasure by forcing cries from my lips.

I have never met a female so methodical. She began at my shoulders and worked her way down my back, searing the flesh with the sharp tail of the bullwhip. The sound alone as it cracked through the air terrified me. Each cut sliced into my skin until I thought I could not bear it. Until the next one.

She traveled down my back slowly and I suspect the stripes that tortured me later were no more than an inch apart. If the Count had not broken my shaving mirror, I would have been able to look, but there were no mirrors in the castle, or none I found.

When she reached my waste, she paused and returned to my cock, still suffering on the other side of the rack, standing tall but alone, except for my balls, which she had also forced through the wires. I did not wish to have an erection. The situation did not call for one. And yet, I found the pain oddly stimulating in a sexual way. But the wires kept me from ejaculating.

My back raked raw, she then used the end of the whip to slap my penis and testicles. Back and forth she went and shamelessly I cried

out. But much to my amazement, the fellow would not quit. He defied her attempts to break him. And when the heat threatened to tear him open, suddenly cool lips slid down my shaft and fingers needed my swollen balls. Cries of pain turned to groans of delight. She licked and sucked him until he felt full and ready to burst. But I could not come. It may have been the manner in which the wires propped up my genitals, or it may have been some conscience arising to inform me that a woman other than my wife was attempting to suck me dry. I do not know from whence my impotence stemmed. Magda, though, did not appear to mind.

Presently she picked up the jar of herbal scented oil again. Before resuming her vicious work, she oiled my lower flanks, rubbing the stinging liquid into my ass cheeks, around the monstrous leather penis the Count had forced up me the night before and which I still wore. The invasive tool was uncomfortable at least, only truly painful when my muscles tensed, as they must at contact with the whip, and yet that sensation was not entirely unpleasant. Much to my surprise, I found that the longer I wore this 'tail' as it were, the more it felt a part of me, a sensual and necessary part.

Magda continued on down between my legs, the inside of my thighs, the backs, and my hips, down my calves to my feet. The liquid pricked but that seemed to lessen the fire raging across my upper body.

When she was satisfied, she picked up the dreaded whip and began anew.

Of course, I had never been whipped; what civilized man has?

I had received the cricket paddle in school once or twice, an initiation into a fraternity, the other time, again by my peers. It was enough to tell me that a warm bottom was not an unpleasant sensation, but the occasion had never arisen for a repeat application and I had not foreseen that it would. And it had not, until the Count used the birches on me.

But this was different, entirely.

Magda is a beautiful woman, although her exact nature mystifies me. She and the other females are like the Count, yet what they are I could not say. Their skin is pale, as though they need sunshine, the one thing they avoid like the plague. Her red hair is coarse and wild

and her green eyes will flash at a moment's notice. Her figure is full, breasts inviting lips to them, and her bottom generous and begging to be squeezed. Of course, last night it was no longer white but seared from the fire I had spread across her at the Count's instruction.

That had been an unusual experience. On the one hand, being in control of her agony satisfied me in a way that was foreign. But as well, part of me wished to resist being a mere instrument the Count utilized to punish Magda. Yet after the previous night with Count Dracula, I knew resistance to his will was impossible.

That night had been unlike any in my experience. When the Count found me fucking his wife, and being titillated by his other two spouses, I expected his ire. That he struck me was not uncalled for and the pain of that blow felt deserved. Still, it embarrassed me to be picked me up like a woman, although there was something arousing as I lay in his strong arms whilst he strode purposefully through the castle and up the stone staircase to my bedroom.

He deposited me abruptly at the small window and threw open the casement. We were several stories above ground level. Cold night air blew against my shivering naked body.

"Count Dracula, I do not know what to say," I stammered. "How to beg for forgiveness—"

"There is no forgiveness, only revenge!" he said in a quiet voice that terrified me.

He pinned my arms behind me with only one hand and opened his mouth. Long eye teeth appeared before my startled eyes. His face was a mask of hunger and dominance. In the semi-darkness his eyes flashed red and angry and I waited, shaking, expecting that my life would soon come to a close.

He plunged his teeth into my throat. The sharp piercing of my jugular turned into a steady burning pain, as if the teeth were made of smouldering tinder. I was hardly able to move under his strong grasp but my hips managed to squirm against him. His body was a rock of masculinity. I felt his enormous cock through his clothing, hard and insistent against mine, and a thrill passed through me. My own member stiffened. His lips pulled at the skin of my throat and I had the sensation of something vital leaving my body. Still, I longed

to give him that and more, anything he wanted.

When he had taken all that he cared to, he picked me up from behind by the waist and thrust me out the window. I believed he was throwing me out, to hurtle to my death on the rocky ground so far below. But he only hung me part way, so that my chest and arms swung freely in the night and my ass and legs dangled inside the room, unable to reach the floor. I gripped the large stones that formed the castle wall in terror for my life.

Immediately I struggled to push myself up and back inside, but he tied something to my waist that held me fast where I was and all my attempts to push back met with resistance. My feet could not gain purchase and I had no way of hoisting myself into the room. I was at his mercy.

Without, the night was windy, great gusts forcing the stark tree branches to cut the air. Wolves off in the distance howled. A full moon hung suspended in the dark sky and grey clouds lashed its surface rapidly. My upper body quickly chilled. My lower body rapidly burned.

A switch struck my ass and I jumped. My cry was swallowed by the wind. Quickly another slash of the willow. Another. I knew from our brief acquaintance that the Count was not a man who went part way. He lashed me mercilessly, with a strength that shocked me. Nothing had prepared me for continuous and harsh punishment.

I howled into the night, drawing the wolves to the courtyard below. Three of them looked up, their red eyes glinting in the moonlight; they wailed in what I imagined to be sympathy at the relentless torture I endured.

The Count said not a word. I had known he was a man of few words and suspected him more inclined to action. Whatever energy would have been wasted with threats and explanations was channeled into his powerful arm as it wielded the birches to shear my bottom.

As he struck, my legs climbed the castle's interior wall, struggling to escape. This, I now realize, resulted in offering a more prominent target for the green branches to flog.

I know not how long he switched me. He changed tools several times, presumably as he wore them out on my hide. I had not expe-

rienced such pain for such duration and know I took it badly. The moon actually moved half across the sky before he had finished, or so I imagined.

I lay limp, my bottom a mass of raw flesh, overcooked, my upper torso and limbs near frozen. The opposing sensations caused me to quiver and shake. I felt shame at my tears and yet they gushed from my eyes. The pulsing produced by the flagellation stiffen my cock. Because of the angle at which I lay, the wall pressed it down, rather than allowing it to furl upward.

Two large hands spread my hot ass cheeks until the crack between them felt as if it would split. This pressed my cock down hard. I tensed, not having a clue as to what would come next. It was as though a physician examined my asshole, poking, prodding, inserting a finger in, then removing same, making assessments. What could be his intention? I wondered. I'd heard of men using other men as women, but that was in Turkey, although I suddenly realized to my horror that we were near the Turkish border and that the Count, himself, had told me he'd taken early education in that land.

"I have no more time for you this night, Mr. Harker," Count Dracula said, as though we'd been discussing British customs the way we had on the previous evening. The implication in his tone was that our intimate discussion would be continued at some future time. He continued, "You understand, I must see to Magda and her comfort or lack thereof."

What happened next I can only vaguely describe. Pain cleft me in two. An object so large I could not comprehend its nature impaled me in that same hole. It tore into me so deeply I immediately let out a wail that cracked the night.

After that I lost consciousness until the Count came for me later and took me to the tower room where I was compelled to punish Magda, who in her turn, got revenge.

As I hung on the rack Magda had affixed me to, that diabolical leather cock remained firmly planted. A constant reminder of the Count's power. Not only had he not removed it for two nights, but I expected I would be wearing it at least until the following evening, and I was not disappointed.

But a peculiar thing occurred. By the time Magda had me tied to

the rack, helpless under her Spanish bullwhip, the Count's legacy intruding into my anus had begun to feel necessary. It was painful, no question, and yet there was a comfort to such pain, as though he were a part of me. It brought a clear picture of being held tightly in his arms while he took from my neck and then mastered me completely and silently with the birches, with no warning and no ability on my part to sway him. Never had I met anyone so powerful, so completely in control. Never had I been so absolutely mastered.

Magda disrupted my thoughts. "Jonathan, we are but half finished, and I have a question for you. Your wife, how do you fuck her?"

Her impertinence infuriated me yet there was nothing I could do but answer; after all, she had the whip. "My wife is a loving woman."

"That is not an answer, but leads to a different question. Have you whipped her or been whipped by her?"

"Don't be ridiculous. We are British. Civilized, although you in this part of the world do not know the meaning of the word."

Magda found the ring at the end of the leather penis. She jiggled it, setting my anus to spasm. "What of your fantasies, Jonathan? Can you not see her across your knee? Can you not imagine the sting as her hand slaps your ass?" She punctuated her question by spanking first one of my ass cheeks, then the other.

I did not confide this to Magda, but in truth, I have had such fantasies. But fantasies they can only be. Mina is not the type of woman who would ever consent to such erotic play. She is from a good family, of high moral values. Once, when we saw two hounds rutting in the streets of Kensington, she nearly fainted. Our lovemaking has been disappointing at best, done in the dark, under the sheets, twice weekly. Just remembering it made my erection wither. Magda, though, fixed that.

While I had been silently reminiscing, she had been preparing for another onslaught.

"Perhaps this will help clarify your thoughts."

Leather snaked across my ankles one at a time. With quick precision she moved up my calves, alternating, then the backs of my thighs. These areas were totally unprepared for such treatment. The muscles in my legs cramped as the skin burned. She stopped short of

my ass cheeks. I knew something was about to occur; she had whipped everywhere along my hind side but my buttocks. My body sang loudly, all but my ass, and it quivered in anticipation of a forced solo.

"I saved the best for the finale," she said, reading my thoughts exactly. "Tell me, Jonathan, which do you prefer? To be the whipper or the whippee? Think carefully."

I felt that either answer would be wrong, or perhaps both were correct. Still, I did not trust Magda. I was under no delusion that my ass flesh would escape her searing leather.

"I am disposed to neither," I said, hoping for the best.

"I do not believe you. I think you are inclined one way or the other but out of training perhaps are afraid to say which."

"Fine," I told her. "Make me the whippee, then, as you will anyway."

She said nothing to that, as if she were considering my answer. She rubbed more of the oil that burns into the flesh of my ass. Not having been whipped before I could not say with any certainty that the oil greatly increased the pain, but I knew Magda had a reason for using it and that was my guess. Her fingers kneaded and squeezed my ass cheeks, rubbing them in all directions. The irritating sensations mingled with those of the rest of my burning flesh and my rehardening cock.

"You have a firm body and yet it is soft in places. You are not yet a man."

"Woman, if only I were free," I warned her, feeling outrageous in my hopelessness, "I would take you this minute, here, on the floor, and you would know a man at last."

Astonishingly enough, she undid my restraints. I was a free man again, although a bit worse for wear.

"Well, was it only a hollow promise?"

"Promise?" I said, although of course I knew to what she referred.

She pointed at my cock, still swollen with desire, then flicked the end of the whip across him several times.

But I had had enough of her whipping. I grabbed the woman and threw her to the floor. She had lacerated my body and now I would lacerate her.

I held her down and spread her legs apart with my knees. My cock was famished from its long night of nasty treatment and found her oven easily. I rammed into her deep. A smile spread across her face as I thrust in and out hard. Her legs wrapped around my waist, forcing me in farther. It was as though her cunt too had been starved and I the source that would feed her.

Within second she arched her body and screamed, her cunt contracting fiercely around me. I thrust deeper, my cock on the verge of exploding.

But the explosion came across my ass. My body jolted, lifting both myself and Magda from the floor. The whip cracked down on me again. The hand that held it was far stronger than Magda's and I knew instantly to whom it belonged.

"You are once again occupied with my wife, Mr. Harker. If I were you, I would hasten to finish the task you have so thoughtlessly begun!"

The leather tore into my ass again. I could do nothing but what I had been ordered to do.

Magda lay beneath me laughing. Her cunt tightened around me, encouraging me to fulfilment, but the lash made it difficult to concentrate. I moved jerkily, my fragile rhythm broken with every crack. I did not know how to help myself. The pain from his hand was almost unbearable and yet if I broke down I felt he would beat me harder. I did not know if he would desist even if I fed my juices to his wife or if that would inspire him to greater heights of fury. All I could do was as he bid me and hope that in some way he would take this as an act of compliance and that my submission would appease him.

The scourge carved me over and over while I struggled to convince my engorged penis to complete the assignment it had undertaken. Finally, with Magda's help, for she caught my balls in her hand and squeezed them hard, I came.

Rich white liquid flowed out of me and into her in pulsing waves. I lay exhausted on top of her, my body singed from head to toe, my ass particularly wounded. I felt like throbbing pain personified. I could not move had I wanted to. I was completely at their mercy.

The Count bent down and grabbed the ring at the end of the leather penis and hauled me to my feet, causing a great piercing inside me. There was a look in his eyes that I took, rightly or wrongly, for approval. I had, barely, done something right, although I was almost dead with the effort.

"You and your leather have made him a man," the Count said to Magda.

"No, my lord, it was your masterful guidance that affected him most."

The Count's smile frightened me. "Time will tell if the experience lingers or if further guidance is required."

He grabbed my flailed ass and pulled me to him. I groaned in pain. I could feel his hands sliding over wetness. Before I collapsed into a faint, I saw those teeth exposed, dagger sharp, aimed at my throat. And behind him Magda, her canines similar, her eyes focusing down, hell bent on the vein in my still erect cock.

Chapter Twelve

I know not how long I lay in that bed. Days, certainly. I was in a dream of sorts, waking and sleeping, delirious.

At one point I recall the Count's face above mine, the sternness of his countenance both thrilling and terrifying. One night I heard a scraping at my window and dragged my torn body there. A large bat with red eyes fluttered against the pane. I locked the casement, then changed my mind and opened the window to look out. It must have been an hallucination because I thought I saw the count crawling down the castle wall like a rodent, but that is not possible. On another occasion noise outside my window drew me there again. I peered to the ground far below. A rustic cart was being loaded with long dark boxes by the light of the moon. Waking or sleeping brought another vision. The Count's three wives, Magda closest to my bed, their large teeth gleaming in the candlelight, eying my body as if it were meat to be consumed. "Can we have him now?" the slim girl begged. "He is not healed sufficiently," Magda told her, applying a soothing salve to my wounds. "In a night or two, when his fever passes. We do not want to use him too quickly." The rotund girl asked, "When will the Master return?" Magda looked in my eyes, hers flashing crimson. "When his business in England is finished. When his business with Mrs. Harker is finished."

"No!" I screamed. "He must leave Mina alone. I will not have it!"

The three witches laughed at me, and indeed I must have appeared a pathetic sight. Bruised, bleeding, feverish to the point of being incapacitated. But the idea of my precious Mina in the hands of

the sadistic Count did more to heal my wounds than the herbal balms. These three only wanted me restored in order to inflict further tortures. While the idea did not repel me, my concern for Mina, that fragile flower, was a far greater incentive to strengthen myself.

It was daylight when the fever passed. I was very weak. Still, I knew I must use the day time, for I could function while the sun shone, and they could not. I tied the bed covers together, as well as other bits of fabric, and affixed one end to the solid bedpost. The window was narrow but I managed to ease through it, half naked—only my trousers had been left in the room.

As I glanced below, I realized I could more easily drop to my death than make it to safety. The wall was high and steep, the stones that composed it jagged. And I was exceptionally weak.

I descend slowly, my foot slipping, the weakness in my arms causing me to slide down the makeshift rope. My hands were abraded from the slip and yet I had to continue.

When I reach the end of my makeshift rope, I was still far from the ground. There was nothing to do but let go. I hit the dirt with a thud, landing on my side, and wondered what bones I had broken from the impact and how many.

This exertion had nearly done me in and I was forced to rest until fear and rage revitalized me. I crawled on my hands and knees to the drawbridge and unravelled the chains to lower it. On the other side lay the dirt road they call the Borgo Pass that had brought me here what seemed like a lifetime ago. The Pass is narrow, one side hugging the mountains, the other dropping off into oblivion. I could do nothing but stagger down it, clutching the mountainside.

The air was chilling, but the sun warmed me. Waterfalls along the mountain refreshed me. But as the sun sank in the sky, the temperature dropped and I knew that come dark, it would plummet. And darkness comes early and stays late in that part of the world.

But luck was seemingly on my side. A cart driven by a gypsy rumbled behind me. I hailed the driver, a swarthy fellow who found me suspicious looking but stopped anyway. I clambered aboard what was really a box on wheels. Recent events had left me too fragile and my eyes closed to the rhythm of the horses clomping. I fell asleep with the memory of the Count's birches marking my hide.

Chapter Thirteen

When I awoke it was dark. I did not know where I was, but I knew I was on a vessel of some kind in the middle of a body of murky water.

The gypsy was nowhere to be seen. Beside me I found a flask of bitter wine like the Greeks drink and a small loaf of black bread. I consumed both greedily.

I glanced around the deck. A man, obviously the captain of the ship, was at the helm. A dark-skinned crew member sat aft smoking a pipe. Under the light of the moon, I saw him glare at me. Suddenly I heard a sound nearby. I turned. A man was being tied to a pillory by two others. A fourth man with massive arms and chest, naked, swung a long whip with nine strips of leather at the end onto the bare back of the bound man. The sailor cried out as he was lashed.

The sight filled me with horror and excitement but I was too exhausted and weak and all I could do was lie back down on the deck and fall asleep to the cries and the slapping of the lash against flesh.

When next I awoke, I was once more on land, and wondered if the ship was reality or a dream. I was now in another cart, not as rustic as the gypsy's. This wagon sported a cover from the sun, which beat down relentlessly. I was warmer than I have been in a long time, and covered with sweat. As we rumbled along, I could only get glimpses out the back opening of a land with gentle rolling hills, not stark and mountainous but verdant. Agricultural land. Row after row

of vines made me realize this was wine-growing country. I imagined I was somewhere around the Mediterranean but had no idea how I arrived there, yet I was grateful to the divine providence which had seen fit to send me home where I might rescue Mina from the clutches of Count Dracula.

We traveled the day—food and wine having been provided for me—and just after sunset the cart stopped. I got out, only to find the driver nowhere in sight.

Before me stood a stone wall into which a Gothic door has been fitted. I approached and knocked. Soon it was flung open and a man wearing a long robe with a hood nearly obscuring his face answered.

"I... I... well," I stammered, "I do not know where I am. I am trying to get home to England."

The man said nothing but stepped aside for me to pass. I entered and the heavy door was locked behind me. We walked through a garden, but the light was too dim for me to see much of it, although from the smell I gathered vegetables and legumes were growing. Another arched door appeared leading into a large whitewashed structure and we passed through that as well. Another corridor led to another door, as if we are headed toward some inner sanctum, and each Gothic door, as we entered, was locked behind.

I confess to being nervous. This appeared to be some religious order, but of what variety I could not tell. The corridors held a dank odor and I felt the floor slope downward as though we were headed into the bowels of the earth. I followed the man who led me in silence, because he was utterly silent, even to my brief inquiries, although perhaps he and I did not speak the same tongue. Our feet padded on the stone floor and his robe rustled as he moved. I still could not see his face, shadowed as it was by the hood, but there was something ominous about all this.

Eventually, when we had passed through seven doors, we entered a large circular chamber, with many doors leading off from it. He pointed to a worn bench in the middle of the room. I sat and watched him leave by one of the doors.

This place was sparsely furnished, only a cupboard of sorts and a long altar, very plain. The walls were stucco and across them hung beams with hooks. Attached to the hooks were gleaming chains and

leather harnesses that, from the weights hanging down, appeared to work on a pulley system. I could not ascertain their purpose, though. All this I saw by the light of a hundred large beeswax candles spread about the room in wrought iron sconces attached to the walls.

I waited for what seems an inordinate length of time, wondering if I'd been forgotten, contemplating following the man who led me here. I stood, having determined to do just that, when suddenly a door opened opposite the one he exited by.

Another man in a hooded robe entered, this one enormous, both tall and large. He walked with purpose and stopped in front of me. Most of the candles were behind him but as I looked up into his face I saw glimmers of serious features and a very determined-looking chin. Candlelight flickered in his dark eyes and for a moment I was reminded of the Count. I felt myself shrink before him and experienced an urge to go down on my knees.

"My name is Jonathan Harker. I am an estate agent from London," I blustered, hoping to disguise my nervousness. I stretched out a hand which was left hanging in the air. "I'm on my way home to England and have arrived here, I'm not sure how."

The opening was not taken by him and I was forced to continue. "My wife, Mina, is in England awaiting me. If I might write to her, let her know where I am, she will at once send money for my safe return."

Of course, this made me sound like a simpleton in the hollowness of this cavernous space. This large fellow still said nothing and I added, "Excuse me, but if you can tell me where I am...?"

Finally he spoke, in a voice deep and rich, slightly accented yet impeccable in its use of the English language. The voice had a familiar ring to it and again I was reminded of Count Dracula. "You have arrived at the door of the Pray for Mercy Sanctuary, the home of a spiritual order, which by now you have no doubt gathered. We provide food, clothing and shelter for travelers en route. Our code prohibits receiving compensation for our services, but there are other forms of payment required. You may stay as long as you are in need. There are, however, rules which must be followed if you are to remain, and followed to the letter."

"Rules? And what might these be?"

"All who enter here must be alleviated of the burdens which they have brought with them."

"Now that I have escaped a bondage to which I was subjected against my will, I have no burdens."

"I speak of a different purification, as you will soon see. Come."

Apparently I had no choice in the matter. I suppose I could have demanded he take me back through the locked doors to the outside, but what would I have done then? Sleep in a vineyard? Eat the tart fruit? Awaken in the morning chilled by the dew and prone to more fever? I was no fool, and I followed him.

We entered a small chamber with a rough wooden bench and nothing more. As he exited, two more of these 'brothers' as I'd come to think of them, entered carrying buckets of water.

Without haste, they stripped me of my ragged clothing and proceeded to wash away the grime from my journey with a fragrant glycerine soap. Their ministrations felt both soothing and refreshing. One scrubbed the front of my body, the other my back. They reached the area below my waist at the same time. The brother behind rubbed his wet cloth down the crack in my ass, cleansing in particular that poor anus the Count had stretched so brutally. The one in front of me washed my cock and balls, soaping them and rinsing several times, squeezing water from his cloth so that it cascaded like a waterfall over my genitals. Between the two of them I was becoming aroused, which they were keenly aware of, and which embarrassed me greatly.

When I was clean, they handed me a robe like the ones they wore. I slipped the heavy wood garment over my head and tied the rope belt around my waist. I had just begun to raise the hood, in the fashion of this place, when one of my bathers grabbed my hand to stop me. I slipped on the leather sandals against the cold of the marble floor and, assuming my purification complete, I followed them back into the main room.

The room was no longer empty but crowded. The air was permeated with the scent of sweat and sandalwood incense. Men in hooded robes stood rigid and silent against the walls, watching. A row of a dozen men in robes faced the altar, their hands bound behind them. I was led to the end of this row. Immediately one of

the bathers tied my wrists together with a scratchy cord.

"Now, see here—" I began.

"Silence!" It was the booming voice of the giant. Terror snaked through me and I clamped my mouth shut. I was turned like the others in the row to face the altar.

One by one a pair of hands was placed on the shoulders of the men to my left and they were forced to their knees, I being the last. A second set of hands pushed us forward, and we toppled like dominoes, faces pressed to the cold stone floor, our backsides high in the air. Chains were wound around our waists and looped from one to the next, then pulled taut and affixed to bollards at each end of the row. Once more the hands moved down the row, rolling each man's robe up and affixing the roll under the rope belt so that his legs and ass were exposed.

I found this action an outrage and yet there was an odd excitement about being bare assed before the eyes of a hundred strange men whom I knew were inspecting me.

A glance to the left showed me the face of the man beside me. His brown eyes met mine. They were a peculiar mix of terror and exhilaration, reflecting, quite likely, my own.

"You who are to be purged, take heed!" the giant said. "Through the anguish of the flesh, all will be released that should not dwell within you. You will be as reborn, under the power of the hand that guides mine. It is but a small sacrifice in a larger plan."

He walked between our row of penitents and the altar. In his hand he held what appeared to be a polished stick that he brushed along each man's face so that it ran the length of the row. When he reaches me I realized the stick was in fact a handle to which were attached nine strands, each braided raw leather with small metal studs imbedded in the weave. I do not know if it was my imagination, but he seemed to linger when he reached me, running the strands over my face and back again. The man next to me seethed with jealousy.

"Skin so fair," the giant said at last, meaning me, as I was the only truly fair-skinned man in attendance. "So unaccustomed to the rigors of the flesh." My face colored and I was grateful that none but the chap to my left saw.

The large man, obviously the Leader of this order, walked behind us again and to the opposite end of the row. "Each of you in turn will repeat the request, 'I am in further need,' until that need has been sated. But woe to the man who dishonors himself with lies, for his punishment shall be increased ten fold."

I heard a sharp crack, a groan, then a shaky voice repeat, "I am in further need." Another crack, a different voice, the same statement. The cries and words that bounced off the high ceiling grew louder as the man with the whip moved down the row. The air turned dense and the pungent odor of sweat increased.

When the cat-o-nine tails struck the fellow next to me, his eyes rolled into his head and a beatific smile spread across his features. Eagerly he repeated the request.

Suddenly the cat spoke to me. Nine stripes landed smartly across my ass. The fine tip of each strand cut into me. My cry was loud and spontaneous. If not for the chains holding me in place, I would have fallen sideways from such a multiple stinging blow. I was struck dumb with shock. Within seconds the whip slashed me again, sending nine more burning stripes across my backside, the little metal studs adding an extra bite. I felt confused. No other man received two. What had I done? By the time I realized it was what I had not done, the cat snapped across me anew. Through the pain of fiery flesh, I yelled, "I am in further need!"

A sound like approval came from the Leader. He returned to the start of the row and the ritual began all over again, each man in turn getting the cat, each repeating the need. The room grew hot, the tension palpable.

By round five my bottom screamed for relief. I was beside myself. The pain felt nearly unbearable and yet I was, to my surprise, bearing it. I took the fifth and a sixth. At the tenth round I heard others drop like flies.

Soon the number reached fifteen and only the man to my left and myself remained. The blows, of course, came faster with only two. My skin was now so lacerated that even the air currents pained me. It had become a point of honor to outlast this man. He took a sixteenth, multiplied by nine of course, and I a sixteenth. Tears that had long ago sprang to my eyes now gush, but I refused to quit.

We both took a seventeenth and requested more. His body trembled uncontrollably and mine did likewise. I felt I would rather die than take the lash again, and yet I could not live with myself if I let this man best me.

Expectation filled the room. Sweat poured down my face and along my sides under the scratchy wool. My head felt empty from the bearing of too much pain. I heard myself scream out, "I am in further need!" as the eighteenth cat walloped me raw.

The face of the fellow next to me was beet red, about as red as I suspected his bottom to be. He took the nineteenth. His eyes rolled into his head but this time no words came from his mouth. He fainted.

I received the whip again. My lower body roasted over an open fire. Scars that formed from my session with Magda and from the Count's fury had reopened and the cat gouged deep. I knew it was madness to go on, and yet I must best this man or I would feel I was nothing. "I am in further need!" I cried.

The cat kissed me one last time. I heard the echo of my scream careen around the walls, joined by the cheers of the crowd. Our cries filled the great chamber with what must be the last sound that existed in the universe. It was, in any event, the last thing I recall hearing.

Chapter Fourteen

How I arrived at a bed, I do not know. My lips were dry, my mouth parched. I felt chilly, and the blanket not heavy enough even over the thick robe. I lay on a narrow cot in pitch darkness on my stomach, shivering in terror, groaning in agony. My bottom was sorely wounded and would not heal quickly, of that I was certain.

Pain forced me to question myself and my motives. To proceed as I had, had been insane. What was my reward for winning but being incapacitated? And yet even in the darkness of that abominable cell, my face split into a grin. Outlasting the one beside me was sweet. And more, proving that my English hide was not so soft—I would have given anything to have seen the face of the Leader! Twenty lashes with a cat-o-nine-tails. Twenty times nine. One hundred and eighty stripes! Had any man in history endured so? I doubted it.

Even as I felt this pride welling, my cock lifted as if raising a flag to proclaim my triumph. The pain I suffered was worth it.

A sound distracted me from my revelry. The door to my cell opened. I squinted at the light. Through blurred vision I saw an immense figure fill the doorway.

I partly turned, for a better view, increasing my physical anguish.

The Leader, and I know it was he, entered the chamber, locking the door behind him, plunging me once again into darkness. A quiver of fearful expectation rippled through me.

He came straight to the head of the low cot. Without light I could not see him, but I smelled his rich odors—sweat from his exertions,

a powerful musky, manly scent. I heard scraping—he pulled something to the head of the bed—and rustling, as if he were lifting his robe. With one strong hand, he grabbed my hair and yanked me forward until my head no longer rested on the cot.

The same firm hand clutched my jaw and pressed the sides; my mouth popped open in response.

Without warning, his cock filled my mouth. The long hard flesh forces its way to the back of my throat. I nearly gagged but controlled myself both out of pride and a desire to see what would occur next.

The delicious scent of him, the sweet-tart taste of his firm flesh inside me brought my senses to the fore. I licked and sucked his giant member quite naturally, as if I have been doing so all my life. I let him use me as a tool for pleasure. My mouth hungered for him, sucking hard and fast, taking him down into my burning throat in a way I knew I would have enjoyed being taken. His powerful manhood thrust into me and I opened, wanting to receive all he had to give.

His cock became aggressive. His skin heated up and the member itself swelled. A powerful volcano erupted in my mouth. Greedily I swallowed his molten juices, letting them singe their way down my throat until I felt filled with his man-potency.

I licked him clean, that enormous cock still erect even after its great discharge. Every aspect of my being was sated and complete. His hand had spared me nothing and his cock had enjoyed me fully. I could do nothing but honor the man and feel honored that he had so chosen me to be the receptacle of his masculine power.

That night I slept and dreamed of fire that burns but does not consume. When I awoke I was refreshed. Each movement seared me with the precious agony the Leader had inflicted and I grew weak in the knees at the memory of him within me. To be mastered so completely, to have my will bent to his...

I made it my first order of business to heal. My second priority was to further absolve myself under his guidance.

Chapter Fifteen

Over the next weeks with the aid of the brothers my wounds mended. I took leisurely strolls in the garden, drank their very dry wine and ate their strong cheeses and the dense black bread they baked in stone ovens. As there was little to do, when I felt comfortable sitting, I composed a letter to Mina.

Mina. I felt estranged from her. It was as though we were on different continents and spoke different languages. The memory of her dry, subdued demeanor caused me far greater agony than the stripes on my backside. I did not know what to say to her, only that I required funds to see me through the rest of the journey. But, in truth, I believed the journey had ended for me. How could I return to a life devoid of passion? My fragile bride with her prudish ways and moralistic attitudes bored me to tears. And yet I must return. For did not Magda infer that Count Dracula himself would be calling on Mina? I shuddered to think of what would happen to that girl under his power, although the idea of Mina undergoing some of what I had experienced at the castle at the hands of the infamous Count brought my cock up to full height.

As my strength increased, one night I took my place along the round wall of the main chamber to watch the Leader flog six more penitents.

Witnessing the bare bottoms quiver as they were lashed to bits almost rivaled the exquisite agony of being lashed. The Leader himself filled me with such awe and fear and longing I could hardly

breathe. Twice, when the cat was raised and his sleeve fell back, I glimpsed an arm straining with well-defined muscles driven to maximum exertion. My cock ascended and my balls tightened, remembering another of his muscles straining against my lips.

Later, in the dark, his sweat-soaked body found me, his rod separating my lips to travel to the back of my dry throat, demanding that I receive him fully. And I did. I cried out in joy as his hot fluids washed over me and into me. I felt cleansed.

Chapter Sixteen

I had been three weeks at the Sanctuary. My wounds had healed and by day I was set to work, scrubbing floors, tending the garden, oiling the leathers that were used for a variety of purposes. At night I entered a realm of ecstasy wherein the Leader exacted purification from his supplicants, first in the great hall, later in a private manner with me and me alone.

I had entered a dream state; my life took on an unreal quality. At times I forget entirely that I had a life in England, a wife, a vocation.

And then, one afternoon a parcel arrived by special courier. It was from Mina. It contained funds, which I would need for my return, and a letter. In it she advised that she was visiting her spoiled friend Lucy. Her plan had been to return to our home but events forestalled that. Lucy, it seems, underwent a mysterious personality change, all on meeting a gentleman new to the country, a certain Count Dracula.

My heart sank. Lucy had fallen under the Count's spell. And Mina was at risk. I must leave. I had obligations. I sought out the Leader, whose face I still had not seen, and explained all this to him.

"You must be fortified against the callous world," he said wisely. "Tonight you will participate in a ceremony to preserve the purity of purpose you have learned on your knees before me."

After sunset, as the outer walls grew chilly and the brothers retreated to the innermost sanctum, we lighted our candles and gathered around the altar. There must have been fifty men present, including the Leader, who stood two heads above the rest.

One monk straddled the altar beating a golden gong. The dull sound reverberated around the hollow walls, each clang colliding with the next until I felt a continuum developing. Silently all removed their robes, all but the Leader. As if by instinct we formed a line before him, in order of height, shortest to tallest.

The Leader opened a cupboard beneath the altar. When each man passed, he was handed a short cat-o-nine tails. As if an order had been given, the men formed a circle, surrounding the Leader and the altar. The gong still sounded, loud, strong, and resonating.

The Leader began to chant. "One flows into all, and all are one." As he repeated the phrase, the gong kept time. A few of the men in the circle raised their cats and brought them down onto the bare back before them. Soon each man raised and lowered his whip as the gong guided our reflexes.

I felt the whip strike me a second before I struck the man in front of me. No more than five seconds passed. I struggled to synchronize my rhythm to match the man behind me. At the next gong we were perfectly timed, leather cracking and being cracked simultaneously upon flesh.

We moved slowly as the Leader chanted, whips flailing to the unearthly sound. My back warmed, the first such warmth it had received since Castle Dracula. The man behind me did not restrain himself and I lashed the fellow before me as liberally, not wishing to deprive him or to break the circle.

We continued thus for over an hour. My flesh burned but my body had reached a involuntary rhythm and I felt connected to all of these brothers. My mind went blank and my thoughts stilled. Movement became spontaneous. The gong sounded, the arms raised as one, leather cracked as one sound, "One flows into all, and all are one," the Leader chanted.

Men groaned. My cock was rock hard and a hazy glance told me that each man in the circle was likewise erect. We moved agonizingly slowly. I felt caught between the pain and the pleasure coursing through my body.

Suddenly the gong ceased and the Leader fell silent. The company of monks stopped as one unit. We stood, a circle of burning bodies, the scent of sweat filling our nostrils. Suddenly the Leader shout-

ed, "One flows into all, and all are one."

The circle closed tight. Each man fell upon the back of the one in front, who bent forward. My cock tip pressed against the anus of the man before me, while the head of a cock probed my opening.

We moved as one. I entered and was entered. My cock rammed into the hole before me and thick flesh split my rectum. We thrust in and out as if we were two men, not fifty. The gong began again, now beating faster, the pace increasing. I had never felt such joy, such ecstasy, such intolerable pain singed with pleasure. Such connection.

The man behind thrust as hard and deep into me as I was thrusting. The beat of the gong quickened. I braced myself as my body moved of its own volition. Faster. Harder. Deeper. The sense of connection was exquisitely painful.

The pace quickened again. I had never moved so fast. Men around me screamed in release, yet still the thrusting continued. The man behind me shot his juices into me, a hot stream that made me tighten even more around him. My cock quivered and pulsed, on the verge of exploding. I felt the man in front of me tremble as he released. Yet, all the cocks in the circle remained erect, working still. Suddenly sparks erupted in my balls. Lightning bolt energy soared through my cock. I felt myself like a bullet fired at high velocity into the man, the man behind still working my asshole.

My head went light, the room spun. A weight was lifted from my shoulders as if I had died and ascended. I had not felt such release since entering Magda, and yet this was very different.

Before long the circle collapsed onto the floor, the cold marble a relief on my hot shoulders. The mood in the room lightened. Men rolled around together, wrestling, laughing, kissing one another. Frolicking with cocks, forming couples and small groups, using the cats in a playful manner, splashing hot beeswax from the candles onto skin.

Before me appeared the Leader. I stared up at him, his face still in shadows. I crawled beneath his robe. The darkness there felt complete. I was encased by his scent, the texture of his hairy skin, his hot rigid flesh. I took his waiting manhood into my mouth. He tasted wonderful, the familiar tangy sweetness of his member and the creamy juices that seeped from him.

When I had licked and sucked and hardened him fully, he pressed me onto the floor on my stomach. He spread my legs and bent my knees, pushing my legs up until my thighs were at my hips and my knees at my waist. I felt splayed like a frog on a dissecting table. My cock under me was still hard and as he lay on top of my back his weight crushed my hips down so that my cock pressed hard against the cool stone. He penetrated me with his enormous manhood, stretching me further and impaling me deeper than the other man had. A cry burst out of me. Tears sprang from my eyes. I did not think I could bear such painful joy. He thrust in and out of me, keeping me plastered tight against the floor, my member compressed between the smooth stone and my body. My ass muscles tightened from the strain of the position he had captured me in. I felt completely controlled by him and unable to do anything about it, not that I wanted to. His insistent thrusts would not be denied. I opened fully, offering my body as a vessel to this Leader who had governed me to places I had hitherto not known existed. I longed to spread myself even wider, for him to enter deeper. I longed for him to split me asunder so that I might reform a new man.

When he shot his fiery liquid into me, my poor cock spurted its juices at the same moment. We melded into one another.

We lay together for the longest time, he firmly buried within me. The others left the room until finally we were alone.

"You will remain as you are," said this man whose face I had yet to see. He withdrew from me and I felt empty and cold. And yet something of him remained; his seed began to seep from my anus and I contracted my sphincter muscle to retain him as long as possible.

He was gone but a short time and when he return he took up a position behind me. My legs were locked into place and I knew the muscles would cramp severely when I moved them, so I stayed still, waiting.

His hands found my testicles and lifted them. He plucked at the skin between them and my penis. Suddenly a terrible pair stabbed me there, as sharp as a knife wound. I screamed. My legs attempted to jerk together, but the Leader's strong hand rested against my bottom and pressed it down, keeping me from moving. Within seconds the

pain lessened yet was still strong. Something cool, like metal, slid against that thin tender skin.

"You are of the brotherhood now. Do not shame us."

I heard the Leader walk across the floor. A door opened and closed. I was alone.

It took me the better part of an hour to move my legs. The area between my cock and balls felt on fire. Gingerly I touched there and discovered a small metal ring had been slipped through the loose flesh from which dangled a long slender piece of metal forged to resemble a penis.

Slowly I slid across the floor until finally I was able to climb to my knees. Leg cramps crippled me and it was all I could do to get to my small cot.

I lay in a pool of agony. The fire under my cock. My spasming leg muscles. The lacerations across my back. All this combined with the agony of knowing that in the morning I would be leaving this place, and the Leader—the taste of him lingered in my mouth, his juices still flowed down my legs.

It did not take much for me to imagine my life ending there and then, for what awaited me in England but living death.

Part Four: Dr. Steward

Chapter Seventeen

"Gentlemen, enter, please."

Dr. John Steward stood aside to let Arthur Holmwood and Quincey Morris into his office. He gestured to leather chairs then took a seat on the other side of his walnut desk. He examined his friends.

Arthur had always struck him as a handsome man, of medium height, with an aristocratic face, very well heeled. He had boxed at prep school and was still in excellent condition—his shoulders and chest muscular, his hips trim. John had met the rough-but-good-looking Quincey in a London pub only a few months before. He had introduced the men to one another and both to the pleasures of Miss Lucy Westenra's boudoir. The three, with so much in common, had become friends.

John closed the office door and the screaming from the patients in the asylum dimmed, but the sound did not disappear altogether. His guests, unaccustomed to the self-inflicted tortures of the insane, were clearly uncomfortable.

John lifted the cut glass decanter of brandy on his desk and raised his eyebrows. Arthur shook his head but Quincey, in his forthright American way said, "Hell, don't mind if I do," and held two fingers sideways.

After John poured Quincey's drink, he sat back in his chair, the rich scents of leather and brandy mixing with the masculine odors permeating the room. The sight of his robust friends pleased him

and gave him courage. "I think you both know why I've asked you here."

"Lucy," Arthur said.

Quincey, who downed the liquor in one gulp, banged the glass onto the desk and wiped his lips with the back of his hand. "She's acting strange, that's for sure."

"Strange," John added, "is an understatement. Have either of you seen her this past week?"

Both men shook their heads.

"Well, neither have I, and I am concerned. Frankly, the Lucy I know and love appears to have vanished and been replaced by a rather limp personality."

"Perhaps," suggested Arthur, "her friend, Mrs. Harker, is responsible in some way for this shift."

"Nope," Quincey said firmly. "Mina and Lucy go way back."

"Mina, is it? You sound familiar. The three of you spent time together?"

"Some. Enough for me to know she didn't bring about the kind of change in Miss Lucy we're seeing. Hell, Lucy wouldn't even see me this week, and the fancy harness I ordered from Texas just came in! She was lookin' forward to it."

"And I've had a similar experience," John added. "When I've called for my semi-weekly sessions, she has avoided me. What strikes me as the anomaly in Miss Lucy's life is her acquaintance with one Count Dracula."

"Who the hell is he?" Quincey wanted to know.

"A wealthy royal from Romania, or some such place," Arthur said with obvious distaste. "Lucy told me about him, in brief, yesterday, when I visited. She had no time for me in private yet condescended to speak whilst en route. Apparently this Count has purchased property all over Whitby. He's a neighbor, she says."

"He escorted her to the theater one evening," John said.

"And the fireworks display on the holiday."

Quincey scratched the back of his neck. "Either you fellows met this Count? What's he like?"

"I've not met him," Arthur said.

"Nor I," John contributed. "But this much I do know: apparently

Lucy sees him nightly, which is why she has had no time for any of us. Hence the purpose of this meeting."

John opened a walnut snuffbox and offered it around. Quincey, who had apparently never tried snuff, said, "You only live once."

He followed John's lead and held the snuff on his fingertip, then inhaled sharply. A happy look spread on his face and he nodded eagerly. The tobacco was obviously to his liking. Within second he pulled out a large white handkerchief and blew his nose.

As John closed the box he said, "I've convinced Mrs. Harker to extend her visit because I believe Lucy needs someone to keep an eye on her. It is my opinion as a physician that Miss Westenra is suffering from a malady of some sort, the nature of which eludes my expertise. Consequently, I have called in an specialist."

"And who might that be?" Arthur inquired.

"Professor Abraham Van Helsing. He was my master at the university where I studied in Amsterdam. The doctor has both a scientific mind and an intrinsic knowledge of human nature. He is a metaphysician. If there is anyone who can discover what has annihilated our Lucy's spirit, it is Dr. Van Helsing."

"You've made a wise move."

"If he can revive that little heifer, he's got my vote!"

Quincey said, helping himself to more snuff.

"Then I have the confidence of you both?"

The two men nodded.

"Good. The Professor arrives on the morrow. I shall bring Lucy here to see him at once, against her will if need be." John jumped to his feet. "Lucy must be returned to us as she once was."

"Here here!" Arthur jumped up and stretched out a hand.

"She sure was a little spitfire," Quincey added, clutching the hand, "and I'd hate to lose her."

John joined in. He felt they formed a triumvirate that would not be deterred in its mission to rescue their Mistress Lucy.

Chapter Eighteen

That evening John Steward decided on an impromptu visit to the Westenra residence. The door was opened by the dour-faced Verna. He found Mina Harker in the drawing room, alone, reading a popular penny dreadful by an Irish novelist of some repute. She greeted him warmly, or as warmly as her tempered spirit permitted.

"Dr. Steward, how nice to see you again. Would you care for tea?"

"Thank you, but no."

"I expect you've come to visit Lucy."

"I have, if she's at home."

"For the moment. She will be going out, though, shortly I believe. The Count."

They sat on divans opposite one another. This Mina was a peculiar woman. He imagined she could be quite attractive, if only she were so inclined. Her hair was a shining chestnut yet pulled back so severely it left little softness to her face. With a jaw set so, and a forehead pinched in a tight, worried expression, she looked never far from despair. The drab clothing she wore hung loose and did not permit even a mild guess as to the shape of her body. And yet he could see something in her dull eyes, like the twinkle of a fragment of diamond deeply embedded in rock, awaiting liberation.

"Tell me, Mrs. Harker—"

"Please, call me Mina."

"Mina. Have you noticed any changes in Lucy of late, other than the ones we spoke of last week?"

She tilted her head to one side and crossed her arms under her breasts, gripping her elbows. Those arms acted as a shelf, pulling the grey fabric of her blouse taut and lifting her bosom so it swelled.

"I can only tell you that I have seen even less of Lucy than before. She sleeps all day and shamelessly galavants with this Count Dracula all night. Apparently he takes her on wild coach rides to the opera, the botanical gardens, further into the country, and God knows where else. Twice I was awoken by the carriage returning just before dawn. I looked from my bedroom window to see Lucy helped to the door by a tall man dressed like an undertaker in somber black. Once I stepped into the hallway as she reached the top of the stairs. She looked weakened, in fact, she could hardly stand. I had the impression she was in pain, although her face glowed with health and vitality. 'Oh Mina,' she sighed when she saw me, 'I've had the most exquisite experience. The Count is like no one I've met before. All fall by the wayside in comparison'. She clutched my hand earnestly and said, 'You must meet him. You must! You will not be the same!'..."

John interrupted. "Has a meeting been arranged?"

"Why, I believe I shall make his acquaintance this very evening, when he arrives to call for her, which should be shortly. Ah, the bell. That must be him."

"Good!" John stood in a determined way, which brought Mina to her feet as well. "We shall greet him together."

He extended his arm to guide her to the hallway. She was a small woman, slimmer than Lucy and not as voluptuous, or at least he did not believe so, from what he could see.

As she held his arm, his elbow brushed her breast. He glanced and saw her face color.

Verna opened the door. On the other side stood one of the most powerful men John Steward had ever seen, rivalled only by Abraham Van Helsing himself.

The man who entered the foyer presented an imposing figure. His strength was physical—a marvelous physique, a classically handsome face with chiseled features, if pale as marble, and the most penetrating black eyes. And yet his strength surpassed the physical and John had the impression of an iron will that could not be crushed.

"I am Dracula," he said in a deep, rich voice, bowing slightly.

When John recovered his own voice, he put out a hand. "Dr. John Steward, Miss Westenra's personal physician, at your service, sir." The hand was ignored.

The Count regarded him as he might appraise an item for purchase, to determine its fragility. John felt paralysed under that sharp stare. Hungry eyes stripped him naked and conducted such a severe examination that John's cock was brought up firm as if it had been stroked. Clearly, the man knew the effect he was having.

He turned his attention to Mina and a slight smile lifted the corners of his cruel lips. He scanned her body, as if deciding how best this sofa might be reupholstered: new springs, stuffing, definitely a more elegant fabric. She stared at him with some hostility, which the Count obviously found amusing. "Mrs. Harker," he said, "I have heard much about you and feel I know you in spirit, if only from now in the flesh."

"And I have heard of you."

For Mina he extended a hand and reluctantly she gave him hers. He brought it to his lips in the European manner. The kiss lasted longer than was socially acceptable, further embarrassing her as she was helpless to do anything but wait until he finished. "I have been impatient to meet you. Of course, Mr. Harker was a guest at my home. He was more than kind to my wife, who was starved for company, and I am eager to repay him."

Once her hand was free, Mina hid it behind her back. She gave the Count a fresh look filled with venom. John marvelled at her tenacity, for he himself felt the eminent danger this man emitted and, for the moment anyway, held his peace.

"Count Dracula," Mina said, "I have not heard from my errant husband in quite some time. Perhaps you can tell me his whereabouts."

The Count's smile broadened. His eyes glittered and for a moment flashed a hint of red like an animal's eyes in the light. They never left Mina's, which seemed to mortify her. "A woman such as yourself should not tolerate an errant mate when so many men would do your bidding. I can assure you that I left him in the capable hands of my wife, Magda, for I had business to attend to in Whitby. Perhaps he is still enjoying her hospitality."

Mina did not want to hear any of this. Her eyes glinted with anger. Her thin lips pressed together and turned white as the Count's face. Her restrained fury made John's balls tighten and he imagined such anger taken out on his hide.

The Count's head snapped around; he speared John with a look that spliced this fantasy before it could expand. Whether the Count had plans for him, or for Mina, John couldn't be certain. He was, however, convinced this dominant man had plans of some sort and secretly John could only hope that he figured in them.

At that moment Lucy descended the stairs, dressed in tall black boots, a waist-length red rose jacket and men's pants with a flap at the rear, like long underwear, which could be unbuttoned. The outfit was totally inappropriate for evening, for any time, actually.

Mina looked as shocked as John felt, and she clutched the banister for support. The Count appeared pleased.

"John, darling. And Mina. I see you've met Count Dracula. Isn't he wonderful? Oh," she said, remembering the small box she carried, "this is for you."

She blushed as she handed the fancily-wrapped package to the Count, who snapped the ribbon in two. Inside the tissue lay a pair of finely-sewn black leather gloves, but of a peculiar variety. They were not soft pigskin, but hard, perhaps, John thought, made of stiff cowhide, the type of hide used for heavy boots. And most peculiarly, the palms were imbedded with thin metal studs.

As the Count slipped the tight-fitting gloves onto his large hands, slowly, sensuously, John felt his penis strain against his pants. One look at Lucy told him she was wet between the legs. Even the hostile Mina stared longingly at the gloves.

Count Dracula fixed his eyes on each of them in turn and John saw what he felt reflected on the faces of the women: a desire to be at the mercy of the hands wearing those stiff studded gloves, to be lifted and probed and entered.

"The hour is late," the Count said to Lucy, "and the hours are few for me. I have a full evening planned and intend to put your gift to good use. Come."

Lucy glided down the stairs as if in a dream and John watched them go out the door, enter the carriage and drive away.

No sooner had they reached the end of the driveway than John said, "I'm going to follow them. I must see what this Count Dracula is up to with our Lucy."

"I'll join you," Mina said, and in truth he was grateful for the company.

They saddled the mare and the bay quickly, riding out under the blue-white waning moon. The carriage was on the road ahead and they kept far enough behind that they would not be seen.

Soon the vehicle turned onto the grounds of Carfax.

"What is this place?" Mina asked.

"These are medieval buildings, with a chapel on the grounds, long empty and in disrepair. I believe, according to Arthur, it is one of the properties the Count purchased, perhaps from your husband."

They watched the carriage stop and the Count help Lucy to the ground. Once they were sure the couple had entered the building, they dismounted and walked their horses halfway, tying them to a Sycamore. The rest of the path they traveled by foot.

The main building was a desolate structure, built from thick local colourless brick over two hundred years ago and surrounded by dense dark trees. Much of the exterior mortar had crumbled and many exterior bricks were loose, or missing completely. Above, a tower had collapsed. The building was lined with Gothic arched windows high up along one wall, fragments of the original leaded stained-glass intact. John and Lucy crouched down and peered in through the missing bricks on ground level until they stumbled upon the room where the Count held Lucy captive.

John pressed a finger to his lips to indicate they should be quiet and pointed inside. Mina nodded. Side-by-side, his left eye, her right at the hole, they watched the candle-lit scene before them.

The Count sat in an enormous high-backed chair, and Lucy obediently knelt before him on the dirt floor, head bowed. From his pocket he removed a black leather mask and pulled it over her entire head, covering her face and neck completely, lacing it tight in the back. There were no eye holes or opening for her mouth, but John thought he saw two little holes for breathing through her nose. The mask excited him—he'd never seen anything like it and wondered how it must feel to be cut off from sight, sound and taste, with

breath only through the nostrils.

Lucy stood and the Count turned her so her back was to him. She was wearing riding gloves and he bound her wrists together with rope, then reached up and pulled her jacket down so that her breasts and half her back were exposed. This effectively cut off her sense of touch, although she could be touched. John realized he was breathing rapidly and became aware that Mina, beside him, was too. Her body leaned into his unawares and he noticed again that soft breast, this time with the added attraction of a firm nipple.

The Count unbuttoned the flap at the back of Lucy's outrageous pants and pulled it down, exposing a portion of her delicious round bottom. He moved her into position then quickly pulled her across his lap. From where John sat, her sweet little ass bulged up through the rectangular opening. It was not the only part of her body exposed but it may as well have been, the way it was so prominently displayed.

Without delay, the Count raised his enormous gloved hand and brought it down smartly on Lucy's bare ass. John felt the blow as if it had landed on him. His balls tightened.

The sound of the cowhide against flesh resonated in the empty hall and John had the feeling this was no love tap but one of the more lasting spanks he had heard. Lucy's bottom jumped high into the air, the only indication that she was affected. The lack of sound coming from her was odd and faintly titillating. Even in the dim candle light within, he could see her ass redden as if it had received half a dozen instead of one, and where the studs had landed, brighter impressions from their bite.

Next to him, Mina held her breath. Her body quivered, the erect nipple tapping against his arm, almost distracting him.

The spanking got underway in earnest now. The Count laid them on fast and furious, his large hand cracking both buttocks at the same time.

As Lucy jumped, John's body spasmed in time. Mina trembled uncontrollably. Her hands went to her ears to drown out the crisp sound. Her nipple brushed furiously against his arm.

Never had John witnessed such a licking. If it were he being punished so, he would have been screaming by now, as would Lucy, had

she had the opportunity. What must it be like? he wondered, desperate to keep his cock from splitting his pants. Lucy could only breath, only smell sweat and new leather and earth. She could not hear the cracking, could not see anything, could perhaps only anticipate from the slight movements of the Count's firm body the hand raised once again to wallop that patch of flesh. That luscious, juicy fleshy square, blocked off, highlighted, granted special privilege by the Count for his sound thrashing.

The spanking continued for a good two hours, the hand apparently not tiring, the bottom apparently never numbing, or so John judged from the heights it still leapt. How could Lucy endure this? John wondered, and he also wondered whether he could.

By the end of it both John and Mina were worn out, as if both had received the licking, rather than simply witnessed it.

Lucy was lowered to the floor with the Count directly facing her swollen flaming behind. His engorged penis, liberated from his pants, probed between the blazing square about where her anus would be. He entered her, the full length of him. Lucy, on her knees, shoulders and breasts pressed to the ground, threw back her masked head in its imposed silence.

He thrust energetically holding her hips to keep her steady and Lucy buckled and banged her steaming behind into him.

John's hand found the buttons on Mina's blouse and undid enough of them that he could locate the firm nipple and squeeze it hard, in time to the thrusts. Mina arched her back, stifling a moan, yet he had the sense she was entirely unaware that he was manipulating her.

As the Count plowed Lucy, John raked the nipple, now a hard bud, responsive, defiant. Mina's hand went to his throbbing crotch but her eyes were glued to the scene before her and John had the feeling she did not know what she was doing. Unawares, she rubbed the fabric of his pants, encouraging his swollen flesh to greater heights. His cock ached as she stroked him. A powerful force coalesced at his balls, ready to deliver its load.

Within seconds the Count thrust hard. He threw back his head and howled like an animal, the voluminous roar riding the night air.

In that moment John imagined the Count driving those juices

into him in the same way; he could imagine propelling his own hot fluid into Mina or Lucy. And those imaginings forced his semen out of him.

Mina, shocked by the spasm inside the cloth, drew back her hand. His fingers still gripped her bare nipple, now bright red in the moonlight. The look on her face was one of confusion and desire mixed with shame.

She batted his hand away, jumped to her feet, rearranged her blouse, and ran back to the horses. He knew he should follow her and offer some explanation. He should see her safely home. And yet he felt not ready to abandon the entertainment within.

He turned back to the opening and jolted. The Count's face was pressed to the empty space, his eyes feral in the moonlight, his stern lips and enormous teeth stained with blood.

"Did you find what you came for, Dr. Steward? Know that I have only just begun. Miss Westenra will be spanked and buggered until sunrise, and her blood sipped throughout the night, all of which occurs in a similar fashion each evening. I assume you are jealous, but of whom?"

John felt outraged. "Fiend! Not only have you taken Lucy from me, but you now insult me as well, in your back-handed manner."

"You have yet to experience my back-handed manner, Dr. Steward, but you shall. And when I call you, you will come. Immediately. On bended knee. Presenting any part of your body I desire as an offering, an offering I shall enjoy to the fullest."

The threat sent a thrill through John and yet filled him with terror. To be at the hands of this monster, to be completely controlled in a way he had not experienced before, even with his Master, Van Helsing...

"Go!" the Count ordered. "See that Mrs. Harker arrives safely at her bed, for that is where I intend to visit her soon."

"And what of me?" The moment the words escaped his lips, John realized he had overstepped his bounds.

The handsomely evil face turned rigid before his eyes. "Do not worry, Dr. Steward. You time is coming and you will be dealt with properly. Now, obey me!"

John stood as though pulled to his feet by a dozen strong hands.

He turned, obediently, and hurried after Mina. She had already started down the road in a gallop but he caught up with her quickly.

She did not encourage conversation and in fact he did not mind. He wanted to be alone with his thoughts of this all-powerful lord and his fantasies of submitting to an indomitable will.

Chapter Nineteen

When Professor Van Helsing arrived at the asylum, John Steward was with the patient Renfield. The moment the madman saw the professor, he fell on his knees before him, emotions pouring forth. "Save us, sir, from the powers of darkness." Suddenly Renfield lifted up his head and grinned like a fool. He now sounded quite lucid. "But, of course, you cannot, being in league with the Devil himself." At which point Renfield began to cackle.

John called the attendants. "Return him to his wrenched cell," he instructed, and they dragged the hysterical man out of the office.

Abraham Van Helsing filled the room. He was not a tall man, but he had presence. Bearded, with grey hair and eyes, his body was solid and sturdy as a fine piece of furniture. Although he carried a metal cane, it was not firm but flexible and in any event John knew it was not used for the purpose of walking.

"A peculiar case," he told Van Helsing, shutting the door. "Renfield has delusions and declares he requires fresh blood and needs to consume it regularly by ingesting the life of a variety of creatures."

"Hardly peculiar," the professor said in a clipped tone that had cut John to the quick often enough. "A common breed of insanity, which you would know had you learned your lessons well at my hands. Apparently you did not. Have you forgotten who is Master here?"

John, feeling chastened, got down on bended knee before his old Master. "Forgive me, sir, for my impudence."

"Impudence and condescension." Van Helsing whacked him hard over both shoulders a dozen times with the metal rod, expertly avoiding the bone to bruise the muscle. Even through John's coat and shirt, the cane hurt enough to bring tears to the corners of his eyes. When the professor had finished, Van Helsing sat in a chair and extended a muddy boot, which John began to lick, a habit ingrained from four years at the university in Amsterdam where he had studied medicine under the professor.

When he finished one boot, the other was presented. The mud was thick and tasted bitter-sweet, mingled with all the other rancid refuse that accumulated on the streets. John felt humiliated, debased, brought down several pegs from his position as head of the asylum. Suddenly he was a lad again, kneeling before his strict professor who let nothing pass, who demanded absolute obedience and who stretched him both mentally and physically beyond where he thought himself capable of going. A warm feeling coursed through his body and his genitals tingled. Licking the boot became a pleasurable act and he rededicated himself to the enjoyable task with renewed vigor.

"Enough!" Van Helsing said sharply. "I do not have all day." He tapped John rapidly on the shoulder three times, the signal to rise.

The face of his first Master looked beautiful in its harshness. The lines etched into the brow, the intensely intelligent eyes. It had been ten years since John had knelt before this powerful enigmatic man, who was renowned throughout the world for his exacting scientific mind that left room for nothing but the empirical. A man who had moved beyond the needs of the flesh as it concerned himself and yet was able through strict discipline to guide those lucky enough to be his students into the properly submissive mental state required for learning.

"You may sit," Van Helsing directed, pointing to the chair opposite and not the one behind the desk. "Let's get right to the problem. Your mistress, Lucy Westenra, no longer shows interest in disciplining you. Give me all the facts as pertaining to her case and I warn you, leave nothing out, else you will again feel my tool of edification."

John related all that had occurred, including the night he and

Mina watched as Count Dracula punished then mounted his mistress. He did, though, not mention one thing—his own feelings of being drawn to the powerful Count Dracula. He convinced himself these were superfluous but knew deep down that he was hiding something but did not know why.

"Undress and assume the position!" the Professor ordered, already standing and removing his coat and vest and rolling up his sleeves. The powerful arm muscles rippled, a reminder to John of his past relationship to the professor. John felt stunned. Excitement and terror vied for prominence at the thought of the punishment he was about to receive.

"Sir, may I lock the door," he stammered, "I am the Director of the asylum. If one of my employees should walk through that door—"

"He will see the Director of the asylum being whipped like a naive youth because of his falsehoods."

John fell onto his knees distraught. "Master, I assure you, I have told all. May we not carry out any punishments you feel I deserve in private, at my home?"

"We may not. For your procrastination, you will receive double. Now, undress, or must I rip the clothes from your wrenched body and cane you until you bleed."

John stripped and lay across his large French-polished desk. The cool wood reminded him of the wooden desks at the Academy, which he had lain across in this same manner regularly to receive private tutelage.

The professor wasted no time, as was his style. The thin flexible metal whipped down onto John's back, shoulders and ass with great alacrity. For an older gentleman, Van Helsing showed surprising vigor and strength and his eye and aim were still deadly accurate.

The stinging blows rippled across John's body from shoulders to the soles of his feet. Involuntarily he jumped as each whack of the rod left its red mark, just short of cutting the skin. He had not felt under absolute control nor received such a good whipping since his university days. Then the rod had not let up, but kept coming, even harder than this one did now. But he was no longer used to this. While Lucy was severe in her ministrations, her power was not that

of a man who had inflicted such lessons for over forty years. And there was the fear that someone would walk through the door. He stuffed a fist into his mouth to keep from crying out as the pain became almost unbearable. Tears gushed from his eyes.

His body heated up. He jerked to the swishing of the stinging metal. Under him, his cock sprang to life and yet he knew that the professor would permit no release.

When Van Helsing finished, John ached so he could hardly move. His back, his ass, the backs of his legs stung as if a swarm of insects had attacked him. He stood on the tender soles of his feet. The front of his body showed the professor that one rod had been instrumental in raising another. His cock throbbed red. His balls ached. But he was ordered to dress and sit in the chair and resume where he had left off.

John trembled, humbled before this man who had trained him so well in the past and who could read him so well. He felt humiliated and ashamed at his deception. He wiped his eyes and blew his nose and in a quivering voice recounted his attraction to the Count in great detail, hardly able to look Van Helsing in the eye.

When he finished he sat pulsing with pain, waiting. Finally Van Helsing said, "I see that we are dealing with a monster, that is clear; this is no mortal man but a vampire, a seducer of all. He is like an animal, and does not discriminate as an intelligent man would do. Miss Westenra is obviously under his spell, as are you to a minor extent. You will bring her here immediately and we will begin treatment at once. If we are to save her from this creature, action must be taken in an orderly and systematic manner. And summon the others as well, they may prove useful."

Chapter Twenty

John, with Mina's help, roused Lucy from her bed and brought her to the asylum under great protest. The sun was setting and she screamed that she must be free to visit Count Dracula. "I must! Let me go to him!"

Word had been sent to both Arthur and Quincey, who joined the three in the basement of the asylum, there to await Van Helsing.

"How dare you!" Lucy yelled at the men and Mina. "I will not tolerate this. I shall whip you all until your skin is in shreds!"

The spark of her old self inspired joy in John Steward and he could see the effect was the same in the others. Each had longed to find their old Lucy again, to receive her attentions.

"More," she continued, "I shall have Count Dracula himself deal with you, then you shall know the true meaning of pain."

"I think not, Miss Westenra." It was the voice of Van Helsing, which drew all eyes to the door. He strode purposefully into the room carrying a large carpetbag with him, which he set on a small table. He turned and stared at Lucy, the look in his eye peculiar, or at least it was one not familiar to John.

"And who, sir, might you be?" Lucy demanded.

"Your savior, but you may call me Master."

"Ha!" Lucy said, thrusting her hips forward with fists resting on them in defiance like a washerwoman, and yet her eyes sparkled in amusement. "Sir, I would suggest you save yourself, for I have but one Master. And also, you do not know me and of what I am capable."

"I know of what you were once capable but are no longer inclined to do."

"I fail to see how this is your business," Lucy said, backing down slightly.

"The truth will be bared before you shortly, as you shall be bared before me. Strip her!"

Lucy looked shocked but recovered quickly and demanded, "No one will touch me!"

The professor looked to John first, who nodded across to Arthur, Quincey and Mina. "The professor is correct. If we wish to save her, we must act as he instructs."

The four descended on Lucy and pulled the dress from her flailing body. She kicked and screamed but they soon had her naked, her plump little buttocks quivering in fury, her breasts jiggling in indignation. Long blonde ringlets fell about her sweet shoulders and the short hairs between her legs curled. Her lips and cheeks were flushed with color and her lavender eyes sparkled at this challenge.

Her body bore the marks of the Count. Her bottom was rosy, but only a square of it, the same as what John and Mina had seen. There were other signs, across her back, her breasts and her thighs, as if she'd suffered a lash. Most prominent were the two puncture wounds at her throat.

She raced to the door, but the professor had locked it. They watched in silence as she struggled with the knob. She yelled at them, and stamped her foot like a petulant child. Meanwhile, Van Helsing calmly removed the tools of his trade from his bag. His back turned to her, he said, "Lie on the table, Miss Westenra, on your stomach. You are endangering yourself and those who love you and are in need of a specialist's care."

Lucy's lower lip trembled and she pouted prettily but something in Van Helsing's tone reached her and she climbed onto the long table in the middle of the room.

Van Helsing handed each of the four onlookers a length of hemp and instructed, "Bind her limbs to the table legs."

Again Lucy flailed and cursed but they managed to secure her enough so that she lay splayed.

"An important principle of science is that of reversal. Anything

taken to an extreme will reverse itself as there is a natural pendulum swinging from one pole to the next. Your poles have been reversed, Miss Westenra, and I intend to reverse them again."

John Steward, from years of classes with the professor, felt free enough to inquire, "Sir, if you wouldn't mind explaining. I myself do not understand your diagnosis nor your treatment and I fear these laymen are entirely in the dark."

Van Helsing now had a piece of hose in his hand, an inch in diameter and approximately two feet long. As he walked to the table he said, "You each know yourselves that at some point pain becomes pleasurable. But let me start simply: an action must needs have a reaction. All things are causal and one affects another. If I bring a paddle down on an unsuspecting behind, the flesh must plump up around the sides of that paddle. That is the nature of science."

"That, sir, is obvious," John said. "But how does this relate to extremes?"

"Watch and learn," the professor instructed.

Lucy's legs were spread wide. He probed her anus and she contracted her ass muscles. "Hold her open!" he said.

Mina grabbed one cheek and John the other, stretching them wide so that Lucy's muscles could no longer close her openings.

"Damn you both!" Lucy screamed.

Professor Van Helsing wiggled the end of the hose until it fit nicely into Lucy anus. Then he pushed and wiggled three quarters of the rubber snake inside her.

Lucy struggled but to no avail; she was being held fast.

John had never seen an appliance like this used in this manner before. He had heard of a process whereby rubber was heated with sulphur and yet he had never seen the like. He watched fascinated as Van Helsing attached a smaller hose to the free end of the larger one and ran it to a hand pump which he had removed from his bag and placed between Lucy's feet.

He then attached the pump to a large glass bottle filled with a foul-smelling whitish liquid, several quarts by the look of it. Immediately the professor began pulling and pushing on the pump's handle and slowly the level of the liquid in the bottle diminished.

All of a sudden Lucy let out a howl. Every muscle in her body

contracted. The howl turned to a wail. The professor continued pumping.

"You're killing her!" Arthur yelled.

"I'm gonna put a stop to this!" Quincey declared.

The professor halted them with a look. "You will remain where you are and not hinder Miss Westenra's treatment or you will deal with me!"

Both Arthur and Quincey looked chastised and excited but they did not move to hinder the process.

The professor continued, despite Lucy's heart-wrenching shrieks, until the bottle was empty. He then removed the smaller hose and quickly thrust a plunger into the end of the larger hose, which he capped, ensuring the liquid would remain inside her.

Through her ear-piercing screams, Van Helsing could be heard to say, "Now, if you gentlemen, and Mrs. Harker will join me, I believe it is time for dinner."

Over a meal of white wine, roast fowl and fresh cranberry sauce, Professor Van Helsing explained to them what he had done. John listened, enthralled.

"The solution forced into Miss Westenra's rectum and expanding it to its full capacity is essentially crushed garlic, diluted. Garlic, of course, is an ancient bane to the vampire and since the anus is Count Dracula's preferred entry point, he will no doubt be discouraged. In a more scientific light, its nutrients enrich the blood and help ward off disease. Of course, if you have ever pressed raw garlic to a sensitive area, you will know the effect, hence her screams. In this case it is even now stinging the rectum, producing in Miss Westenra one of two possible reactions."

He shoved the tender breast meat into his mouth and munched happily, letting the juices from the fat spill down his chin. John was astonished by this man, normally so impeccable and neat in the extreme. He had never witnessed such erotic pleasures in Van Helsing. In fact, John had long been puzzled by this man who, within the young Dr. Steward's experience, had neither tasted of another's flesh nor been tasted by any. Of course, it was the mark of genius to be eccentric.

"Professor Van Helsing," Mina asked, "I am having trouble under-

standing your theory of extremes."

"Mrs. Harker, obviously your experience is limited."

Mina blushed, and John noticed her nipples firm. Perhaps it was his imagination, but the dress she wore tonight seemed a bit tighter and less drab in color than the ones he had seen her in before.

"Quite simply, Miss Westenra will do one of two things: preferably, she will reconsider her recent attraction to a life of submission. When one of her temperament has a option of receiving or inflicting, the latter is often chosen, but not always. The other thing that could occur to her is related. If pain is desirable, then the one who is capable of administering it most effectively becomes the coveted Master. In the event that Miss Westenra is unable to make the shift back to her former self, she will at least learn that there is a Master superior to the vampire Count, capable of fulfilling her deepest longings, namely myself."

Well, John thought, this was a peculiar twist. Van Helsing, the old curmudgeon himself, taking on a female submissive! John had never heard the like. As far as he knew, Van Helsing preferred disciplining males. The man had said on more than one occasion that men were superior because they were hardier and therefore capable of tolerating rougher treatment, making the experience for the Master more rewarding.

"But how's this relate to what you were talking about today? About extremes?" Quincey asked.

Van Helsing lay his fork down and blotted his lips with the napkin. He gave Quincey an appraising look, and Quincey blanched, as if something had been seen which he had carefully kept hidden.

"If I play with opposites, Mr. Morris, then I am in fact able to create white out of black pigment and vice versa. I could, in fact, create a sadist from a masochist or turn a dominant personality into a submissive. In theory, by forcing someone to an extreme, a woman could be turned into a man or," and here he gave Quincey a penetrating look, "a man into a woman."

The theory was not elaborated on and Quincey did not push for further explanation. John thought of doing so himself, but the professor seemed eager to return to the basement and check on Lucy.

When they arrived she was moaning. The sound was half pain,

half pleasure.

Van Helsing crouched at the end of the table and grabbed her lux-uriant hair, forcing her to look him in the eye. Her tortures had only enlivened her features. Her eyes were brighter, her lips and cheeks pinker. She looked at Van Helsing with a touch of adoration. "Miss Westenra," he said, "I hope you have reconsidered your ways."

"I have, sir," she said compliantly. Apparently, John thought, we have no hope of retrieving our Mistress.

The professor immediately went to his bag and brought back a strange-looking paddle.

"This, Mr. Morris," he said, "may prove to be a concrete example of the theory you and Mrs. Harker are having such trouble under-standing."

He walked to the side of the table. "Miss Westenra has been in considerable pain. Not enough, however, to produce the preferred result, although the secondary result is well underway to becoming fixed in her mind."

He held the paddle up so all could see it clearly. It was half an inch thick, made of grey rubber and somewhat flexible. Curiously, holes had been drilled here and there on its surface.

"Why rubber, sir," John asked.

"When a paddle contacts flesh," Van Helsing said, "that flesh is warmed, of course. Repeated contact increases the heat. Wood pad-dles on skin create heat, leather on skin creates more heat, but rub-ber paddling flesh will produce the most heat. The material has been altered from its natural form, for it is found in a tree and changed by man's hand into something other than what nature manufactured. Hence, its inherent transformative properties."

"We do the same to leather," Arthur suggested.

"You are correct, Mr. Holmwood, leather is treated in brine and tanned, whereas wood is in it's natural state. But the tanning process is not as extreme as the processing of rubber. That substance shifts from liquid to solid."

"So," John asked, "the rubber creates more heat more quickly. But why the holes? Surely they reduce the effect."

Van Helsing handed him the paddle. It was lighter than any pad-dle John had held, even those made of thin birch. One side was

smooth rubber, the other ribbed. He ran his palm across both sides, wondering what such a paddle would do to flesh already as tender as Lucy's.

"You feel the lightness," the professor said. "It is the holes. A lighter paddle moves faster."

"Won't it have a lessened impact?" It was Mina who asked and the professor smiled indulgently at her, making John think the man was losing his mind. Mina blushed scarlet.

"Mrs. Harker, this is physics, beyond the understanding of most people, certainly a woman like yourself."

Mina bristled at such treatment. Had not the professor held an implement that could speak to her as well as Lucy, she likely would have contradicted him. John saw that she realized her precarious situation and, for the moment, decided to act prudently.

"The impact will become apparent," Van Helsing said. "The holes serve an additional purpose which, too, becomes obvious, if you will all be patient."

He took a small rubber ball from his bag of tricks and instructed John, "Insert this into Miss Westenra's mouth."

Lucy resisted, but John forced open her jaw and slid the ball in. Her face was pale with anticipation, for she had heard everything and was eager with expectation.

John felt titillated. After all the lickings he had received at her hand he was now about to watch her receive a greater thrashing, from the Master disciplinarian himself.

Van Helsing raised the paddle and brought the smooth side down hard on Lucy's right ass cheek. Her torso hopped into the air as much as the restraints permitted and the short fat rubber hose sticking out of her anus quivered. The one cheek the paddle had punished reddened immediately, with the added advantage of creating bright crimson circles where the holes had struck. They reminded John of the circles made by the use of hot glass cups on the back when trying to draw a cold from the body. The professor cracked her other cheek soundly, creating a similar effect.

Lucy screamed, but the rubber ball kept the sound muffled and John quickly saw the advantage of that. The thought occurred to him that he might use the same equipment on his more vocal patients.

Through his excitement he was curious, and examined the hot marks with his fingers. The holes in the paddle were edges which, he now understood, meant that they created the kind of line any edge would make.

Van Helsing raised and lowered the paddle onto each cheek again. The effect was immediate—scalding cheeks with acid red circles.

"May I try, sir?" It was Arthur who had spoken and John was surprised at this.

The professor handed over the paddle. Arthur took a stance, firmly planting his feet to ensure balance. He let Lucy have it full force, twice on each cheek. The fervor in his eyes appealed to John, who had an immediate fantasy of Arthur's paddle striking his ass dead on. He had never seen his long-time friend in this light before and had to admit the idea of being spanked by Arthur the boxer was exhilarating.

"Mr. Holmwood," Van Helsing interrupted, "if you are going to do the job, you must not hold back, else Miss Westenra will suffer more in the long run. If you are not man enough, simply say so."

Arthur took up the challenge. "I shall do better, sir," he said, and Van Helsing nodded.

John watched with excitement as Arthur paddled Lucy with the vigor of a young, strong man. Her ass cheeks flamed in two colors and the hose bounced in the air. Between her splayed legs, John saw liquid glistening at her moist opening and he longed to fuck her wet cunt.

Arthur worked up a sweat quickly as he was so energetic. John could now see that as the paddle struck, the skin from Lucy's bottom was forced up into the open holes, hence the rings of red. Those rings formed little ridges that swelled, blistering before his eyes.

Suddenly Van Helsing grabbed Arthur's hand in mid air. "Enough. If you break the blisters you not only risk infection but also postpone further treatment. Miss Westenra is in dire condition and will need almost continuous therapy.

"Stand against the wall, the three of you," he ordered, indicating that Mina should join him on the other side of the room.

The men took their places along the wall, John in trepidation, knowing full well of what the professor was capable.

And yet, before his startled eyes, Van Helsing untied Lucy and removed the ball from her mouth.

"Miss Westenra," he said, "you will service all, excluding myself, and Mrs. Harker of course, beginning with Mr. Holmwood, to whom you owe most."

Mina's face paled and rage filled her eyes at this perceived insult.

Tears streaked Lucy's face, yet her skin tone was pink. Her eyes flickered with the ecstasy caused by severe pain and excitement.

"Sir, I beg you, may I first use the toilet," she said.

"No, Miss Westenra, you may not, but you will do as you have been ordered in silence or receive another round with the paddle." He punctuated the command with a sharp crack of the rubber against her raw bottom.

Immediately she hopped from the table and on hands and knees crawled to Arthur.

She unbuttoned his trousers and slipped them down to his knees. The muscles of his thighs bulged against the skin and his brown pubic hair curled at his crotch. She looked up at him through her wet lashes and in a throaty voice, raw from screaming, said lasciviously, "Arthur, my love," and took his member into her mouth.

Lucy worked him well, licking and sucking both his cock and then his balls. Arthur struggled for control but the events had been too much for him and he came readily between her lips.

Next Lucy crawled to Quincey and undid his pants as well. He wore a strange contraption, possibly designed for riding, which held his rigid cock firmly in place. She unhooked this and his member sprang upward. Lucy's tongue lapped at the underside of his penis. He arched his back and held her head, guiding it. John watched Quincey's balls tighten. Lucy's head bobbed over him far longer than with Arthur. Quincey thrust his hips forward and groaned loudly as he shot into her mouth.

Lucy licked her full lips of the hot juices and crawled to John. His cock stood at attention. She held his balls in her hand and squeezed, first gently, then harder. Pressure built in his scrotum. Her rough tongue slowly licked up his shaft and over the tip of his cock then down the inside. Meanwhile her raw bottom with the rubber tubing still dangling from it like a tale bobbed in the air in time, exciting

him—he could almost feel heat rising off her ass.

She tightened her hungry lips and pulled up and down his cock, devouring him, both the top and underside as well as working the swollen head. His legs trembled and she moved faster. Suddenly John could control himself no longer. Hot semen roared through him and exploded into her. Lucy swallowed all of it and licked him clean.

John glanced around the room. Mina, in a rage of frustration, flew out the door.

Arthur and Quincey both wore dreamy expressions on their faces.

Lucy had crawled to the Professor. Van Helsing bent over her, rubbing the ribbed side of the paddle against her sore bottom, forcing moans from her lips. John saw moisture dripping from her pulsing, swollen pussy and his cock began to rise again.

The professor finally removed the tube and warned Lucy to hold her water until she reached the toilet upon pain of another thrashing, whereupon he released her to an attendant.

While she was gone, he confided in the men, "The plan is working, at least in part. I believe we are already seeing a new woman. By tomorrow we shall know for certain which way she will turn. But either way, Count Dracula is a threat no more. John, the keys to your cells."

John handed the professor a ring of keys. When Lucy returned, Van Helsing had him lead them upstairs to Mr. Renfield's cell.

There he chained Lucy spread-eagle to a rough wall under a grate to the outside where water leaked down from the soil at street level and ran over her head and shoulders and in rivulets down her breasts. She sobbed and pleaded, calling the professor, "My Master," but he could not be dissuaded from his intent.

Renfield sat in a corner, silently watching this spectacle, entranced, munching on stray insects.

When the naked Lucy was affixed as he desired, the professor took a small box from his pocket and opened it. He removed something and pressed it to one of Lucy's nipples. She screamed. He removed another and did the same to her other nipple. Lucy cried out, "Oh no, Master! Not this! I beg you, my true Master, do not subject me so! I cannot bear it!"

John lifted the lantern. "Leeches?" he said. "She has already been

bled by the vampire. I do not see the point."

Van Helsing gave him a harsh stare and John's bottom twitched involuntarily. "I will instruct you on the point in greater detail in private, Dr. Steward, quite likely late into the night. For the moment it is enough to know that what Count Dracula can do, I also am capable of, in my own way."

He turned to Renfield in the corner, whose eyes shone. "Mr. Renfield, being aware of your predilection for living creatures filled with blood, I can only press upon you the importance of waiting until the morning, when these black fellows affixed to her tits will be full of what you most desire. In the meantime, Miss Westenra requires your lips on another part of her anatomy, if you gather my meaning."

From the look on the madman's face, John could tell that Renfield understood.

As John guided the others from the room, Renfield was already positioned beneath the shrieking Lucy, lapping and sucking at the juices flowing from her swollen cunt.

Chapter Twenty One

John spent a painful night at the hands of the Professor for his insubordination. He learned first-hand the blistering heat produced by the dreadful rubber paddle as Van Helsing laid it on his behind without hesitation.

By morning John was reformed, stricken with remorse for his haughty manner, and pledging to follow the Professor's instructions to the letter without question.

Stiff and sore, he arrived at the asylum just after sunrise to find Renfield merrily dining on leeches. Lucy's nipples were swollen and she looked exhausted but beautiful. He released her bonds and carried her to a coach wrapped in the long cape she'd worn the night before. She threw her arms around his neck and kissed him full on the lips, her tongue warm and sensual in his mouth.

At the Westenra mansion, Verna and Mina took charge or John would have seen Lucy to bed and impaled her on the spot. As it was, he returned to the office for a day of work that he carried out mostly standing.

Just before sunset Lucy was brought back to the basement at the asylum. Tonight, though, she came willingly. When Van Helsing and the others arrived, Lucy threw herself at the Master's feet, licking his boots and caressing his ankles.

"Onto the examining table, Miss Westenra, and be quick about it," the professor said.

Lucy clambered onto the long table like a puppy eager to please.

Tonight she glowed, her eyes bright, her fair skin tinged with healthy pink. Her hair looked lustrous as it spread across her back to her waist, stopping just short of the bottom cheeks that had been blistered. The little welts had subsided, due, probably, to the cool wall the professor had so cleverly chained her against. The skin was red, though, with the redder circles clearly visible.

"Spread your legs," the professor ordered, and Lucy complied.

"I see you have moved in one of the two predicted directions, therefore my diagnosis and prognosis have been confirmed. There is, however, further treatment required to insure you do not slip back into old habits and stand in harm's way."

Again he brought the rubber paddle to the table. Lucy watched him, a mixture of lust and fear imbedded in her features.

John sniffed the air, now permeated with her powerful secretions and felt excited and expectant himself. Even as he became aware of this, his sore ass cheeks tingled as if the sight of the paddle produced an instinctive reaction.

The professor slapped Lucy's cheeks with the paddle and a little yelp came out of her mouth.

"Miss," he said sternly, "you will cease tightening the muscles of your bottom as I blister you anew else we will commence once again from the beginning. Do I make myself clear?"

Lucy whispered, "Yes, Master Van Helsing."

"Yes, what?" he roared, slapping her bottom hard with the rubber. "Yes, Master!"

"Indeed, you have but one Master, hence there is no need to name me, or is that not so?"

Lucy looked terrified. "I am your obedient servant," she said, but apparently that wasn't a good enough answer.

A cool look came over the Professor, who realized that he had allowed emotion to color his judgement. John was amazed. The man had never once shown the slightest bit of feeling in all the years he had known him. His punishments had been meted out cleanly and methodically, with scientific precision. And each case was subject to careful observation throughout the process. The Professor despised emotional displays, in himself and others, particularly when working. He did not tolerate the frivolous in his students or his patients.

John's bottom could attest to his own abundance of sloppy work habits which the Professor had systematically corrected over the years. In fact, even last night, as John spent the remainder of the dark hours leaning over the arm of a chair while the professor paddled the haughtiness out of him, there was no sign of emotion. It was simply a Master instructing a student in a way that would have a lasting effect. John could only wonder at the effect Lucy was having on the great man.

"I believe we shall begin with fifty," Van Helsing was saying, "which you shall count."

"Fifty?" Lucy's voice was shocked. Even she did not expect such severe treatment two nights in a row.

"Fifty on each side," the Professor corrected.

Without pause, he smacked her on each cheek and said, "Count!"

"One!" Lucy cried. "Two! Three! Four!"

"You will relax those muscles, Miss, and begin the count again!"

Despair sounded in Lucy's voice as she began the count all over.

Each broad bite of the paddle rippled up John's body as his own ass cheeks remembered clearly the sound and feel.

Lucy got to twenty before she tightened. The professor instructed her to begin again.

John was fascinated at how her round bottom took the paddling without tensing. Each plump cheek quivered as it reddened, but the muscles did not contract. John knew both scientifically and from direct experience that pain brings on involuntary muscle contractions. Those contractions provide the added benefit of restricting the pain so that it will not proceed far beyond the point of contact. Leaving herself loose, poor Lucy would feel the snap of the paddle resonate through her entire body. Suddenly John regretted that throughout the night he had tensed. He wondered what this total body pain would feel like.

Lucy's ass cheeks danced to the professor's beat. Tears streamed from her eyes. Her arms hung over the sides of the table loosely, struggling to avoid the dreaded tension that would bring on further punishment. Her voice sounded as ragged as her bottom appeared. Welts had risen again and her ass looked twice as sore as John's felt.

Finally she counted fifty, choking out the words.

"You are a slow learner, Miss Westenra, but there is hope for you. You three," he said, pointing at the men, "undress."

Mina, once again, had been left out and the outrage showed on her face. This time the Professor did not ignore her entirely.

"Mrs. Harker, sit please, and observe."

This did little to appease her but she sat as directed.

"Dr. Steward," the professor ordered, "onto the floor on your back. Miss Westenra, you will mount him at once."

John lay on the rough hardwood floor, the raw fibers scratching at his tender bottom. Lucy moved from the table as quickly as she could. She knelt over him and impaled herself on his hot cock.

"Mr. Morris, to the front."

Quincey took his place. He stood, legs wide apart, bracing himself, and Lucy took his member full into her mouth.

"And Mr. Holmwood, to the rear. It is up to you to counter the effects of Count Dracula."

Arthur knelt behind Lucy and plunged his long cock into her back door.

"Mrs. Harker, if you will." Van Helsing handed two sticks to Mina. She looked at them dumbly for a moment but then began to tap them together in a regular rhythm.

The four on the floor moved in time with the beating sticks.

As Lucy came down onto John, Arthur rose up into her. As she lifted up, Quincey thrust his cock into her mouth. The look on her face struck John as blissful. She quickly moved into another realm. Being filled on all counts brought out the best in her.

John felt the muscles of her cunt tighten around him as Mina picked up the pace. The fleshy folds gathered him in and rippled over him. The massage worked it's magic. His cock swelled and his balls felt on fire. His ass rose and fell on the rough boards. She bounced against his crotch and at that moment Arthur's nuts crashed against his own. Quincey, overhead, emitted a strong manly scent, mingled with the delicious sweet odors from Lucy. John reached up and rubbed her swollen nipples and she squirmed, her insides becoming slicker and gripping him tighter.

Mina beat the sticks at a tense pace. John felt their rhythms blending and they moved as one. The fire in his balls caught, soaring up

his shaft. He thrust up into Lucy and at the same moment Arthur thrust from behind and Quincey in front. Lucy's body spasmed as if she were having a seizure. Sounds burst from each of the men in unison as the links melded. It was as if a bolt of lightening shot through the four of them.

They were drenched in sweat, panting, sticky.

"Enough!" Van Helsing said, smacking the paddle smartly against Quincey's bottom until he backed off, then doing the same with Arthur, who took longer to move and hence received more.

Lucy disengaged herself, leaving John alone on the floor. He felt limp, spent. "Up Dr. Steward, or I shall be forced to rouse you."

John stood quickly, but not fast enough to avoid a crack of the paddle against his prickling behind.

"Escort Mrs. Harker home," the professor instructed. "Count Dracula is no longer a threat!"

The men dressed quickly. Quincey and Arthur left the room in a burst of gaiety. Mina, however, sat rigid in her seat, still clutching the sticks. When John touched her arm, she jerked away and gave him a violent look. She stood and hurried out the door.

"Professor, is there anything further you need?" John asked.

Van Helsing seated himself on the chair Mina abandoned. Lucy crawled between his legs and unbuttoning his fly. John's mouth dropped open. He saw Van Helsing's large penis liberated—he had never seen it before and the length and width of the uncircumcised wand were remarkable.

Lucy licked the flesh erect and played with his enormous balls while John stood as if struck dumb. Van Helsing permitting this! An indulgence of the flesh! John could hardly believe his eyes.

"You may go, Doctor Steward," the professor said, waving the paddle he held towards the door. "As you see, I am victorious."

Part Five: Lucy

Chapter Twenty Two

I fled that cursed asylum, not waiting for Dr. Steward or anyone else to escort me, and demanded of the locksman a coach to return me at once to the Westenra mansion. My body and brain were on fire. I had seen things no virtuous woman should witness.

Never had I been so insulted because of my gender. Van Helsing, that onerous sadist, treated me as though I less than competent, certainly neither worthy of knowledge nor experience.

At the manor house I declined the tea Verna offered me and instead retired to my room with a glass of sherry but even after drinking it felt too agitated to sleep. On impulse, I raced for the stables, much to Hodge's consternation, and made him saddle the mare, Rosebud, for a midnight ride. And ride her I did. Unabashedly I straddled her firm back like a man, racing across the fields, headed for the Mulgrave Woods.

As we entered the woods, I slowed her to a gallop and soon to a trot, for she was breathing heavily, and slick with sweat from the exertion. Instinctively she followed the paths to which she was accustomed.

The night was lovely and quiet but my nerves were on edge.

Every snapping twig, each hoot of an owl caused my body to jump. Overhead the moon glowed its ghostly white and looked full enough to burst. I felt wetness break between my legs, something beyond the constant arousal that had hounded me recently, and I knew my monthly cycle had begun.

We reached a clearing and Rosebud stopped abruptly. I lashed her with the reins and dug in my heels but she refused to continue. "All right," I told her, "if you're determined to be stubborn, I suppose we can rest here."

I dismounted and tied her to a branch.

My body felt on fire. I had witnessed such depravities and yet they were not really depravities, for if they had been only that, why should I long so to participate and feel so cast aside?

The air was humid and the sky clear. I looked up at the countless stars and wondered why fate had brought me to Whitby to witness acts that had ripped away my virginal view of life. I now longed for the passion I saw others wallowing in. And yet would my cravings ever be sated? A cry of despair escaped my lips as I realized that I might live my entire life unfulfilled.

Suddenly Rosebud neighed, as if in sympathy. "You know, there are times I feel I cannot bear this," I told her.

"Yes, I know that," a voice answered. I jumped around in alarm.

A tall man stood at the edge of the wood wearing a long cape. My heart began to beat wildly for I suddenly realized I was alone in the thicket with a stranger.

"But you know me, Mrs. Harker," he said, stepping into the clearing. By the light of the pale moon I saw that it was Count Dracula. This knowledge did little to alleviate my fear. In fact, he had become the devil personified in my mind and I felt unprotected before him.

"Good evening to you, sir," I said, turning towards Rosebud, eager to make my escape.

"She will not let you mount her," he informed me.

I did not heed his warning but struggled to slip my foot into the stirrup. The horse had become disturbed. She was skittish and sidled away from me and when I continued my attempt to mount her, she reared up on her back legs.

"Stop it!" I demanded, frightened, but the horse would not obey. "What have you done to her?" I demanded of the Count, turning.

I jolted. He stood inches from me, his cruelly handsome face towering above mine. A vague scent filled the air, an undercurrent of earth and all things sensual.

"Merely controlled her will, as I shall control yours."

His dark eyes held me. I could not speak and felt my limbs were too heavy to move. He reached out a hand and unbuttoned my blouse slowly. The fabric he pulled down, exposing my shoulders and breasts cupped by my corset to the warm night air caressing my skin. "You must not do this," I managed to tell him. "I am a married woman. Are you not a gentleman?"

"I am a warrior," he said, "and I take what I want. And I want you, Mina."

His words sent a thrill through me. I shivered and felt my skin turn to gooseflesh.

He pulled the pins and coil from my hair until it fell loose about my shoulders. Although I was half naked before him, I did not feel embarrassed. A glance down told me that what I felt was so: my nipples had hardened, anticipating his touch. And touch them he did.

His fingers worked each until they were even firmer, forcing me to arch my back and shamelessly thrust my breasts out as if eager for more. He gripped me about the waist and lifted me as though I weighed nothing. His lips clamped onto one nipple. My head fell back and my lips parted. He licked and sucked my tender flesh, bringing me to heights of pleasure I had not dreamed possible. Pleasure that threatened to overwhelm me. And then he tasted my other breast. Sensation washed over me. I could only lie in his arms moaning, quivering, aware of his enormous manhood pressing against me, feeling red moisture running down my inner thighs which, for some reason, did not give me pause.

I know not how long he toyed with my nipples, only that the sensations resonated physical joy throughout my body until I felt I must die from delight.

Before I was aware of it, he was undoing my skirts and corset. "Please," I said, suddenly embarrassed as I knew what he would find. No man had ever seen my menses. I felt I could not bear the humiliation. I struggled in his strong arms but was no match for his phenomenal strength. Soon he pulled my bloomers down and I was bare before him.

He snapped the reigns from Rosebud's bridle and led me to a low-hanging tree limb. I followed willingly, passive from his intoxicating touch, and I longed to drink my fill of him until I became senseless.

He bound my wrists together and both to the limb; I was able to grasp the thick branch and did so, feeling a need to grip onto something. Arms above my head, my body tingled with desire. The notion of being a woman engulfed me for the first time in my life, a woman in the presence of a potent man who wanted her.

He snapped the remaining leather in two with his bare hands and lifted one of my feet. He secured my ankle so that the toe of my boot held me in place, then tied my other ankle in the same manner.

My body pulsed, on fire with a peculiar hunger new to me.

I hung from the tree, a ripe, swollen fruit gently swinging, already leaking its sweet juices, about to burst and release all, about to be plucked.

Count Dracula crouched beneath me. His large mouth covered most of my womanly opening. I felt his cool rough tongue lick me from rear to front and back again. He lapped at the blood and other liquid flowing from me like a man dying of thirst.

I moaned in ecstasy. Never had I felt such need, such urgency. He sucked at my opening, pulling the fluids from me and I cried out as my small hardened button tingled under his incessant ministrations.

We stayed like this, I dangling over his eager mouth while the moon ate its way across the sky. My cries mingled with those of the night creatures. It was not until the sky began to lighten that he gave me relief.

I felt weak. Exhausted. Tender. My swollen nipples throbbed. My plump womanly slit pulsed. The skin over my entire body vibrated, open in his direction.

He released my bonds and pulled me to him. His lips zealously clamped onto my throat. I felt a piercing that burned and I melted into the arms of my demon lover, who enfolded me in his dark cape. His voice swirled through my mind with a command.

I knew not how I understood what I must do, and yet I did understand. And more, I would not see him again until I had obeyed.

I also know not when he left me but suddenly I stood alone naked in the clearing. I felt abandoned. Lonely. Chilled by the cool dew. Dawn was approaching rapidly. I dressed quickly and mounted Rosebud, who was now as calm as could be. Before the sun rose, I arrived at the manor and dressed for a visit to the asylum.

Chapter Twenty Three

Just after sunrise, Mina Harker barged into John Steward's office demanding, "I wish to visit Lucy. Now!"

"I'm afraid that may not be wise, Mrs. Harker. As you know, Professor Van Helsing is treating her condition..."

"I don't care about that. I insist you show me to Lucy at once, and I will not take 'No!' for an answer."

The woman looked determined. He thought for a moment about the professor's orders. If Van Helsing should learn that he had disobeyed him, John would have a good caning to look forward to. On the other hand, how would the professor find out? And even if he did, with Lucy out of commission, John was a practical enough man that he reconciled to the idea of taking his pleasures where he could find them. His ass was healing nicely and eager for further attention. Before Van Helsing returned to Amsterdam, John intended to obtain another taste of that remarkable holed paddle, a taste that might linger.

"All right, Mrs. Harker, but you may not stay long. Lucy needs her rest, such as it is, so that her therapy may be effective."

He escorted Mina to Renfield's cell. Lucy, chained as on the previous occasion, would tonight be removed to the hidden sleeping quarters the professor had insisted upon in the bowels of the asylum. John expected from what Van Helsing said that the professor would soon be dealing with Lucy alone. He had plans for Miss Westenra, that was clear, none of which John could fathom.

Lucy opened her eyes, swollen shut from crying, and looked through the slits at her friend. "Mina," she whispered. "I see you understand his power."

John assumed they were discussing Van Helsing. Lucy certainly understood and Mina perhaps so, although she had not tasted his puissance directly.

"May I have a word alone with her?" Mina asked.

"Certainly," John said, and stepped outside the cell.

The two women whispered and giggled together while John and the lunatic Renfield looked on. Renfield stood at the door's barred window grinning up at him and licked his lips with his fat tongue. "The ways of women are mysterious, are they not Dr. Steward? What rational man can hope to understand them and yet a rational man is drawn to them as is a moth to a flame. Or a human mouth." He popped a brown-winged moth between his lips. The insect's antenna fluttered wildly before its entire body was sucked to its horrid fate. The man was revolting and John dreaded leaving Lucy alone with him, but it was on Van Helsing's orders and the Professor knew best about in these matters. Obviously the treatment was effective for had John not seen the once wilful Lucy Westenra bend willingly to every demand?

When Mina finished, he escorted her to a waiting carriage.

"Will she spend the night there, then?" she asked.

"The Professor has made arrangements. Don't concern yourself, Mina, they are for her own good and careful attention is being paid her."

"And you believe she is coming along nicely?"

"That is my perception, although we must wait to see what further treatment the Professor prescribes."

A strange smile crossed her face. John helped her board the carriage by guiding her arm. She nearly fell backwards and instinctively his free hand flew to prop up her bottom. She seemed to linger a moment then continue on into the coach. He had the impression that this 'fall' was planned, although he could not imagine the staid Mrs. Harker doing so. Once the door had closed, she peered out the window and down at him, giving an almost lecherous grin, one he found himself responding to. Perhaps it was his imagination, but he

could have sworn her hair was not as tightly coiled nor her features as set as before. She looked infinitely more attractive, playful, and he wondered at her potential.

"I shall hold you personally responsible to see that Lucy is well cared for. You will see to that, won't you Dr. Steward? John?"

His name on her lips sent a message to his cock, which sprang up. The effect she was having on him amazed him, as though she had somehow opened to a dark corner of her nature.

The carriage sped away, leaving John staring off after it, imagining Mrs. Harker devoid of clothing holding a cricket bat in her hands.

Chapter Twenty Four

I slept until the sun gave itself up to the horizon and the sky drained of color. I awoke in my bed renewed. I threw the covers from my burning body and lay sprawled, my nightdress tangled about my waist and off one shoulder. The window was open and cool air rippled across my exposed flesh.

I watched the sky darken until I could no longer make out the line of the horizon. Even before I saw him, I felt his presence. The air became dense, as before a storm. The wind cooled further and blew the curtains about. I had difficulty breathing and I felt chilled. My body trembled violently with hot longing yet goose bumps riddled my flesh.

When he appeared at my second story window, I did not questions how that was possible. I simply threw open my arms and he entered them.

Within moments my body was liberated of my nightdress. His kisses were rough and passionate. I felt painful bites inflicted all over my torso, especially my waiting nipples. I could do nothing to stop him and did not want to. All I managed were moans that expressed both my delight and discomfort.

We tumbled and writhed on the bed until eventually I hung over the edge, my head nearly touching the floor. His teeth clamped onto one of my jutting breasts. I could only moan and gasp my pleasure as he punished my nipples with his determined mouth, sucking, biting, whipping the willing flesh with his tongue. Blood rushed to my

head. I felt dizzy. I no longer knew where or who I was.

He tormented my breasts until I believed I would faint from the sensations, then pulled me up by the hair and captured my lips with his.

My body blazed with longing. I panted, unable to breathe deeply because of the passion engulfing me. His lips found the wound in my throat and he pierced me again, sending shock waves through me, causing my womanly parts to contract violently and blood to gush from that slit.

His hungry mouth followed the fleshy path to that red fountain and again he drank until his thirst was quenched.

Such illicit pleasure embarrassed me greatly and yet I wanted nothing more than to satisfy him in this way. His tongue explored all of my openings, sliding into me deeply, his hot breath stimulating me.

By the light of the moon, he pulled me to a seated position so that I sat atop his legs, his enormous member between us. Power emanated from his face and his voice was commanding. "Whilst they played wits against me—against me who commanded nations, and intrigued for them, and fought for them, hundreds of years before they were born—I was countermining them. And you are now flesh of my flesh; blood of my blood; kin of my kin; my bountiful wine-press and shall be later on my companion and helper." He cut his breast with a fingernail and ordered, "Drink, Mina."

Horrified, fascinated, I moved towards his breast like a infant to a nipple. Blood flowed from the wound and I lapped at it. His hand on the back of my neck held me tight against him. I could not breathe through my nose and was forced to gulp air and blood with my mouth. Initially I found this act repulsive, but my lover's free hand slid down my back and penetrated both of my holes and I sucked furiously as his fingers thrust into me, causing me spasms of delight.

My inner walls tighten around him. His rubbing felt like matches striking a flint, each attempt heating all surfaces until a spark threatened to erupt. With every strike the spark came closer to being actualized.

When I felt one strike away from ignition, suddenly he removed

his fingers. I screamed in frustration. He grabbed my shoulders and pushed me from him, forcing me to meet his dark eyes.

"I will not fulfil you this night," he said.

Hurt, I burst into tears.

"Lie on your stomach, Mina," he ordered. Overwhelmed with hopelessness, I obeyed.

He inserted two pillows under my hips, raising my pulsing openings shamefully into the air. Then he took my hand and moved it between my legs. "Pleasure yourself!" he commanded.

"I cannot!" I cried. I had never done so and had been taught all my life that it was not right. But he insisted with his eyes and I felt powerless to disobey.

He guided my fingers over my slippery nub. Each touch sent a wave of pleasure rippling through me. I rubbed myself in a circular manner that caused my bottom to rise and fall. But soon the Count moved my fingers inside me. I had never felt this delicious area, the skin so slick and yet ribbed, so receptive to my own touch.

He led my hand in a rhythmic thrusting. My finger tips stroked the sensitive hot flesh swollen with desire in much the way he had stroked me. My breathing became rapid, my heart raced. I experienced a tingling and twitching throughout my body. My legs spread of their own volition and my breasts jutted forward, demanding to be touched. I used my free hand to reach beneath me and satisfy one of them.

I played with my nipple in the manner I had learned from the Count. It felt as though my nipple and the opening between my legs were directly linked. How had I not known this?

The heat built to a dangerous level. Incineration seemed eminent, and yet I could no stop what I had begun.

Instinctively I rubbed harder and faster, my body straining and jerking towards something. The work grew labored and yet easier, as it was more pleasurable the faster I went. My inner sanctum clutched my fingers in a plump hug and squeezed hard.

Suddenly the room around me spun then disappeared. I lost my breath completely and hurtled into a chasm of boiling air. I cried out in a delirium of delight. My body convulsed wildly as if I were throwing a fit. I could neither halt my cries nor my buckling, nor did I wish to.

But it came to a natural conclusion and soon I lay on the sheets drenched in sweat cooled by the night air. Spent. The Count was somewhere in the room, although I could not see him, just shadows with piercing points of red light. His voice filled me with power.

"When my brain says 'Come!' to you, you shall cross land or sea to do my bidding; and to that end this!"

And I knew it was true. He had given me a wondrous knowledge that freed me. What the others would not provide, I could now offer myself. And in future I knew he would guide me to further hedonistic delights. I would do anything for him.

I writhed and twisted and curled and stretched like a feline in heat. My universe had expanded and I discovered a secret that everyone, it seemed, knew but me. And now I knew also. Whatever occurred from that moment on, I would never be the same, thanks to Count Dracula.

Chapter Twenty Five

"Stand between the posts where Dr. Steward will chain you." Van Helsing sounded level, controlled, and John Steward felt he needed the certainty that voice provided for what was to come.

Lucy, naked, crossed the room of her own volition. "Yes, my Master," she said, her tone silky, not in the least aware of what awaited her. Still, she was different, softer, and John marveled at how she had changed.

The posts she had been directed to were in the bathhouse of the asylum. It was here where lunatics like Renfield were secured to the sooty cement walls for their weekly scrubbing, for without such the stench of sweat, vomit, urine and feces became impossible for the staff to bear.

Lucy spread her legs wide and stretched her arms out and up. Her curvaceous body was luscious, plump in the right places, slim where appropriate. Her long blonde hair draped down her back, stopping just short of her bright red buttocks.

While John tied her wrists and Arthur and Quincey her ankles to the posts, Lucy writhed and thrust her body forward. Her tongue darted from her mouth and flicked in John's direction; he felt his balls tighten.

"Am I to be whipped again?" she asked avidly, her nipples hard. John could smell her tart female scent fill the room.

"Not just yet," the professor said. "Your treatment now becomes prophylactic in nature. Bend as best you can so that I may examine your rump."

This was not said in the clinical tone Van Helsing was famous for, but with a deep and guttural quality to his voice that caused John to stare at him in wonder. The man seemed to have changed. Over the last few days his mind vacillated from its usual mental precision to emotional lassitude. It was clear now to John that the professor was obsessed with Lucy, more obsessed than any man he had known.

Lucy bent at the waist so that her bottom thrust out behind her like the lewd French photographs of bordello women. Van Helsing's hands slid over her crimson cheeks and she writhed against him, her eyes closed, torso gracefully arched, head thrown back in rapture. But whereas John expected the professor to examine her anus and vaginal openings, the man merely continued fondling her bottom in a lurid manner.

Finally he finished amusing himself and walked to a small cauldron on the table. Within it lay burning coals and a poker, heating to red hot. Quincey had been consulted on this treatment but apparently Van Helsing had learned all he needed to know fairly quickly. The professor removed the iron. He licked his finger and touched the end. Moisture caused the hot rod to sizzle. A small cross bar had been fashioned there, each bar no longer than half an inch.

"Hold her legs," Van Helsing instructed Arthur and Quincey with a nod. "You will secure her hips, and they must not move," he told John, who immediately placed himself in front of Lucy. He pressed her hips back as far as the restraints would permit and held them there with the pressure of his body. John and Quincey each grabbed a thigh and securely locked arms around them.

"Do you agree to this treatment, Lucy, because if you do not you are lost?"

"All that you ask and more, my Master," she panted.

"Do not close yourself to the pain," Van Helsing warned, "else the results will be less effective on the important invisible levels. We must prevent further infestation by that lowest of life forms, the vampire, and save you for the man who is able to tame your promiscuous nature."

"That is you, my Master," she said, her face glowing with pride and desire.

But that looked soon turned to one of horror. Van Helsing burned

the image of the cross into her behind. Her scream pierced the air. Her hips quaked and John held them as steady as he could, the professor ordering, "Keep her rigid!" John and Quincey both did their best as well. But Lucy's agony brought out superior strength and it took the three of them to hold her.

Urine sprayed from between her legs and watery feces from her rectum. Her unholy shrieks caused John to wish he could clasp his hands over his ears.

The professor nodded and the three released Lucy, who fainted dead away. They were instructed to throw cold water from waiting buckets onto her, both to revive her and to cleanse her body of the foul, unladylike emissions. As they did so, John, who had been at the front, could not at first locate the branded area to cool it.

Suddenly, he was startled to see the black cross poised a hair above her anus. The sight stunned him momentarily, but he regained himself enough to toss water onto that singed spot. He could imagine no place more vulnerable.

Van Helsing noticed his face and pointed his metal cane. "No demon of the night may enter by that passage now. Only lesser demons," he said wryly. "Wash and revive her and bring her to my bed chamber at once."

Van Helsing's old correctional tone had returned and yet John knew that no matter what he did, he would not be the recipient of any of that painstaking attention this night. All of the professor's time was reserved for Lucy.

John traced the burned tissue with his finger tip and Lucy moaned. He considered all the years spent in service to the professor, and then the last two submitting to Lucy's whims. None of it had the lasting impact, none of it the magnitude of this brand. He envied her this.

"There are far more exotic tortures that exist in our world, doctor, but one must submit to a worthy Master who possesses such knowledge."

They all spun towards the voice. Count Dracula filled the doorway, Mina Harker barely visible behind him, her hair askew, her eyes wide, her pink lips parted. In a moment John knew that she had fallen under the Count's spell.

"We have denied you access!" Van Helsing stated boldly, for obviously he knew to whom he spoke.

Dracula threw back his head and laughed, his long canines prominent. "Have you? And do you believe your brand is so mystical it cannot be overbranded? Perhaps your American friend will enlighten you on the intricacies of such proprietary markings."

Quincey admitted, "He's got a point, Professor."

"Silence!" Van Helsing said. "Be gone, fiend, back to the hell that spawned you."

Dracula not only did not leave, but now entered the room.

He walked to Lucy, who hung limply from her restraints, although he carefully skirted around to her front and John had the impression the brand was effective.

Dracula took Lucy's chin in his hand and tilted her face up. She moaned and struggled to open her eyes. When she did and saw Dracula, she tried to turn her head at once to Van Helsing, whispering, "My Master!" but she was being held fast.

"I see," the Count said, a dark look crossing his severe features.

Foolishly, in John's eyes, Quincey and Arthur raced to Lucy's rescue. Dracula turned on them. With a look and pointing a finger to the ground, he snarled, "On your knees, insects, where you both belong!"

They collapsed before him, Quincey lowering his entire body onto the filthy floor wet with Lucy's excrement.

Dracula walked around the room as if he owned it. John had the clear impression he was thinking something through, and the moment John recognized that to be so, the Count shot a look in his direction that paralysed him. He felt like an impudent boy, slapped for asking too personal a question.

"What is it you want?" Van Helsing said. The Professor was no fool. He held the iron out, using the cross as a shield to protect both himself and Lucy.

"You are a man of science, I one of instinct."

"You are not a man at all, but an undead monster."

"Monster perhaps, but still man, Professor, as I'm certain Miss Westenra has confided in you."

"What is your point?"

"Both of us have mastered the dark arts, that is obvious, yet I am curious as to whether or not you believe your methods superior to my own."

"Can you not see for yourself? Lucy is mine."

"Perhaps for the moment. But you cannot keep her prisoner. You must sleep. On occasion you will fall ill. You are older than she and quite likely will die first, while I, I live forever."

John could see that these thoughts had already crossed Van Helsing's mind.

Dracula extended his boot to Quincey, who immediately began licking it dry. "If we were equally matched, I would propose a contest. To see which of us can be called Master Supreme."

"Idiotic," Van Helsing said, although John could tell the idea intrigued him.

"Of course it is. A competition. The winner to reap the reward." Dracula gestured towards the gorgeous woman suspended between the poles. "The one defeated would forever more vow to abandon his quest in her direction."

"Rubbish!" Van Helsing growled. "Why should I place what I already own onto the block?"

"If one is truly Master, loss of a slave is incomprehensible. Of course, you are not my equal, therefore this concept may be beyond you. Certainly the idea of a tournament is ludicrous."

Van Helsing turned his back to Dracula, which John considered a brave act indeed. The professor drew in a deep breath. "For the sake of argument, why should I believe you would hold to such a bargain."

"I would give you my word."

Van Helsing spun around and laughed. "And what could you possibly swear on?"

"The reputation of my house is still dear to me. Vlad Tepes was a warrior whose word was honorable, of that you must be aware. In this state after life as you know it, I will not disgrace my ancestors!"

The professor sat in a chair and studied Dracula, as did John. The nobleman exuded power and majesty—John could barely remain standing, the desire to fall at his feet and join Quincey at that filthy boot very nearly overwhelmed him. Dracula's eyes were dark orbs

that seemed to swallow all the light in the room.

His harsh features indicated he could be merciless. John wondered how many he had killed in his time, in battles and in other ways, for history had recorded the legend of this infamous warrior count. He had staked thousands, punished thieves severely, been brutal to strong and weak alike. And now, in this corrupted state in which he existed, would any of the limits normal men acknowledge hold sway with this dangerous vampire?

John remembered the licking Lucy had received at Carfax, multiplied each night the Count had taken possession of her. John's rectum tightened and his penis hardened. To be punished in this way continuously, from sunset to sunrise, by one who would not respect ordinary boundaries...

Dracula turned sharply in his direction and John felt his neck and face flush. "Dr. Steward, when the opportunity presents itself, know that I will flay you within an inch of your life, or perhaps an inch on the other side of it!"

John felt the color drain from his face.

"Enough!" Van Helsing jumped to his feet. "You have proposed a competition and agreed to abide by the results. Winner take all and the loser will return home in defeat?"

Dracula's eyes smiled but his lips remained fixed. "As I said, Professor."

"And how do you see this competition? Are we to vie for Miss Lucy's loyalties?"

Dracula said coldly, "A pedestrian battle, do you not agree? During the daylight you would hold her, by night she would be mine. Any fool can predict that such a struggle would soon bore the combatants. No, Professor Van Helsing, I propose a match of a more interesting dimension."

"Then waste no more of my time and let me hear it."

The Count pulled his foot away from Quincey's hungry tongue and paced the room. "Your logic convinces you any man or woman can be swayed towards either dominance or submission, is that correct?"

"Yes, that is my theory, with certain exceptions, of course, but those are few indeed."

"On this point we agree, Professor. Lucy, of course, was a dominant, as the flesh of these three sniveling lackeys will confirm." Dracula looked with disdain at Quincey, Arthur and John. "But now she has swung to the other side, is that not so?"

"Again, sir, what is your point?" Van Helsing was growing testy and John began to sweat with nervous excitement. When the Professor was annoyed, he could be quite severe.

"Presumably your superior logic and intellect can return Lucy to her former state, or is this beyond your powers?"

The Professor paused. John knew that Van Helsing did not feel on solid ground here. Hadn't he tried to revive Lucy's cruel ways, only to find that impossible?

"Let me assure you, Professor, I can," Dracula said quietly.

The gauntlet thrown, Van Helsing picked it up. "As can I, should I so desire."

A sly smile twisted the Count's lips for a split second and then was gone, and John wondered whether or not he had imagined it. "Another example might be Mrs. Harker. Can she be swayed to either end of the spectrum?"

Mina had been standing in the corner, forgotten as usual. John glanced at her. She seemed intrigued by all that was being said. She caught John's eye and the raw passion he found there burned through him.

"She is obviously a masochist by nature," the Professor said, "but to get to that nature would require far more time than I for one am willing to commit. She is encrusted with societal rules and regulations."

"I believe she is a sadist," Dracula stated flatly.

Van Helsing laughed. "Balderdash!"

Although he had not much experience with ascertaining natural inclinations, John agreed with the Professor. If anything, Mina exhibited signs of passivity through her frustration and he did not see her in any way taking the reigns.

"Then," the Count said evenly, "you would not object if I attempt to instill masterful qualities in her."

The professor looked shrewdly at the Count. "You wish me to revive Lucy's dominant nature while you inculcate the same in Mrs.

Harker. I believe I know where this is leading."

Dracula nodded.

"All right," Van Helsing said. "How much time do you require for preparation?"

"An hour, perhaps two."

Van Helsing looked a bit jolted and John saw he had anticipated more than one evening would be available.

"Unless, of course, you feel your work will be the more substantial," Dracula taunted.

"I need no more time," the Professor said. "Dr. Steward will arrange an arena, if you are agreed."

"Excellent. Before sunrise we shall know the outcome. Are you prepared to live with the results, Professor?"

"It is you who should be prepared to exist with what will surely be your defeat."

"Defeat," Dracula said enigmatically, "takes on an entirely different meaning when one has lived many lifetimes."

Chapter Twenty Six

The Count took me to a grove close by the asylum. As we sat under a budding birch tree beneath the night sky, I lying in his strong arms, enfolded in his dark cape which obscured even that moonlight, I felt engulfed as in a womb.

I heard my own breath and only one heartbeat. My bosom was exposed within this larger encasement and he stroked and cherished my titties, drawing sighs from my lips. Juices flowed between my legs, aromatic, sweet and wondrous, and I felt secure in the knowledge that I, with Count Dracula's help, could satisfy my growing longing. As I drifted into a somnambulant state, sounds filled my being, words that I could not readily understand. The whisperings of ghosts on the wind filled me, penetrated me, directed me.

How long we stayed thus, I cannot say. But suddenly he roused me to my feet and we were walking back to the stone fortress that housed the insane. And Lucy. Truly she had become an obsession, I realized to my consternation.

He led me down past the basement where the confrontation with Van Helsing had transpired. We descended narrow stone steps, with a low ceiling. The air warmed considerably and the walls were moist. The scent of earth saturated my nostrils and as I clung to the walls for support I felt something scurry across my fingertips. My breasts were alive with sensation.

At the lowest level under the building, we walked down a corridor to a room at the end lit by lanterns. Within was a square cell

made of intersecting wires, situated in the middle of this chamber. Around the outside of the box-like cell five chairs had been arranged.

Van Helsing stood in one corner of the room with Lucy. She wore a long rose-colored cape. That and the diffused lighting gave her cheeks a peaches-and-cream glow. For some unknown reason, that irritated me. Dr. Steward, Mr. Morris and Arthur Holmwood were also present, and strangely enough Mr. Renfield, his hands bound together in front of him. All turned as Count Dracula and I entered.

Dr. Steward joined us immediately. "The Professor felt it would be fairer to have an impartial bystander make the selection than someone more intimately involved. As there were no impartial persons on the premises whose discretion could be counted on, I took the liberty of asking Mr. Renfield to select an assortment of tools; in exchange, he has requested that he may be present for the event." Mr. Renfield would be discrete, I knew, because no one would believe him if he wasn't.

The Count nodded assent to the arrangements.

The door to the cage stood ajar and Dr. Steward escorted both Lucy and myself inside. "Undress, please," he told us. This I hadn't expected. Instinctively I turned to Dracula. His dark eyes bore deep into me, reassuring me, commanding me. I was not aware I was undressing until my skirts fell to my ankles.

I removed my shoes and stockings as well and turned. Lucy had only to undo the cape clasped about her throat, for she was naked underneath.

Her round body glowed in the candlelight. Her nipples stood erect, the aurora around them swollen. She looked at me with a haughty, wicked expression on her face. I knew that in the past such would have embarrassed me. Now I simply longed for the power to turn that expression into another, one that bespoke pain and submission to my will. One of humility.

"If you both are agreeable," Dr. Steward said to Count Dracula and Professor Van Helsing, "we will proceed as follows: None of the spectators may interfere. At such time as one of the participants assumes control of the other physically, restraints may be permitted. In fact, this is the natural order, for unless one controls the other suf-

ficiently, no physical restraint would work."

The Count gave Dr. Steward a stern look, and a similar look came from Van Helsing. These two dynamic men would not be lectured to on the art of domination by one who frequents the bottom of an interaction. The doctor looked properly contrite; I had no doubt that later he would pay for his sins.

"The contest shall be decided," he continued, "when one bows to the other by verbalizing the term 'Mistress'. Are there points which needs be discussed? If so, we may debate them within a reasonable time frame."

"The outcome must be determined before sunrise," Count Dracula reiterated. "Other than that, I have no restrictions."

"Nor I," said Van Helsing.

"Ladies?" Dr. Steward asked us, gathering our clothing in his arms.

"No, John," Lucy said coyly. That very flirtatious quality which had so intrigued me in the past now brought my reproving nature to the fore. This girl needed governing. Obviously Miss Whippet and Dr. Van Helsing had failed; it was left to me to do the dirty business.

Before I could answer Dr. Steward, Lucy lunged. She grabbed my hair, twisting it in her fist. A fire seared my scalp and I screamed. She swung me around and slapped me hard across the face, then backhanded me the other way, her nails raking my skin.

I clutched her free arm and twisted it behind her back. The pain of my hair being pulled was nearly unbearable, but I would not succumb. I slapped her bottom, the crisp sound resounding throughout the hollow basement, interlaced by John's cries, "We have not yet begun!" to which the Count replied, "You are, as always, redundant, Doctor Steward."

Chapter Twenty Seven

As John took his seat between Dracula and Van Helsing, the sharp sound of flesh against flesh rang through his ears. Mina had freed her hair, although Lucy still clutched a large clump of it in one hand. Lucy's arm were now pinned back behind her. Mina's bare hand came down loudly on those quivering ass cheeks. John, wedged as he was between two powerful masters both of whom were now displeased with him, felt caught in a vice of tension. The danger was palpable.

"Does this remind you of anything, Lucy? Of secrets shared and pleasures forbidden?" Mina asked in a voice so low John wasn't quite sure of the words. Lucy, her back and reddening cheeks in clear view, twisted and turned and quickly threw Mina against the cage wall. Mina bounced off the wire and was shoved onto the floor. Blonde hair flying, Lucy was on her in a second.

The revived fiery nature of his former Mistress excited John. He knew how quickly she could move, how extreme her actions could be. He envied Mina as Lucy straddled her, facing her feet.

Lucy reached for a paddle the size of a large wooden kitchen spoon but flatter, from an array of implements Mr. Renfield had strewn around the periphery of the cage. This she used to beat Mina's behind. The slimmer woman, unaccustomed to such quick and immediate pain, squirmed and struggled hard to throw her oppressor.

But Lucy was hell-bent on winning. Her weight squished Mina

against the floor. John wondered how Dr. Van Helsing had accomplished this reversal in Lucy. He'd heard only some of the words spoken, and knew promises had been made, promises of a later fulfilment Lucy obviously craved, as evidenced by the vigor with which she applied the heavy wooden spoon.

Mina cried out and dug her nail into Lucy's thighs. Blood flowed from the angry red gashes. Finally Mina grabbed Lucy's long tresses and threw her off.

Rage darkened Mrs. Harker's face. If John could have interpreted the look it would have been along the lines that Lucy was about to receive a large dose of a very foul prescription.

Both women were dusted with the dirt from the basement's floor. The brown silt only added to the appeal of their bouncing, juggling tits and behinds.

Mina tackled Lucy and ripped the paddle from her grip, but then was instantly retackled. Lucy, who had always favored implements, wrenched the spoon back from her hands. She used this on the fleshy parts of Mina's shoulders and on her breasts.

"Miss Whippet taught you well," Mina gasped as she struggled, "but you are in need of a refresher course." By a curious twist of fate, Lucy lost her balance and toppled sideways for no reason John could see. Mina got her chance.

She wedged Lucy between the wall of the cage and controlled her with body weight alone. She sat atop the prone Miss Westenra, who suffered beneath a short thick prod used in the asylum to goad inmates into a particular area. Mina, however, used it as a rod with which to whip Lucy. As Mina whacked her mercilessly, she said, "You want discipline, Miss, and you want it badly!" Lucy's face looked shocked, then ecstasy suddenly laced the agony. Her eyes appealed to Van Helsing's for understanding.

John glimpsed the Professor out of the corner of his eye. A man who abided by the rules, the Professor said nothing. He gave her no instruction. But the intensity of displeasure emitted from that stern face chilled John. Lucy felt that displeasure even more than he did. He could see it in her eyes—the helpless look of being trapped between two desires. She wanted to give herself over to the paddle, to live with it and allow it to control her completely until it became

part of her. Her other, stronger desire was to please her Master, knowing that in the long run his paddle would be the more enduring.

With a strength that seemed to John inhuman, she shoved Mina away. In seconds she was on her feet. Muted brown matted her glowing bottom and the combination of colors excited him. It suddenly occurred to him that he had never been punished while lying on the ground, tasting the bitter-sweet soil, letting his tears turn it to mud that he lapped and sucked as he was flogged against the dirt, his cock fucking the earth itself.

The women struggled hour after hour, their bodies glistening with sweat, for the basement was a peculiar mixture of both cool and humid. Their scents permeated the air, firing the excitement of the men. Dirt streaking their vibrating bodies darkened from the moisture. Light and dark hair flew about until they both looked like wild creatures, elementals, in a battle that would decide the fate of the world.

And all the while John pulsed and throbbed from the danger he sat crushed between. His behind perched gingerly on the edge of the chair and twitched involuntarily from the memory of past punishments. Sweat rolled down his back and he loosened his collar with trembling fingers. His heart pounded with fear and the longing to be used and abused by these women and by either man or monster and, when he was truthful with himself, by all simultaneously.

Chapter Twenty Eight

Lucy called me "Betrayer" and used the foulest language, for example, "Bitch" and "Cunt" and other words of the gutter that I had not heard before and yet instinctively understood from their vaguely onomatopoeic quality. Yet they did not bother me. It was as though I were an entirely different person. My old inhibitions had dropped away and I no longer felt shy and fearful. I was encased in the strength of my Master, as if his own powerful nature were within me, guiding me.

Lucy had me pinned in a manner which trapped me on my knees. She bent me back, one leg locked around my throat while she imprisoned my hands between my legs and up behind me. Helpless, I could only lay there as she tortured my titties with a diabolical wooden implement. She tweezed and plucked and pinched and twisted as if she would pull them from my body. I howled in a delicious agony and struggled to free myself. In a frenzy of pain I jerked to my side and she shoved several of her fingers into my bottom hole, hard, as far up as she was able. Now she had gone too far!

My teeth clamped onto her upper arm and I bit down. She screamed and I felt something beneath her skin tear. I tasted blood, coppery and flowing, but with the thickness of a fruit liquor. Warm, it cooled quickly in my mouth.

Lucy thrust me from her. The blood had somehow given me renewed energy. I grabbed her long hair and shoved her into the wire wall. I could see from the excited looks of the men that her features

were distorted from being mashed against the wires. Count Dracula appeared pleased. His dark eyes shot red sparks in my direction and my energy surged.

"From your response, Miss Westenra, I see a fortnight of paddling would suit you better!" I knew not from whence these words of wisdom sprang, yet recognized them as the statements of the illustrious Miss Whippet. "You submitted first to a woman, and submit again you shall, as is the natural order of things." Without hesitation, I banged her face into the wires repeatedly.

Van Helsing jumped to his feet. About to cry out, he managed to restrain himself as I mangled Lucy's lovely features for her. He sat again and I felt triumph swirl through me.

My actions coupled with the Professor's inappropriate response had the effect of crushing more than Lucy's nose. When I pulled her away, she looked bloodied and defeated, and I knew that most of that latter reaction was caused by Professor Van Helsing himself. I threw her on her back and jumped on top of her. I captured both her wrists above her head and my lips found hers, which were smeared with blood.

"Humble yourself, Lucy, for you cannot best me. We have known one another far longer than we have known this inferior gender. It was Miss Whippet you first gave yourself to so freely and it is me to whom you shall submit now."

There seemed little fight left in her. I did, however, feel a longing seep from her pores. She wanted to please me, to obey me, to endure the pain and pleasure I would grant her. I felt the strength of her desire and recognized it from my yearning for the Count himself. Secure in the knowledge that I could leave her sprawled where she was, her voluptuous body heaving, painted with dirt and blood, I scanned the row of implements Mr. Renfield had so judiciously selected.

When I returned, I carried a length of hemp with me. I dragged Lucy to the wall facing the men and positioned her so that she directly faced Van Helsing, with Mr. Renfield at his feet, cheerfully masturbating himself. She whimpered and glanced at the Professor. His features were horror stricken, his eyes flecked with fury. Emotion had made him weak before her, before all of us. Out of the corner of

my eye I saw Count Dracula gloat at this turn of events.

"Kiss her goodbye, Professor," I said boldly, "for you are an impotent sort and your control deflating. Lucy is mine now, as she has always been, long before you arrived." The words coming from my lips sounded entirely unlike me, as though I were possessed. And yet this voice spoke of my own secret cravings.

Once I'd bound the proud Miss Westenra, ankles and wrists spread and tied together where the cage met the ground, her bottom rose into the air for all to see. Her defeated face and chest were pressed deliberately into the dirt. I selected a very small whip. I do not know how I knew the impact this one would create, yet I did. I seemed to have tapped into some universal wellspring of knowledge that was far beyond my own personal understanding.

The whip's handle was but four inches and the dozen leather strands connected thereto hung about six inches each. A pure white ladies whip, I thought, properly used on a lady's behind to renew her virtue.

"I will whip you until you announce to whose authority you will bow. Until that moment occurs, you may express your agony in any manner you wish, as it will only evolve into pleasure when the proper answer is obtained."

I had encased her waist with ropes, tied far up the wire wall. This had the effect of forcing her to hold her bottom high for ease of whipping. I knew the position was uncomfortable, but that made it all the more interesting.

I stood behind her and brought the whip down hard on one cheek of her already pink buttocks. Immediately a dozen red lines appeared. I lashed the other cheek as well. More lines surfaced. Without pause I lashed each cheek in succession, carefully separating the strands after each strike by running my fingers through them. Within moments Lucy was breathless from screaming.

The quiet whip left a loud impression. The lines created a pattern and I struggled to aim my blows so that the design on one cheek mirrored the other, like a child making ink blots.

Her body heaved and twisted and she struggled to lower her flanks to avoid my implement of correction, but cleverly—and again I knew not from whence this knowledge came—I had bound her in

the most dramatic manner and she was stuck.

The picture I painted took on a shading of colors, from pink to purple, the dominant hue red. The lines crisscrossed and fanned out across her derriere, the darkest colors on the outside of the pattern. I altered my position so that I could achieve the fan effect from the bottom up and the sides in as well. As I whipped to my heart's content, above her pink hole I noticed the mark of the cross. Van Helsing was such a simpleton. Once my Master, Dracula, reclaimed Lucy, that mark would soon disappear under another brand. I envisioned the center bar turned into a D by the addition of a semi-circle from top right to bottom right, and to the left of the center bar a C. My Master would approve of this design, I knew.

I paused once to insert my index finger into her anal canal and my thumb into her womanly slit, and squeezed them together hard. Lucy shrieked and begged me to cease, but the act was so pleasurable, particularly her response, that I felt inspired to do it again before I resumed whipping her.

My arm felt surprisingly strong. I could continue this chastisement indefinitely, or so it seemed. My body spun in a rhythmic motion, twisting and turning and bringing the lash down with a force I did not know I possessed. Each stroke built a delicious tension within me and I became lost in a pleasurable maze of my own physical sensations. The whip and my hand were no longer separate but one, Lucy's bottom the foot that snugly fit my shoe.

"Stop it! Stop it now!" Van Helsing was on his feet, as was Count Dracula, a look of the conqueror permeating the latter's features.

Lucy was virtually screeching, "Mistress Mina, spare me, Mistress, I am yours!"

Within seconds the Count opened the cage and tore the ropes holding Lucy from the wires. He picked his prize up in his arms. His eyes did not connect with mine and I felt frightened by this, yet in some way I also felt assured that he approved of my victory and the manner in which it had been carried out.

He strode from the room, I on his heels. Professor Van Helsing picked up a pistol, loaded no doubt, and aimed it at us. It was the madman Renfield who jumped to his feet and knocked against the Professor's arm, crying, "Sir, you may hit Lucy, or Mrs. Harker!"

The bullet's discharge in the small hollow chamber was deafening. It ricocheted around the stone walls and I knew not where it struck until I heard Lucy cry out.

Dracula turned, a sneer on his lips. "You can neither win nor lose graciously, Professor. Lucy is mine now, won fairly by your so civilized rules. I will save her from the death you intended for her. I suggest you learn from your errors. For should I see you again, I will not be so gentle. Next time it is you who will be carried off in my arms!"

I struggled up the narrow stairs behind him, Dracula taking four at a time, I barely keeping up. Outside the wind wailed furiously as if commanded by his approach. Trees with new buds snapped wildly about and it felt as though a violent storm brewed. Although dawn was near, dark clouds enshrouded the sky making it seem closer to midnight.

"Master, shall we return to your homeland now?"

Dracula deposited Lucy, who swooned, into the back of a waiting black coach with four enormous plumbed black horses. He turned as if remembering me after having forgotten I was there. Firmly he cupped my chin in his hand and turned my head so that my neck and the wounds he had honored me with were visible. "If time permitted," he said with regret, the tips of his incisors glinting in what little light the sky offered. My body burned to be penetrated by him.

"You will remain in England."

"But Master," I cried, "I cannot bear existence without you. Why must I stay?"

What blurted from my mouth produced a look of censure on his face, as if I had no business questioning him. Immediately I shrank back, but he grabbed the back of my neck and pulled me close; his breath cooled my cheek.

"You will stay because I command it. Await the return of your husband. If you cannot satisfy his longings, at least learn to satisfy your own. For then you will be prepared for me, and only then will you hear my call and come to me."

Knowing that I would not be sated this night, knowing that he was leaving, abandoning me to these incompetent mortals filled me with despair.

As my Lord of Darker Passions raced off into the night, cracking

the whip over the heads of the wild-eyes horses, something within me shattered. A fragile bond had been nearly severed. And why? Suddenly I knew the reason: Jonathan. Dismal fate had mated me to him, else I would be with my true Master now.

The rain fell, chilling my bones, washing the mud from my body as well as what lingered of his touch. The quantity of the downpour barely exceeded that of my tears.

Chapter Twenty Nine

"It is finished," Arthur said. "Lucy is dead."

"No," John cried. "The bullet entered her shoulder. I do not think she will die."

"Not that," Arthur said, "but dead because she is with Dracula."

"She's still among the living," Quincey reminded him.

"Lucy is dead to me," Arthur said firmly.

"Silence!" Van Helsing looked enraged. He paced like a caged carnivore waiting for an opening so that once again the beast could roam free in the world.

As the Professor paced, John realized he had never felt such a magnitude of emotion coming from the man. Emotion that had done him in. It had been more Van Helsing's display that weakened Lucy than anything Mina did, or the bizarre and cryptic messages she whispered. Lucy's very foundation of strength had eroded. Van Helsing had failed her.

Many things could be said of this Count Dracula, but the control he exercised on his passions had subjugated what had been the greatest Master John knew. The loss made him sad and also frightened, for his world view had forcibly altered.

Suddenly Van Helsing stopped cold. He looked at the others one by one, a hard kernel of something unshakable blazing in his eyes. John felt galvanized and knew that Arthur and Quincey experienced the same thing.

"Gentlemen," the Professor said calmly, "pack your valises immediately. Tonight we leave for Transylvania!"

Part Six: Reunion

Chapter Thirty

I arrived back in England on a crisp morning and took the train to Whitby. Mina was still staying with Lucy, as far as I knew, and I expected to find her there. What I did not expect was to find her alone. And in a state.

The door of the manor was opened by a tall slim fellow who identified himself as Hodge, the butler, a sober-looking chap. I found my wife in the parlor, seated tensely on a sofa staring out at the fields behind the house that lead to a wooded area.

"Mina," I said.

She turned, a startled look crossing her face. Almost immediately it shifted to anger, which she made a feeble attempt to disguise.

"Jonathan," she said, as though she'd seen me just yesterday. She looked pale, under duress, her features streaked with bitterness and disappointment. I wondered how I'd ever found her attractive.

Still, I opened my arms and dutifully she entered them, her body rigid. On her throat I saw two raw wounds, the mark of the vampire. She pecked me on the cheek as though the job was distasteful.

I found this a far cry from the luxuriously decadent experiences of which I had so recently partaken. After an absence of several months, it seemed to me that a more extravagant greeting was in order. I felt annoyed with her, which colored my words. "Mina, I take it you were expecting me."

"Not at all," she said, breaking off the embrace to return to her seat by the window. She looked across the field as if pining for some-

one who had just left by that route. "Not having heard from you in two months, I expected nothing."

"Of course you've heard from me," I reminded her. "I received the funds I requested, and your letter about Lucy's condition. You must have received mine."

She gave me a peculiar look. "I don't know what you're talking about with regards to a letter from you, as I've received none. Of course I wrote. A wife writes to her husband. You simply did not answer."

I sighed and went to sit next to her. She moved away as if I were a stranger making unwanted advances. Either she was playing some sort of silly game with me or else she had not sent the money. But then how did I get her letter? It could have been forwarded from the castle, but no one there knew I was at the Sanctuary. Or did they? And there was the possibility the letter had been intercepted.

I looked at Mina's profile. There seemed no reason for her to lie, but she was acting strangely.

"Well, we can sort this out later," I said. "For now it's enough I've returned and we are together again." But if truth be told, I felt unhappy at the idea. It suddenly occurred to me that I had made a serious mistake marrying this girl. What had I seen in her? Any potential had dried up over the last months. But, of course, I was no longer the same man who had left her in London to sell real estate to Count Dracula.

"And what of Lucy?" I said, hoping a more innocuous subject might alter her mood. "How is she?"

"Gone."

"Gone? You don't mean she's dead."

"Of course not!" Mina snapped. "Nothing so hopeful."

I'd never heard such hostility in her voice.

"She's gone to Transylvania, with the Count. Her lovers have followed her there, as well as Professor Van Helsing, a specialist called in to treat her so-called 'condition.'"

"I see," I said, although I did not really see much, other than that Lucy was in the hands of the Count. A small smile slid over my face at the image of the petite, petulant Miss Westenra, so dominant that at times she was overbearing, submitting to the Lord of the Undead.

And I had no doubt that she was submitting to him, on all counts.

Mina noticed my smile and challenged me. "What's so funny, Jonathan?"

"A simple thought, Mina, about Lucy," I said, trying to placate her as I had done in the past and yet I felt my own impatience rising.

"Lucy!" she cried. "Must everyone always be concerned with Lucy? What about me?"

Before I could stop her, she ran to the fireplace and grabbed up a handful of birch branches. I hurried to her, trying to calm her, but she turned on me, whipping my face with the switches.

She seemed possessed. I was stunned. Like a madwoman hellbent on cutting me to shreds, she tore my jacket from me and stripped my shirt to the waist, then lashed me mercilessly with the hard switches.

The branches cut the skin on my chest, arms and stomach, leaving red lines that bubbled with blood. She was a slim woman, but fury lent her power. All the while she beat me, I watched her, coolly analyzing what was before me.

Mina lashed out wildly. Her eyes looked deranged. Her body twisted in a frenzy of violent emotion. The switches splintered and broke apart and still she whipped me with their remains, as though I personified all that frustrated her. And indeed, she was permeated with frustration.

The pain streaking across my flesh paled in comparison to the pain pulsing from her body. The more anger she felt, the harder she whipped, the harder she struck, the more volatile her feelings. And yet this exorbitant emotional display showed no sign of abating.

She worked herself up into a state of hysteria, screaming, frothing at the mouth, her eyes roving wildly. The moment I realized this was leading nowhere, I became afraid for her. I grabbed her wrists. "Enough!"

Mina threw her head back and let out a howl that sounded like a doomed animal. I could hardly believe my ears.

"Let me go!" she shrieked. "Don't touch me. Don't ever touch me again! I belong to Count Dracula, and him alone."

"Mina, you don't know what you're saying."

"I do. I am going to him. Tomorrow."

Crying uncontrollably, she broke away and raced from the room, leaving me standing with a chestful of wounds and a heart wound much deeper.

What had happened to Mina, I could only guess. How had she come to this state? Granted, it was preferable to the diluted creature who had greeted me, and yet this was not behavior that appealed to me. Had her frustration lessened, I could have withstood the storm. It was as though a bottomless cauldron of ire raging within, feeding the torment, being fed by the torment, and so on, and would never subside. I knew as well as I knew my own name that the Count had used her in some despicable manner for his own purposes and that was the root of such insanity. Yet what to do about it, if anything, eluded me.

But I also felt self-pity creeping in. What was I left with? A wife who resembled a faded rose, or one who was all thorns? I wanted neither.

"Sir?"

It was Hodge. "Yes, what is it?" I asked, too distraught to do more than right my shirt.

"Much has happened of late and I have had my own observations. If I may speak freely, sir."

"Please do."

We spoke for the next hour, after which much that had confused me on arrival became crystal clear.

Chapter Thirty One

Jonathan. Thinking about him enraged me. How I despised him! He was weak, unbearably so. Not like Count Dracula, who thrilled me with his power. The Count understands what a woman needs.

I had made up my mind; tomorrow I would leave by train for Transylvania. It was a frightening action and I didn't know how I would travel the rails alone, for I had never heard of a woman doing so. Even Lucy would not engage in such an activity, except in England and perhaps France, but never through some of the more primitive countries en route between England and Transylvania.

Lucy. Her very name drove me insane. She had everything, I nothing. I blamed her, perhaps unfairly, for being at the core of my frustration. Ever since my arrival at Whitby, Lucy had taunted me, driven me to a pitch and yet allowed no release. But not her only. The others conspired as well: Dr. Steward, Arthur, Quincey, Professor Van Helsing. Even Verna contributed. All but Count Dracula, who raised me to such heights as I had never before reached.

I refused to stay with Jonathan. He was not a man but a boy, incapable of satisfying me, and I did not wish to waste my life being unfulfilled.

If I was destined to share the Count with Lucy and all the others in order to gain release, then so be it. I would reside in a harem, one of many women and probably men that the Count favors with his attentions. Something is better than nothing. Jonathan be damned!

When Jonathan joined me for dinner, he acted as though nothing

out of the ordinary had occurred. His face was marked from the switching I gave him. Would that I'd had more and younger branches and he would have been left with no face at all!

We sat at opposite ends of the long dining table while Verna and Hodge served us a mutton stew with fresh bread and sweet butter. We did not speak until dessert, when Jonathan began to talk about his trip.

"I must tell you, Mina, it has now been my experience that there is much to be learned from other cultures. I think we in England tend to feel we are the most advanced nation on the face of the earth, but this is not so. Others have knowledge we might call primitive, and yet it holds a wisdom all its own which in the end is greater than what we know in our minds. I expect I will be going on business trips several times a year in future and hope to glean new ideas in my travels."

I sighed, bored with him and his heady recipes for wisdom.

"I feel a headache coming on," I said. It was a lie, but I loathed being in his presence and preferred my own company.

"Before you go," he said, standing, "I think we should discuss your trip."

Leave it to Jonathan to discuss my 'trip' as though it were a visit to the market and not a trek half way across a continent.

"I don't believe there is anything we need discuss," I said curtly.

"On the contrary, Mina. Of course, you realize the dangers involved in traveling alone, once you leave the more civilized landscapes."

I had not wanted to dwell on this. In fact, I was afraid. Women just did not travel alone through much of the world. And yet, what could I do? "I shall manage," I assured him, although I could not assure myself.

"As we are still married, it is my duty to accompany you."

"I'm afraid that's not—"

"Mina, I insist. You do not know the route and I do. You are still my wife and to this extent I shall be responsible for you. Once delivered to Castle Dracula, you are on your own. This will eliminate both of our worries and perhaps bring an amiable end to our relationship."

While I had an immediate resistance to such a plan—and the idea of traveling with Jonathan for a good ten days did not at all appeal—still, I saw the merits. I was obsessed with Count Dracula, even I knew that. And yet I was still practical enough to realize that accompaniment on the journey would expedite matters considerably. I spoke no foreign languages, while Jonathan spoke several, or enough to get by. Purchasing passage, food, shelter, all of it would prove extremely difficult.

And truly, I owed him the time. After all, we were wed, if in name only. Any remnants of guilt I felt about leaving him would surely be washed away by being in his company for a prolonged period of time. He could not sway me. And he was too reasonable and passive a man to attempt to demand anything in the way of marital rights from me. It seemed the best solution.

Jonathan looked relieved when I agreed. "Good," he said in his tolerant manner. "I shall be in charge of all the arrangements, if that is agreeable to you."

I nodded.

"What time does the train leave for London?"

"Eight in the morning," I said.

"Right. I shall sleep in the other guest room and see you on the morrow."

He left the room without further ado.

I must confess to a foolish feeling. A sliver of disappointment imbedded itself in me that he should let me go so easily. And yet I knew that was silly. Jonathan was not made of the right stuff, at least as far as I was concerned. He couldn't help it. He was weak and it was his nature to avoid going against the grain.

Again, I realized how empty my life with him would be and felt renewed in my decision to find Count Dracula. He was my only hope.

Chapter Thirty Two

Our train left Whitby Station on time and arrived in London at 9 a.m. I persuaded Mina to stop off at our home, although she was against it, imagining quite likely that I would use force to imprison her there. Nothing could have been further from my thoughts.

While she packed the steamer trunk—for finally common sense prevailed and she realized she would need clothes—I went to the bank and did a few other errands, including shopping in London's more notorious neighborhoods. By noon we were on the train to Dover.

The trip across the English Channel proved pleasant, for the weather was clear. I stood at the fore rail inhaling the sea breezes as they coursed through the narrow passage that is the closest link between England and the Continent.

Mina stayed inside, avoiding me, I could tell. Finally we arrived in France and boarded the train for Paris. We arrived at La Gare Centrale in time for dinner but decided to buy a picnic lunch and take it with us so as to continue on, travelling overnight, which was to my liking. I purchased tickets to Barcelona, with a stopover in Carcassonne, near the Spanish border. That town provided a large English-style hotel where we could spend the following night.

Mina and I arranged ourselves in the first-class compartment as the train pulled out of Paris. At some other time I would have enjoyed a night in Montparnasse, but for now that would have to wait.

At the outskirts of the city, the ticket taker opened the compartment door to collect our tickets, which I held. As I handed them over, I told him in French that we would like to be alone and inquired if there was a way to arrange that. With a wink, he assured me a sign on the outside of the door would alert everyone that this compartment was unavailable and would see to it immediately. That suited me.

Mina sat primly on the edge of the long seat opposite, for the compartments could hold six adults easily. She stared out the window but her mind was elsewhere. Her body was rigid, her face set. If she had been tense yesterday, today she resembled in spirit a band pulled so taut that it might snap at any moment.

"Mina."

She turned her head to stare at me with vacant eyes. The circles beneath them had widened. Obviously she had not slept well. I, on the other hand, had slept like a log, anticipating the journey ahead.

"I'm curious," I said. "Count Dracula. You know he is a vampire. He has taken your blood. Do you resent him for this?"

I knew full well the feelings she would have, as I had been a donor myself.

"Of course not!" she snapped. "If I felt that way, would I be anxious to reunite with him?"

"Perhaps not. But perhaps. After all, he has abandoned you."

She gave me a disgusted look, as though I were a fool incapable of understanding the obvious.

The train had reached a good speed. The rattle and bang of the steam engine, the clanking of the wheels against the track, the whistle blowing, all of these sounds combining made conversation difficult if not impossible. Besides, Mina had closed her eyes, perhaps from exhaustion, possibly to avoid further discussion with me. I used the opportunity.

I opened the overnight bag on the seat beside me which I'd brought from London. Inside, next to the comestibles, were items I had purchased. I took out a rawhide loop, shaped a bit like the alchemical symbol of infinity, although there were in fact two distinct pieces of leather involved. Each ovals had one loose end that went through a leather bar in the center with a hole in it. By pulling

the two loose ends, the ovals would tighten.

Although Mina appeared to be sleeping, I knew that the slightest touch from me would wake her. I moved quickly.

I slipped one oval over one of her hands and pulled both of her arms behind her back.

Her eyes flew open. When she realized what was happening, she struggled. But by then, I had the second oval around her other wrist. At that point it was easy to pull the loose cords and contract the ovals, effectively binding her wrists together.

"Jonathan, what do you think you're doing?"

"A woman of your intelligence should be able to figure that out."

"I demand to be released this instant!"

As I reached into my bag I said, "Your demands no longer carry weight with me, Mina. However, feel free to make them, but know they shall not be met."

"This is an outrage," she cried as she saw the smooth wooden paddle I extracted from the bag. It was made of solid birch, a fine hardwood, long lasting. The wood had been finished with shellac, giving it a glossy appearance and a slight yellow tone.

I looked at Mina. Her eyes were large and round, as if she could not fathom just what I had in mind. And yet there was a spark to them that told me she not only knew but indeed was looking forward to realizing my intent.

I pulled her across the compartment and across my lap. She struggled and kicked at the wall facing the corridor, meanwhile calling me all the names a lady of her bearing should be loathe to utter.

Slowly I lifted the long skirt of her wool travelling suit.

Beneath were two petticoats of white cotton, and I raised those also. Her plain cotton bloomers were next. These I lowered to mid-thigh level.

What I had exposed was my wife's wholesome white bottom. I had in our short and joyless marriage never seen her naked and was delightfully pleased with the low rounded cheeks that greeted me. I ran my hand over the cool flesh.

"How dare you!" She struggled, attempting to strike me with her bound hands. I grabbed them and held them steady, meanwhile exerting pressure by forcing them down onto the small of her back

so that she could move little more than her legs.

"This is a local train, not an express," I advised her. "We will be stopping regularly to pick up passengers and to allow others to disembark. While the train is in motion, feel free to cry out—no one will hear you. While the train is in a station, however, you will be silent."

"The moment we arrive at the next station, I shall immediately call for help."

"I hope you're prepared for your help to view your bare ass."

That gave her pause. Finally she said, "I shall suffer that indignity to be free of you."

"I might remind you, Mina, I am carrying the money and tickets. There are places along this route where a woman would not wish to be stranded penniless. And how would you explain yourself anyway? You've left your husband to go where? And to reunite with whom? Think about it, Mina. The mentality of the south is to frown on such behavior. And I need not add the reactions as we head east."

She paused to consider all that I had said. Then, "You're not meaning to spank me all the way to Carcassonne?"

"I mean to give your bottom the attention it deserves all the way to Transylvania!"

She inhaled sharply and a quiver passed through her. She did, however, stop kicking the wall.

"You can't be serious," she murmured softly.

The train was slowing. We were pulling into a station already. This I had not anticipated. If Mina cried out now, the game would surely be up. But to my amazement, she kept quiet, except for further questions.

"This is jealousy, isn't it Jonathan? You are attempting to dissuade me."

"Certainly not."

"You want to punish me."

"Incorrect."

"Then what?"

"I merely wish to indulge a long-standing desire. I am not the same man who left you, Mina. The one who holds you across his knee so securely has learned a great deal from his travels. You did, if

I am not mistaken, agree to this journey on my terms."

Her voice rose sharply as the train began to move out of the station. She knew time was short and wanted to delay the inevitable. "Your terms yes, but that had to do with the arrangements. Not this."

"These are the arrangements I have made, and you will submit to them. You have no choice."

That silenced her and sent another shiver running through her body.

Once we picked up speed, the ear-splitting railroad sounds increased so that I could begin without fear of Mina being heard.

I spanked her behind briskly with the paddle, on one cheek only. Immediately her bottom began jumping into the air. This response I found satisfying. I knew the crisp bite the birch produced. The pain was harsh, not easy to take, and she did not take it well. Within seconds she was sobbing loudly, but I felt certain no one on the other side of the door could hear her.

I confess I found immediate reward for my labors. It seemed I had learned from my experiences. As my arm achieved a rhythm bringing down the paddle, I began to understand something of what motivated the Leader of the cult. I felt a glimmer of the fulfilment he must have experienced. Also, there was titillation in the sharp sound. My action produced an immediate reaction, a reaction I and I alone controlled.

The ride to the next station lasted approximately seven minutes, a disappointingly short trip. I used the time well, though, to vigorously apply the wood to that one cheek only. It reddened nicely, a sharp contrast to the white cheek, like red and white roses side by side.

As we pulled into the station, my paddle stilled. I began to rub her hot ass cheeks. Mina's sobs, however, subsided but a little, enough, though, that she wouldn't be heard by any but me, which was as I wished it to be.

While we waited for the train to move, I explored her cunny and her asshole with my fingers, assessing what each could incorporate.

Chapter Thirty Three

"Jonathan! Have mercy!" I begged him between each station to cease and if he would not stop to at least lessen the agony by giving my other cheek the same degree of attention, for to be paddled on one side only is unbearable.

The pauses at the stations were never long enough and yet they were too long. Biting pain swelled out from that one dear spot he worried until the entire cheek filled with pulsing soreness. I felt as if someone had scaled my hide. And that hide he rubbed and caressed, turning the painful scorching into warm, pleasant sensations.

And while I waited in dread for the train to move and with it the wooden paddle, Jonathan probed my openings in a cold and disinterested way.

But the moment the train reached full steam again and Jonathan resumed belaboring that wretched spot, I could not believe his passion. He was determined and had his own agenda, one apparently independent of mine. "Surely my skin will crack, if it has not already!" I cried, but he ignored my complaint and the paddle did not miss a beat.

How he controlled me! I swooned from pain so harsh it assured me I could do nothing to halt him. And between stations the licking evolved into the most delicious heat. I knew not why he was spanking me so fiercely for I could not understand his answers. And yet anguish kept me from dwelling on the questions.

I had been whipped by Verna and Lucy, but never like this! The

paddle bit me, its sharp teeth gnawing my skin again and again, leaving me raw, and nothing I could say or do swayed him. By the time we reached Carcassonne the following morning I was limp with exhaustion but at last I had given myself over to the paddle and accepted it as my reality. While that did not bring relief, the surrender did afford a peculiar pleasure and peace of mind.

My entire body rocked with suffering too sweet to bear.

My eyes had cried a thousand tears and could cry no more. And yet they were clear now and I was seeing Jonathan as if for the first time.

He had never appeared so handsome to me, so strong. His body was muscular, filled with radiant energy, as if he were a sun god, capable of whipping that ball of fire through the sky.

While he arranged for our luggage to be carried to the hotel and for a carriage, I stood passively, half my bottom alive in a way I had not before experienced, awaiting his order.

Sitting in the carriage produced tumultuous waves from my derriere that crashed through my body. I did not arrive at the hotel too soon.

Jonathan ordered a breakfast to be sent to our room. While we waited, he had me undress and sit on the bed. I complied utterly; I would have done all that he asked.

He looked to me now to be a stranger, haunting, dark in his manner, someone whose will was absolute, as strong as the iron tracks on which our train traveled and as indestructible, but that appealed to me. I was relaxed, for once, letting another lead me.

While the food was brought into our suite, I wondered if the pulsing heat from my right cheek would ever subside. I doubted I would see its end that day, not after so many hours of paddling. And yet that notion felt delicious: throughout the coming day and night I would be aware of continuous heat. Chills rippling through me.

We dined in silence on croissant, brie and black tea, although the last was nothing like the tea at home. I was naked and Jonathan fully clothed. I felt exhausted and but for the pain in my bottom could have closed my eyes and slept.

When we finished eating, Jonathan told me to lie on the bed. He undressed. I had never seen his organ before and was in awe of its

size and the power. I noticed a peculiar small gold rod dangling from the underside of his genitals. In shape it very much resembled Jonathan's own rod. I wondered if that jewelry had been there all along and I'd never noticed it. For some reason I found it exciting.

He used the curtain ties to secure my wrists to the bedstead. I knew what he had in mind and my nipples hardened as I anticipated what he would do to me.

He lay his head between my legs, which I spread eagerly. I felt heat there too. His cool tongue licked my opening from back to front, slowly. He repeated the movement, the broad rough flesh dragging over my anus and along my slit, making me quiver uncontrollably. My breath came in ragged gasps and my titties ached. When I felt I could stand his tongue no more, he used his lips to suck on the sensitive button at my front. I had not felt anything so pleasurable. He pulled and sucked and licked the fleshy nub, forcing my hips to dance and squirm, my swollen bottom growing sorer as I ground it against the stiff linen sheet. "Jonathan!" I called, his name bursting from some place deep within me, and felt embarrassed to be so loose.

Now his tongue probed inside me, my opening hungry for that implement, welcoming it's darting action. Every pore of my flesh opened, thirsty for his quenching juices. I felt I must drink long and deep or die.

Jonathan moved up my body, his organ spearing me, sliding into me fully. I gasped, penetrated, impaled, as if I hung suspended in the air, held to the earth only by his hot flesh in my tight wetness.

His thrusts were steady, sure and deep, not permitting time to adapt to them before he increased the speed, driving me to new places within myself.

I felt a place far inside expand. With each thrust, the head of his rock-hard organ kissed that spot and, like hungry lips, I opened wider. I wanted him inside me. As I acknowledged that, he drove into me fast and hard, banishing all thoughts from my mind.

My knees bent and my hips rose to meet his. Jonathan forced my ankles forward until they were above my head.

I lay completely exposed, spread before him, vulnerable to his desires, and my own. He pounded into me until I opened to him

completely and then he truly entered me.

I screamed his name, unable to stop myself. My body trembled and shuddered uncontrollably. Wave upon wave of pleasure broke over me and still he would not cease until both of us had been sated.

We slept until sunset and when we awoke, Jonathan took me again. My primed body receive his pumping and he sprayed me well with his coolant.

We slept and woke and loved again, and the next morning waited for the train to Barcelona.

"Do you wish to continue this journey with me or alone?" he asked.

The day was bright and clear. The night with Jonathan had been enjoyable but now that had faded and my longing for the Count surfaced. His face in my mind drew me as if I were being called across half the world and my destiny was tied to his.

Jonathan did not matter to me and to convey that I said, "As you please. If you wish to accompany me, I will not forbid it."

Once we were settled in our compartment, Jonathan called, "Mina! Across my lap, at once."

I sat frozen. He could not intend to paddle me again. My cheek would be sore for days as it was. And after such a night of ecstasy! He no longer looked as appealing to me but had not reverted completely to the stuffed shirt he had been.

He reached across the compartment and yanked me to him, angry that I had hesitated. Before much time passed I was laid bare across his knees once again. My bottom quivered in fear and anticipation.

"Jonathan," I said nervously, "I do not understand."

"There is nothing for you to understand. I wish to enjoy myself. I enjoy spanking you. I will spank you throughout the day, between stations."

"But... but did you not enjoy our lovemaking?"

"Of course I enjoyed fucking you. Use your head, Mina. If I didn't, would I have bothered to do it more than once?"

"You said yesterday you will not try to change my mind. Is that still so?"

"I am a man of my word, as you well know. I assured you I would

take you as far as Transylvania. Did I not make that clear? And what does any of this have to do with anything other than that you are trying to delay the inevitable."

"Not delay," I said, although I was. "I merely wish to understand."

"Then understand this, Mina. Until we reach the Borgo Pass, you belong to me and I will do with my property what I wish. You may love me or hate me, enjoy your lickings or detest them, none of that matters to me at all. I will do as I please and you will please me."

With that the paddle spoke to my other cheek, which answered immediately. I could not believe how quickly the stinging became intolerable, and yet I could do nothing but tolerate it. And I did. All the way to Barcelona.

Chapter Thirty Four

In Barcelona I again questioned Mina as to whether or not she wished to be accompanied further.

She seemed to have entered an altered state of mind, like that of a mystic. I recognized this elevated state from my sojourn at the Sanctuary. In fact, traveling through the wine country reminded me of my visit there and the exquisite lessons I had learned. The ever-present metal lay cool against my hot balls, a constant reminder of how the Leader had charged me to not bring shame upon the Brotherhood. I took this responsibility seriously.

Once again, Mina informed me that my company would not be discouraged and as I was enjoying myself and the little tableaus I had been enacting with my wife, I decided to continue.

Mina and I boarded a Turkish boat that would carry us through the Mediterranean to Istanbul. We could have gone overland the entire way by the Orient Express in half the time, but this route seemed more interesting to me and I had a sense I'd been here before.

As it turned out, the trip was rewarding in a different manner.

The boy who moved our baggage into our cabin dropped my overnight case and the paddle fell out. When he saw it, he stopped in his tracks. His almond-shaped eyes widened. I did not speak his language but understood enough of his gestures to know that he wished me to accompany him.

Down in the hold I met a small group of Turks playing a game

much like dominoes. The boy said something to them. The four men looked at me curiously, nodding in silent approval.

Finally one stood and retrieved a parcel from beneath his bunk. There were two objects, one long and slim the other short and fat, both wrapped in soft brightly colored chamois-type cloth. He unwrapped the longer first. It was a cane about four feet in length, made of split bamboo. I'd heard of the bastinado, of course, and knew exactly how it was used, but never expected to find one. Mainly it was a tool of torture, used on prisoners. The soles of the feet would be swatted softly for hours, causing the bottom of the feet to swell. The moment I saw it I knew I must have it. The other, smaller object, was one I was not familiar with, at least this particular type. The men, through elaborate hand gestures, indicated its use. This, too, I knew I must have.

Through a complicated translation from the Arab dialect through the fractured French one of the men spoke, I was able to purchase these two implements for a reasonable sum. Delighted, I carried my prizes back to the cabin, there to find Mina asleep.

She lay sprawled naked on the cot on her belly, her glowing bottom a testament to my skill and fortitude. I had found paddling her today even more exhilarating than the day before. Her bottom intrigued me, how the skin quivered and shook and altered color to the tune I played. This activity spoke to me and I felt as if I had at last identified my calling as a musician of sorts. The tortures I had suffered at the hands of the Count and the Leader had not been wasted. Those rituals of pain had matured me and I was ready to take my place alongside those two brilliant masters as a artist in my own right, an artist eagerly perfecting his craft.

I looked at the woman lying atop the cot, most of her flesh white and creamy, her bottom as hot as two red radishes. Her long dark brown hair lay strewn across her back and the pillow—on entering Spain, I had insisted she wear it down from now on and cease constricting it into the old-maidish style Mina favored.

When I had ended today's licking, Mina looked at me with large and liquid-filled round eyes. She appeared so vulnerable, so pried open. Nearly all of the despair that had permeated her being had vanished from her face, which was relaxed and soft now. Even her

lips seemed fuller as they parted in an open, receptive manner. She glowed with a beauty I had not seen before, partly, I think, because it had not been brought out. It forced me to confront my errors of the past. My weakness had been a bane to her, my leniency and moderation like a wall that moved back as she leaned against it. Rather than supporting her, I gave way.

Of course, Count Dracula had provided her what I could not. Until now. And although I had discovered my own strength, it was too late. Mina would be lost to me in only a few days, and yet I could not keep her prisoner.

I unwrapped the items and lay them on the steamer trunk. Shortly I may not have her, but I had her now. And I would make good use of the time remaining.

The smaller object was eight inches long, made of a fine-grained exotic wood. Shaped like an English cucumber and about as thick, it was composed of slates of wood interspersed with narrow openings, like a circular picket fence. One end was round, the other flat. The flat end contained a key and a metal ring.

The Turks had given me leather thongs, and I tied three to the ring.

I pushed Mina's knees under her, so that her glowing ass cheeks parted and lifted into the air. Exhausted, she moaned softly but did not wake. I knotted a forth thong securely about her waist.

I was entranced with her openings. The mysterious crack that led from those plump moist lips into her tight hot cunny. Even as I watched, the shiny wet lips glistened in invitation. I would visit them again soon. The crack also led to her puckered hole, a pink island in a boiling sea of red, compressed, virginal. It was here that I had my work cut out for me.

I picked up the smooth wooden plug and placed it at her opening. Mina still slept but another moan escaped her lips and that puckered opening contracted, as if she intuited what was in store for her.

Slowly, over the next hour, I wiggled the wooden penis inside her. Her anus was tighter than I had imagined, but consistent pressure moved the plug further until it was half way in. I found the process delightful and did not mind spending the time. Mina groaned and cried out in her sleep but a smile spread across her face. She mur-

mured and I bent low to hear her call my name.

But the name she called was 'Dracula!'

Infuriated, I forced the plug all the way in. Mina woke screaming. She was disoriented and while she came to her senses I tightly knotted the thongs from the ring to the one around her waist, holding the Turkish dildo securely in place.

She tried to move but I wouldn't let her get out of that submissive position yet. I turned the key at the end of the plug until she cried out again. The beauty of the instrument is that its slats expand; a marvel of ancient mechanics.

I ordered her to kneel, punctuating the command with a sharp smack to her bottom. She knelt bolt upright. I could see from her face that the plug was uncomfortable, which delighted me. "Count Dracula indeed!" I said. "Hands behind your back!" She may end up in his arms, but not before I was through with her.

Shoulders back, her breasts jutted nicely, the nipples swollen and offering themselves for my pleasure. I took one into my mouth and sucked it firm, whipping it with my tongue, nipping with my teeth. Mina's body spasmed. Her head fell back, and she moaned, partly from the stimulation my mouth provided and partly from the wooden shaft invading her rectum.

My inclination was to spank her again. But that would be less than satisfying as she had so many new sensations to deal with, and besides, her bottom wanted time for restoration. Her response would increase if she could tolerate more and to tolerate more, I needed to work with a clean slate.

I did not waste the opportunity, though. My cock was hard and I sat her upon it. She slid down onto me easily, her cunt wet and hot and swollen. Gripping her waist where the thong was tied, I lifted her up and down. Her tight pussy gripped me for dear life. Her face flushed and her breathing quickened. Within moments she threw her arms around my neck and trembled violently.

I paused while she got her bearing, then began anew. The juices flowed from her, increasing my lust, but I had the self control to bring her to another orgasm. Her hot cunny was starved and needed proper feeding, and I intended to feed her until she was full, if only to make up for my shortcomings.

Hours had gone by. I brought her to her sixth orgasm. She complained in a half-hearted manner, "Jonathan, I'm so sore."

"And will be sorer still," I assured her.

"I cannot endure such twisted pleasures," she protested.

"You limit yourself, Mina, but tonight you will exceed your previous boundaries."

We passed the night this way, my wife protesting that she could not tolerate another orgasm and I providing one anyway, much to her delight and chagrin.

By morning she was indeed sore, as was I, but it had been worth it. Before I allowed her sleep, I gave the key a further twist.

As I drifted off, the peaceful smile on her face filled me with much love for this woman whom I was about to lose. Had I but understood my duties sooner...

I slept vowing not to dwell on the past.

Chapter Thirty Five

We were seven days into the trip and my bottom still pink from that last licking received several days before! Jonathan was cruel and yet I could not hate him for his treatment of me because secretly I craved it. Oh, the paddles and straps and his palm were no joking matter. I did not so much enjoy the pain as the pleasure it brought. For when the paddling and spanking were through and my flesh burned, then it felt good to me, and then is when Jonathan took me in the way a man takes a woman. At those times I felt completely submissive to him and gave myself over entirely as I had not been able to before. The pleasure of this passion was so exquisite that I could not fathom how I had ever lived without it.

But this thing he inserted into my most private place, that was another matter. He permitted me relief on each of the mornings and evenings of our trip, but to my horror demanded that I do my most personal toilet acts in his presence. He placed a traveling commode on the floor and had me squat naked before him over it, I struggling for balance as the ship pitched. I felt completely humiliated and would not have released anything had these not been my only opportunities. To have him watch me strain as my bowels moved, as my urine hissed into the metal pot... I was mortified. And then, once I had finished, he made me lie across his lap where he reinserted the nasty plug. Each time it was larger still and the torment of entry greater. The wood was so hard, so unforgiving, and several times a day Jonathan added insult to injury by twisting the key at one end to

expand it, much to my dismay. For this object not only stretched me but filled me in a manner that made me feel ashamed at the pleasure. To what purpose this was being done, I did not know. Jonathan refused to answer my questions.

I was amazed at how different he seemed. His demeanor had altered to that of a man who knows what he wants and takes it. I confess I was very attracted to him and a little afraid of his iron will, in much the same way I feared Count Dracula yet was drawn to him. But with Jonathan I suspected his recent actions were an aberration and not a permanent alteration in his character. I believed this was all a sham and that he was trying to dissuade me from going to the Count, but he would not succeed. I felt bound and determined to be with Dracula, for be he man or monster, he could fulfil me.

We arrived by boat in Istanbul and needed to wait there until the next day for the train to Buda-Pesth, then onward to Bistrita. Jonathan wanted to go riding and we did in a manner of speaking, he on a large gelding, I lying across the saddle in front of him naked, my body bared to the wind.

This country is wild, the trees bent and twisted with the whipping gales in winter, the soil blistered by the harsh summer sun. These observations I made from my position on the horse as Jonathan cracked his riding crop against the backs of my thighs. Coarse horse hairs rubbed my titties erect. My bottom was bare before heaven and my soft button bounced not far from the horses firm back.

Jonathan lifted me and sat me on top of his member. My hot thighs straggled his breeches. He walked the gelding then moved him into a trot and finally a gallop. Jonathan's hard flesh speared me in time to the horses hooves as I bounced happily along. Then he lay me across the saddle again and whipped my stinging thighs. By the time we returned to the inn where we were staying, my face was streaked with tears and the backs of my thighs were raw.

Jonathan had me lie on the bed face down. He spread me wide and tied my arms and legs to the bedstead, then used the harsh crop on my delicate inner thighs, which had never been whipped before. I screamed and cried in pain, begging him to cease, but as always he only finished when he was satisfied. He seemed to know my limits

better than I, for when I thought I could take no more, I was always amazed that I could.

He crawled up my body, his rock hard member impaling my throbbing inner flesh from behind. His thrusts were long and solid and steady, each slamming the dreadful plug into my rectum, causing pleasure mingled with pain to streak through me. Once again he had brought me to a deliciously vulnerable state where I could no longer tell the difference. My moist womanly slit welcomed him and made his visit worthwhile.

Later, when Jonathan asked me yet again if he should continue to accompany me, I said, "Of course." After all, we were almost at my destination.

But as we traveled from Buda-Pesth to Bistrita, I began to feel nervous, for this was indeed the last leg of my journey. Our arrangement was that at the Borgo Pass Jonathan would leave me and I would travel alone to Castle Dracula by coach.

Chapter Thirty Six

"When will we arrive?" Mina asked me.

I checked my pocket watch. "Approximately six hours. I suppose it's time for a parting gift."

She had, of course, no idea what I meant.

"Undress and kneel on the seat," I told her.

"Jonathan, this is not very private."

Indeed, this train was not at all like the European variety. The compartment was ours alone yet there was no lock on the door and people had been constantly popping in, realizing their mistake then leaving. I knew that for Mina the idea of being naked before strange eyes would be impossible, at least under normal circumstances.

I felt the look in my eye must be dangerous because of her reaction. She undressed as if she did not do so with her will. I would see to it that the act was accomplished against her will if need be, and truly, that is how I felt. She would not have liked the manner in which it was done. She did as I bid her, removing her traveling jacket and skirt, her long petticoats, shoes and stockings. She no longer wore a corset and bloomers—I had forbidden it. I saw that she would have liked to remove the terrible thing that speared her rectum, but she could not, for only I could do that and I had no intention of removing it just yet.

I had her kneel on the seat, her nearly healed bottom exposed before me. The sight of skin only slightly pink brought my cock to its full height. It had been worth the wait.

"I have saved something special for you, Mina," I said.

"I know I shall be whipped," she said in a voice filled with terror and desire. "From this position what else would I have to look forward to? Fortunately, it can not continue more than six hours."

I knew this made her feel in control. I intended to change that comfortable, confident feeling.

A quick glance behind her did quite a bit to move ahead my goal. I showed her the thin bamboo cane, or one half of it to be precise, for it had been split lengthwise. Mina, I knew, had not been whipped with a cane. I suspected she believed that because it was thin, it would not have the impact of a thicker object. I could see she was reassuring herself: the train would stop regularly and afford her relief.

I stood behind her and cracked the somewhat flexible cane across her bottom. It was a very light whack. She barely uttered a word. She did, however, glance behind her again and from that look of disdain I felt she thought I'd lost my mettle.

Her resolve to leave me showed in her face and brought out the monster in me.

But over the next hour, as the cane whisked her bottom in its delicate manner, she came to realize that she had been mistaken. The train did stop at stations on the way, but I did not. Her screams were heard by all, but this did not bother me. My seemingly light-weight whipping had turned horribly painful for her. She writhed and cried out, "I cannot believe how such easy switches can cause such grief!"

She was beside herself with agony, which I found delightful.

"You have five more hours to suffer at my hands," I informed her, "and I shall see you through the whole round, of that I can assure you."

The door to the compartment opened and an old man and his wife looked in. I knew Mina felt shame at being whipped before these strangers. The large muscles of her behind contracted in pain around the horrible dildo. I kept the rod coming. The man and woman stood at the door and watched a long time. The humiliation of a stranger witnessing her being mercilessly caned added tears to the ones that continued to flow from Mina's eyes.

The bamboo left her no room to manoeuvre. She could not avoid

it and she could not stand it. She howled out her misery as the hours passed, the gentle swishing welting her backside, swelling her bottom and coloring it to purple. The act of whipping her so continuously swelled my cock to heights it had not hitherto reached until my balls ached with semen I needed to expel. But still I continued. Her pleas did not effect me. She no longer tried to avoid the blows, having learned that doing so they came worse.

Finally, as we were an hour from the Borgo Pass, I lay down the rod. Her behind steamed in anguish. Her entire body trembled uncontrollably. I knew she had never been punished so and imagined she hoped never to be so again.

Chapter Thirty Seven

It was a punishment, regardless of what Jonathan said. He was angry at me for leaving him and intended to make his final statement a strong one.

The thongs holding the plug in place were cut and the object of much discomfort removed. My relief was short lived.

At first I thought he was replacing it with a far larger tool, but what I felt probing my anus was fleshy and hot. His cock pierced me then filled my rectum with its full length. I felt split asunder.

He stroked in and out, spreading me wider, rubbing places inside me that radiated hedonistic pleasure throughout my rectum. My vagina contracted and I orgasmed spontaneously. I could hardly stand the pleasure of being taken in this way. Shamelessly I thrust my fiery behind back into him, begging for him to plunge deeper and harder, to invade me completely. I heard the door open and knew someone was watching. But I could no longer control myself. My husband's cock owned me and told me so in no uncertain terms. I could do nothing but follow my own irrepressible longings and eagerly submit to him.

As we arrived at the Borgo Pass, my emotions were a potpourri and I had the distinct impression that something was amiss but I could not identify what. The train pulled away from the station and Jonathan and I stood alone together on the platform. Nearby a coach for hire waited to take me to my final destination where my fate would be sealed.

Jonathan stood before me, tall, slim, handsome, his eyes serious and penetrating.

"You're going to beg me to stay," I said.

"Not at all," he told me. He handed me a large sum of money. "You have your inheritance as well to draw from," he said, "I wish you the best."

I could not fathom his reaction and told him so.

He looked at me with a steady masterful gaze. "Mina, the choice is yours. If you stay with me you know now how your life will be. You will receive more of the same. Much more."

His words sent a thrill through me. A life of pain and pleasure with a man of flesh and blood compared with being a member of a harem, caught in the spell of a cruel monster who must divide his time among many seeking his attention. Either decision was one I might regret.

The train arrived on the opposite track, waiting to take Jonathan from me forever. He picked up his bag which held the means to pleasure and grabbed the back of my neck in his hand, pulling me to him. He kissed me hard on the lips, his tongue sliding into my mouth, filling me, sending waves of pleasure rippling through me. My burning vagina and rectum contracted and my derriere pulsed with the molten heat inflicted by his hand.

He was boarding the train when I ran to him. "Jonathan, I want you."

He looked down at me. The train began to pull away and I had to run to keep up. "If you come with me, Mina, you stay with me, you submit to me and submit willingly. As your Master I have a right to imprint my ownership on you daily, and shall. Can you live that life, Mina?"

"Gladly!" I told him.

The train began to move faster and Jonathan bent down and grabbed me around the waist, scooping me up to the step. My skirt rose and his hands slid under it, clasping my naked scorched buttocks in a proprietary way. I looked up into his light eyes filled with dark promises and felt I belonged to him fully, and to him alone.

I saw my steamer trunk, still on the platform, fading from view. A trunk packed with symbols of the faded woman I had been and

was no longer. Silently I bid farewell to Count Dracula. Whatever he was, he had opened me to my own dark passions.

As my demon lover looked into my eyes, he placed something into my hand. I looked down. A ring, like the one in his genitals. I nodded my head, knowing I would be wearing this intimate gift very very soon. I also knew I had made the correct decision.

Chapter Thirty Eight

Quincey Morris stared at the massive fortress embedded into the side of the mountain. His legs felt unsteady. This castle, or what remained of it, had melded with the harsh boulders over the centuries. Whatever occurred within its crumbling walls no doubt reflected a mentality as ancient as the landscape itself, and as severe. This was not Texas!

The massive drawbridge had been lowered, as if their party was expected. When the four men entered the courtyard, they dismounted at once. Van Helsing tied his horses' reigns to an iron post, and the others followed his lead.

Why Quincey had come here was beyond his understanding. What had started as a simple visit to England for business purposes had turned into an adventure that might lead to his destruction. Back in Texas, he had experience nothing like the bedroom antics of the frisky Miss Westenra. That, alone, would have been enough of a treat for any man of the world. But what followed left him 'non-plussed', as the good Dr. Steward would put it. He'd never seen such escapades played out, even in the Austin whorehouses he patronized. Much to his surprise and delight, he'd never debased himself to such an extent—he didn't think he had it in him. And now here he was, following Professor Van Helsing to this wilderness in a remote region that, by the looks of it, very few civilized people had set foot in.

He watched the professor gather his apparatus. Clearly the man was obsessed with Lucy. And while Quincey had enjoyed himself

immensely at her parties, still, she wasn't the reason he came half way around the world. When he fessed up, he knew he was fascinated by the enigmatic Count Dracula.

Van Helsing mounted the steps of the castle as if he'd been here before and might be welcome. He didn't knock but pressed the latch. The door opened. Maybe they were expected.

He led them into a vast hallway stretching so high up into the gloom that Quincey couldn't see the ceiling. The place was cold and filthy, massive cobwebs strewn between the pillars and over the banister, and across the tapestries and portraits and code-of-arms adorning the walls.

Rooms led off at various angles and the professor stopped their procession from going further. "We have but one hour to find her," he said, "then the sun sets and Dracula will be on us, of that you can be certain. We are the mice, this his trap, hence the easy access."

The task seemed impossible to Quincey. Four of them couldn't cover so much territory in such a short time. And there were greater worries. "It's not a good idea to split up," he warned.

Van Helsing spun around. His metal cane smacked Quincey across the face. "Mr. Morris, if you are not man enough to investigate in a logical fashion, I shall tether you outside with the horses."

Quincey felt stunned. The sharp sting was followed by a severe burning of the skin. He moved his finger to his cheek—the flesh had already swelled. He felt humiliated before the other men, not something he would put up with on home soil.

"You, Mr. Morris, will take the top floor, John the next down, then Arthur the one below. I shall investigate these rooms, although I suspect not even the undead reside on this level. I shall also examine below, where the crypt must be located. You all have your kits?"

Each man held up a knapsack.

Quincey, John and Arthur started up the stairs. Once they had left Arthur to the murky second floor and were headed up the stone steps to the third, John said, "That rod is wicked, is it not?"

"You can say that again," Quincey admitted, feeling his flesh scream with each step. And although his cheek smarted still, the professor's hand did not measure up in some fundamental way. Quincey thought of that other man, the one whose rod he had yet

to experience. "He's amazing."

"Who, Dracula?"

John and Quincey looked at one another, startled. They had obviously had the same thought. "I haven't met anyone like him."

"The Count makes me feel like a school boy," John confided, "awaiting his pleasure, or displeasure."

Quincey left John at the third floor and proceeded up to the top level, or what he felt must be the top. He wandered through a series of bedrooms with old heavy wood furniture, dark and oppressive. And yet this atmosphere also held a fascination for him. Things here seemed solid and permanent, unlike in the United States. Not just the eternal mountains, but this castle had been this way for centuries and would continue to be so indefinitely. Quincey and his puny will could never alter that fact.

When he had exhausted all the rooms along this wing and was about to enter the western section, he saw the sun drop below the horizon through the cut glass casements. Suddenly he heard a sound to his left. He re-entered a room he had already inspected and discovered there a door that somehow he had missed. He opened it. Narrow black marble steps led up. They spiralled and the steep passage grew even narrower. Finally he reached another door, this one locked.

The door would not budge. He set down his knapsack. Although it was pitch dark, he made a quick search over the walls with his hands and along the top of the door frame for a key. Within he heard a sound, like groaning. He peered through the keyhole.

A hundred yellow beeswax candles lit the room. Lucy hung from a contraption shaped like a giant X. Her wrists were tied at the two posts at the top and her ankles spread wide and secured at the bottom. Fresh whip marks streaked her lily white chest. Her face looked exquisite, though, her loveliness obviously enhanced by the agony she suffered.

He felt transfixed as he watched her breasts quiver. Never had he seen her so intense, so alive, and yet it was clear that she had altered. Besides the tone of her skin, two pointed teeth jutting over her lower lip alerted him to this peculiar post-death state.

Suddenly Quincey, still bent over, became aware of a hand inching

slowly up the inside of his thigh. The hand reached his balls and stopped. Quincey froze. The hand clutched them and he trembled. The hand began to squeeze and Quincey screamed.

Chapter Thirty Nine

John heard Quincey's scream and raced up to the top floor.

"Which direction?" he wondered aloud. He took the nearest corridor.

John searched the rooms along this wing. Finally he stumbled upon a door that led up. He called down the staircase to Arthur to join him and, not waiting for a reply, ascended the narrow steps alone. At the top of the dark twisting stairwell he was met by a ravenous beauty, the likes of which he had never encountered.

The girl, for she was no more than 20, stood, hands on hips, breasts thrust towards him, visible through a gossamer gown that revealed tantalizingly curves. A rawhide bullwhip hung around her neck. She tilted her head in an insolent manner and flipped her red tresses back from her face. John felt a stirring at his crotch.

"John!" Quincey called from across the room. He was affixed to a stocks, bent over, head and wrists through the holes, ankles trapped in yet another stocks at his feet. Next to him, Lucy hung on a St. Andrews' Cross, her chest nearly stripped of flesh.

"I have had an Englishman before," the girl said. "I found him flabby and weak and not familiar with my whip, as was Dracula's new bride. Does this flaw run through the blood of your nation?" The girl's voice was deep and throaty, with a peasant quality to it that John found lustful. He threw his shoulders back and his chest out in patriotic pride.

She extended her hand and smiled seductively. "Come."

"No!" Quincey yelled. "We're here to rescue Lucy. Use your weapons!" John remembered his pack and withdrew a sharp stake and the heavy mallet.

The girl hissed at him like a snake. Her enormous eye teeth flashed in the candlelight, and her green irises pulsed with an unholy light.

Suddenly, from behind him, two more beauties appeared, one fleshy, the other slim, both dark-haired. Each gripped an arm and he was propelled into the chamber.

Now that he was within, John realized the true purpose of this tower—a torture realm. Affixed to the walls were all manner of restraints and implements of punishment, many of them ancient.

The women dragged to a heavy-looking chair. John struggled in a way that would have caused an ordinary chair to topple; this one stayed rooted to the stone floor. The chair proper was made of a dark dense wood, the seat of metal. The three women tore his clothes from his body as if they were jackals shredding the flesh from prey they intended to devour. The slim girl and the fleshy vixen tied him securely, wrists and ankles, while the red-head encased his neck with a black leather band like the type of collar a hound would wear. All this forced him to sit upright.

The red-haired one moved to Quincey and used a knife to slowly cut off his pants and shirt, leaving him wearing only boots, like John.

"You may call me Magda," she said, "first wife of Count Dracula." She ran a hand over the rod mark on Quincey's cheek. "Who did this to you?"

"Professor Van Helsing."

"Ah!" This seemed to intrigue her. "Awe-inspiring. Great skill is required to slash the skin with such precision. The Dutch have a way with the flesh, do they not?"

"And slash yours I shall if you do not release these men immediately!" The Professor and Arthur stood at the door, the latter holding a stake and mallet, and the former extending a large crucifix before him.

Magda glared at them, eyes flashing, a coquettish smile playing on her lips. "A man of your talents is wasted on mere mortals. I

would think they present no challenge, no way to extend your own boundaries."

"Perhaps, madam, those boundaries can be explored on your hide at some later date. For the moment, though, I am immune to the seductive tricks of the undead. You will release these three at once."

No one moved. Through the opaque glass of the only window, John saw the sky darken considerably, as if the last tendrils of light had been sucked from it. Van Helsing noticed too.

"My Master will arrive shortly," Magda said, "for it is him you came to visit, is that not so?"

"Enough of this!" the Professor said. He nodded at Arthur, who made his way to Lucy and untied her.

Lucy's eyes flashed crimson seduction at him and her carmine lips spread into a voluptuous smile, exposing the sharp white teeth. She glanced once at Magda, who nodded, then opened her arms and thrust her tits in his direction. "Arthur, my love. I am hungry for you. Come to me."

Arthur seemed mesmerized. John watched him inch forward into those pale arms.

Suddenly Van Helsing's cross jammed between the two.

Lucy shrank back.

Arthur came to his senses.

"Such theatrics do not become a man of science." Count Dracula stood at the entrance to the room. He closed the heaven wooden door and locked it, pocketing the key.

John held his breath as this imposing figure strode forward, the long midnight cape flowing behind him. He snatched the bullwhip from Magda's neck and cracked it in the air. The alarming sound reverberated throughout the room, creating a palpable tension. John's body trembled and he began to sweat.

"I am perhaps the more dramatic," Dracula said, walking right up to Van Helsing who, remarkably, stood his ground. The cross helped. Dracula glanced at Arthur. John could see his friend's eyes perfectly. The lids widened then narrowed, as did the pupils. The briefest struggle of wills ensued before Arthur succumbed.

"Take it from him!" Dracula ordered.

Arthur, as if hypnotized, snatched the cross from Van Helsing's hands and broke the joint, creating two harmless pieces of wood. This permitted the Count to move closer, which he did.

He stopped only when he towered over the shorter Dutchman. Van Helsing looked fearless, as if he possessed some knowledge that Count Dracula did not.

Dracula reached out and stroked his cheek, as he would touch a woman's. His hand gripped the back of Van Helsing's neck and pulled his face forward. John couldn't believe his eyes. The vampire was about to kiss the Professor!

But suddenly Dracula thrust him backwards across the room. "I see!" he yelled. "That will not protect you for long. Even you must perspire and the tears your pores cry will wash away the effects of the water you have so painstakingly consumed."

John could only imagine it was the holy water. Van Helsing had insisted they stop en route and fill their water flasks at a cathedral, although he was the only one to drink.

But Dracula was not to be outdone. With a glance, he passed an order to Magda, who summoned the two dark-haired beauties and Lucy. They grabbed Arthur and stripped him, then dragged him to a ship's pillory. He was lashed facing it, exposing his back, arms spread wide, feet together. The slim one stuffed his cock through a hole in the crossbar where the wood thinned, then tied his waist, entrapping him.

"You have lost them before you begin," the Count told Van Helsing. "These men are mine, or will be, as shall you be. And when I take you, Professor, you will cry out in agony and bliss, begging me to use you in any manner I see fit. And I shall."

Van Helsing hovered against one wall, glancing around the room at the spectacle. Still, to John, he seemed proud, not ready to bend a knee before this superior Master. But the Professor's troops were incapacitated. Each of the four lovelies was not of this earth, or perhaps too much of the earth, including his beloved Lucy. And then there was the Count, exuding power and mastery at every turn. Why, John wondered, didn't the Professor struggle to get out while he could? The situation seemed utterly hopeless. John was resigned to his fate, however delicious it might be, and he was soon to find out.

"My lovelies," the Count began, "you are bored and I have devised a game for your amusement. Come."

He held a private conference with each, which lasted only moments, except for Magda, who argued her case heatedly. Finally Dracula nodded, and she seemed satisfied.

Being the eldest, Magda had first choice. She selected Van Helsing, for he obviously fascinated her. The slender girl chose Quincey and the fleshy one Arthur. Lucy selected John. He felt waves of jealousy course through the air in his direction, the most intense from Van Helsing himself.

Dracula, like the ringmaster of a circus, stood in the center of the room and snapped his ten foot bullwhip in the air half a dozen times. The sound stabbed at the eardrums and seemed to cut the air in two; John knew full well that the tail of that whip could do the same to his flesh, in the proper hand.

John watched the slim girl bend down before Arthur's phallus. She teased his trapped flesh, using her full lips on him in a manner that brought his fellow to its full height quickly. She reached around the post and grabbed his ass cheeks in her hands, kneading them, digging her long fingernails into the thick muscles, sending sensations rippling through Arthur, exciting John. Gradually she worked her hands inward until she had his cheeks spread, his balls clutched in one hand, a finger of her other hand poised over Arthur's anus. John could only see Arthur from the side. His friend was breathing in and out quickly and helplessly. The slim girl sucked his juices from him and he cried out as he spurted into her.

"John, my love." Lucy captured his attention.

She bent before him, her silky blonde hair falling over her face. Remarkably the wounds across her body were already healing and he would have liked to have studied this medical curiosity. She slipped his feet into a pair of heavy metal boots and began turning cranks along the sides. The boots shrank against his feet until the bones felt on the verge of being crushed. A groan escaped his lips, at which point she stopped.

"Lucy, you have become diabolical!" he gasped.

She flashed those sharp fangs at him, and he shrivelled before them.

But Lucy would not be defeated by his fear. She snapped a metal ring divided into three sections over his balls and sagging cock, lifting his genitals, separating his testes and forcing them and his cock to rise high. Then she worked his penis with her hands until he firmed. The sensation was not unpleasant and he became rigid quickly.

Next she affixed a metal hat to his head with screws all around. She turned them until the pressure on his brain became intense. "For heaven's sake, Lucy, you must cease! Where did you learn such games?"

"John, you've always loved my games."

"Your games were simple."

"Perhaps too simple," she said cryptically.

Next she fit a blindfold over his eyes and a leather ball into his mouth, held by thongs that tied behind his head. His hands were encased in more cold metal, again tightened until he groaned. Metallic bands locked over his chest, at stomach level, his thighs and calves. She reached under his ass cheeks and spread them so that his anus sat exposed to the metal seat, then tightened all the restraints.

Just before she stuffed melted wax into his ears, he heard a scream. Arthur was no longer the recipient of pleasure, at least not from how John interpreted the sound.

John could not see, nor hear nor cry out. Many parts of his body felt intense pressure. He had never been bound in such a complete manner and although he felt fearful, it was thoroughly exciting. Always before he had not needed restraint. He had offered himself for punishment of his own volition, to Lucy, to the Professor, and taken all they could give. But imprisoned as he was inspired new levels of terror in him. Whatever Lucy decided to do to him, he could not stop. He was reminded of her masked head at Carfax, and her trapped limbs. She had been completely cut off from intercourse with the world, while that small exposed strip of her behind received far more than its share of attention. The memory caused him to shiver with delight and fear.

As he sat bound in the chair, he was thrust back onto himself. The utter silence except for his own breathing and the wild beating of his heart left him time to think about who he was and what he really

wanted. Faces flashed before his mind's eye, thoughts of pleasures received and taken and regrets for those missed, particularly with Mina Harker.

Fingers gripped his nipples. This flesh on flesh sent a wave of sensation through his veins like lava flowing down a mountainside. His nipples responded by firming under the cool fingers that pinched them. His heart beat faster. Suddenly the fingers that controlled him were gone. Air on the sensitive nipples sent more delights rippling down to his engorged penis.

Pain exploded across his flesh. Hard ice clamped onto both burning nipples. Had he not been captured so completely he would have jumped through the roof. His squall of pain went unheard except in his own ears. His breath shortened into panting as he rode the searing pain shooting from his nipples through his body. It took a long time for the sensations to become sufferable.

Fingers toyed with his cock and balls. The tension he felt there was almost beyond tolerance. He wanted release and yet the metal locking his genitals into position blocked his juices inside him.

Tears streamed from his face. Lucy was a monster and he at her mercy. He could not even beg, just suffer what she inflicted upon him. But the stroking of his cock calmed him. Her hands traveled the inside of his thighs and along his chest and shoulders and neck, relaxing him, helping him sink into the floating feeling that had crept up unawares. It was as though he slept yet was awake. He felt at peace, every inch of his flesh tuned to what pleasures and tortures she provided. Even though he could not understand why, he trusted her completely to understand his needs.

Her touch brought him higher again, his skin hungry for more. The ache in his balls felt joyous. How he longed for that feeling to last forever!

He felt warm. Pliable. Malleable in her hands.

Left once again to his own devices, he traveled this stream of elation. And then the warmth increased and localized.

John realized that it centered on his ass and his anus so completely pressed to the seat. A seat he remembered was metal.

A seat he now realized was heating up.

Chapter Forty

Quincey had watched Lucy create a flame inside the small iron caldron and slide the pot under John's chair. Lucy, now dressed in a green velvet dress that exposed her ample cleavage, approached the fleshy girl and pulled her aside. Their tête à tête involved verbal and physical interaction, with much hugging and kissing and fondling of one another's body parts. From the looks cast in his direction, he knew he was the subject of their discussion.

The fleshy girl giggled and nodded. Immediately they inverted the stocks to which he was attached so that he lay still bent at the waist but facing the ceiling. They undid his ankles, for which he felt grateful, and stretched his legs out then tied them to the wood at his feet. This put a terrific strain on his lower back, alleviated as they wove rope back and forth, creating a supporting hammock. They left him alone for a few moments and he glanced around the room.

The seat must have heated quickly. John squired to the little extend his restraints permitted. Arthur was being sucked firm for the third time by the slim girl. The look on his face reflected a fine blend of pleasure and pain and Quincey wondered how much even a man in as good shape as Arthur could take. He expected they would both find out this night.

The Professor stood against one wall talking with Magda. Just talking. Now that's strange, Quincey thought.

He turned his head to see Count Dracula lounging on a chaise in the center of the tower, Dark Lord of all he surveyed.

Dracula was watching him. Closely. Quincey's cock sprang to attention under that dark demanding gaze, and he fondly remembered licking the filth from the Count's boots back at the asylum.

When Lucy and the fleshy girl returned, Lucy first removed the pot from beneath the chair the twitching John was trapped in.

That metal, Quincey knew, would not cool quickly.

They brought with them an armload of items. The first he became aware of was the sharp-looking knife with a four inch blade that had cut the clothing off Arthur. The girl who had selected Quincey poised it above his genitals.

Desperately, he said, "Ladies, be reasonable—"

"Quincey," Lucy chided him, "you American boys are overly protective of your manhood, as though all we women think about is destroying what provides us pleasure. Calm yourself. I will hold him," she told the other female.

The fleshy girl rubbed something wet onto his crotch where his poor fellow put up a good show despite his terror. Quincey felt humiliated as tears gushed from his eyes. Though that blurry vision, he saw Count Dracula still watching closely, waiting, no doubt, for the blood to flow.

In seconds they had lathered the hairs of his crotch and stomach. Lucy held his hips to steady the trembling. The knife blade, sharp as any razor, scraped along his skin slowly. The fleshy girl shaved his balls first, the undersides, the top and all along the delicate shrivelled skin, then took the hairs from his crack near the vulnerable area around his anus. They splattered hot burning candle wax over the wiry dark hairs on his stomach, chest, shoulders, back, arms and legs. When they peeled it away, the hairs came too, if painfully. The fleshy girl soaped his face and removed his moustache and sideburns and the new growth of beard. Other than his head, his entire body was now hairless.

He felt exposed, nothing between him and the air. The current passing through the room cooled his skin and brought out little bumps on his flesh. This must be how women feel, he realized, sensual, erotic, open, no barriers to pleasure and pain. He was not adverse to the feeling. Yet. For that reason he did not resist unduly.

A groan forced his eyes to the left. Arthur cried out again and

from the number of such cries, Quincey counted that his prick was being sucked for the sixth time. Anguish and ecstasy creased Arthur's upper-class features. His lips trembled and his eyes floated upward into their sockets in a dreamy way. The slim dark-haired beauty stood. She picked up what looked like a sewing needle. Quincey watched spellbound as she pierced Arthur's nipple from left to right. Arthur threw his head back and howled.

To Quincey's left, Lucy stoked the coals in the pot and returned it to beneath John's chair. John sat rigid, bound, inwardly directed.

Most peculiar was Van Helsing and Magda, still talking. And Count Dracula, ruler supreme over all he surveyed, watching everything.

Lucy and the fleshy girl kissed long and deeply again, fondling one another's breasts. They then untied Quincey's legs and removed the stocks from his head and wrists. Once he was upright, they attached a woman's corset around his middle. "Really, Lucy, this is outrageous—"

"Quiet, Miss, or your behind will feel my paddle!"

Count Dracula fixed his eyes on Quincey's, his and Quincey kept his mouth shut, for he had no intention of suffering the humiliation of being paddled while this monster looked on.

The whale bones pressing into his stomach area were an entirely new sensation. He had always enjoyed seeing corseted woman and had occasionally wondered what such a garment would feel like. Now he knew. It felt marvellous.

They tightened the stays until his ass protrude behind him and his pectoral muscles rode the top of the contraption like breasts. And didn't they pull them tight at the waist! Breathtakingly so, but it made a bit of an hour-glass.

The females spun him in a circle until they were satisfied with their work. They embraced again. Their hips and nipples touched and their lips connected. With mouths open, both women stuck out their tongues as if they were snakes kissing, and he found this erotic.

Next came fancy bloomers, the silk soft and comforting against his newly exposed skin. When they were halfway up, Lucy said, "I've an idea."

She left the room but returned almost at once. In her hand she held what might be the opposite of a codpiece. The triangular metal-

lic shield she attached to his groin area pressed his cock and balls back and under so that they seemed to disappear, or at least no longer bulged in front as they normally did.

"Sit, Miss Morris!" Lucy pointed to a stool and Quincey sat gingerly, trying to find a comfortable position, unable to truly bend because of the corset, smarting at the feminization she had inflicted on him. And before the Count!

The fleshy girl slid thin cotton stocking up his legs, unrolling them slowly, then red garters to hold them in place. Count Dracula looked on with interest and Quincey's face burned in shame.

There were no boots that would fit him and the petticoats were short, but when he looked down, he was surprised to find them billowing from his frame in an aesthetic manner.

Lucy and the other girl slid a scarlet dress over his head. They pinned it tightly to his body and tied a sash about his waist. The taffeta rustled with each slight movement and cooled his skin. A peculiar feeling washed over Quincey, one of release. He felt that now he could relax in a way that before had not been possible.

Arthur cried out again, this time begging for mercy, but the girl would have none of it. She used a tiny whip to lash his deflated cock, which struggled to do her bidding, then pierced his other nipple. John jumped and quivered like a piece of fat on a spit. Lucy placed a hand to her mouth and cried, "Oh, I forgot about him!"

She glanced at Dracula, whose eyes narrowed with displeasure. "Had I wanted the doctor fried to a crisp," his voice boomed from the center of the room, "I could have seen to that myself."

Lucy pulled the hot pot from under the metal seat which, Quincey knew, would take even longer to cool this time. He thought he smelled burning meat.

Magda's diaphanous gown had slid from her shoulders, exposing one well-developed breast that invited sucking. Quincey glanced down at his own feeble mounds and felt them lacking.

Van Helsing stood before Magda, still impervious to her seductive charms. Her exposed tit jutted in his direction like a puppy wanting petting. Her hips swayed as she spoke. Van Helsing now held Magda's bullwhip in his hands and was fingering the knotted cord at the end; his eyes never left Magda's.

"Sit again, Quin!" Lucy said. Quincey sat, letting this new name flow through his mind. Quin, was it? A wonderful name for a woman. Strong. Proud. And yet touched with a passion for submission. It occurred to him that the name suited him better than his own.

The two women worked on his hair, piling and curling it into a style befitting a proper lady. Lucy brought out a box of face paints and touched his cheeks, lips and eyelids with colors that no doubt made him look like a street walker, but since Quincey could do nothing to stop her, he passively submitted. They hung seed pearls about his throat and imbedded tortoise shell combs in his hair. When they finished preening over him, they brought him to his feet and spun him in circles again, giggling at their creation, kissing one another's nipples and inserting fingers into their womanly slits.

Lucy produced a peculiar wooden arrangement with one large hole and two smaller ones. It opened like a jaw. They fitted his neck into the main opening and his wrists one in front of the other into the other two, then snapped the contraption closed. Quincey stood with his arms raised in front of him, bound in a mobile stocks.

"Come," Lucy said, pulling the stocks, "I know a man who can appreciate your charms."

She led him across the room, past the moaning erect Arthur, until they approached Count Dracula, who immediately stood.

"Ladies," he said bowing slightly, and turned to Quincey, his dark eyes seductive and dangerous. Quincey felt utterly mortified. He longed to hide his face and the desire he knew it revealed, but the stocks kept him exposed.

"Miss Quin Morris, I would like to present Count Dracula, ruler absolute of this castle. Count, Miss Morris, from America."

The Count pulled Quincey forward so that his lips could kiss one of the trapped hands. Those icy lips sent a pleasant chill up Quincey's arm.

"Miss Morris has come to us all the way from Texas, via England, to train under a gentleman with exotic tastes. She has, however, been terribly naughty, which I hope you will attend to. If you will both excuse me," she said, and left to see about John's discomfort.

"Miss Morris will be the recipient of my undivided attention,"

Dracula assured Lucy, then, to Quincey, "I shall not disappoint you, Miss Morris. And you shall not disappoint me. Come."

Dracula securely gripped the end of the stocks and pulled Quincey around the room like a pet on a leash. Quincey, face flushed, looked demurely down. His heart pounded. His body trembled. Whatever was to come was something he had not anticipated.

They strolled the room like a man and his dog walking a promenade, Dracula leading him as if Quincey were a prized bitch.

A small straw bed covered with fine white muslin had been made up against one wall. Dracula sat on the edge. Immediately Quincey was pulled across his lap. Quincey's skirts were raised and affixed to the fabric at his waist and his silk bloomers peeled down to his knees.

Before Quincey knew what was happening, a finger probed deep into his anus. His sphincter tensed and he groaned at the invasion, although it felt thrilling in an illicit sort of way.

"You are still a virgin," Dracula said matter-of-factly. "Proud. A coquette. Teasing men with your scent and yet denying them access. I have breached the orifices of many virgins."

Quincey knew his face was scarlet with shame.

"Do you believe," Dracula continued, "such behavior in a woman like yourself should go unpunished?"

Quincey was afraid to answer, knowing that whatever he said would make little difference to his fate. Still, the idea of playing this game intrigued him. He had always wondered what the opposite sex experienced at the hands of a strong Master and now was his chance to find out.

And in fact the vulnerable position he lay in excited him. "I do not, sir," Quincey heard himself answer.

"Then," Count Dracula continued, "as a gentleman and a disciplinarian, it is my duty to accommodate you by providing correction harsh enough to tame your passions and make them accessible."

The hand that smacked Quincey's ass was large and heavy, jolting him. In the fraction of a second his bottom rode the air, the hand found his cheeks again and slapped them downward. The spanking was as harsh as promised. Fierce blows rained down in rapid succession and Quincey gasped helplessly; he could do nothing but submit

to the rapidly increasing heat, for in the back of his mind he knew the Count capable of far worse.

The stinging along his behind escalated rapidly. As Quincey bounced on the knee of the dominant man spanking him so severely, erotic sensations coursed through his loins. Never had he felt so out of control, so fragmented, so in need of consolidation. His flesh steamed. Tears flowed, and he released them freely, like a woman. Through the haze of righteous pain, he experienced a peculiar mix of anger and gratitude. Even if he could have stopped this agony, he would not. Deep inside he knew he had craved such handling all his life and that finally he had found someone strong enough both physically and mentally to spare him nothing.

Quincey knew he was about to explore dimensions he had never before acknowledged. In the end he hoped he would have a clearer vision of who or what lay within him.

Chapter Forty One

Magda writhed before the stern Professor from Amsterdam, sensual movements that would have enticed her Master, Count Dracula, but on this man seemed to have little effect. The Professor's eyes flashed danger, yet his body stayed rigid, unaffected by her invitation. He only held the whip, still fingering the flat strand of leather and twisting the knotted cord at the end as she spoke with him about the pleasures and pains she had experienced at the hands of her tyrannical Master.

"As I told you, Professor, the flesh of our kind heals rapidly. Whippings that take normal skin a week to heal, effect me so that my flesh revives over the course of a day or so." She let the fabric slip lower, revealing her belly button with the jewel embedded therein. It clung to her hips as she undulated before him in a dance of seduction. This man held the key to what until now Magda had been denied.

Van Helsing listened intently, which gave her hope. She had served no Master but the Count. She both longed to feel the lash from one of such repute as well as cringed in terror at the idea. Dracula was a sexual creature, his appetites strong and his drives towards sating them unstoppable. Van Helsing had a reputation as an asexual being, one whose gratification comes from simply inflicting pain. At least until he encountered Lucy. She was the beginning of his desires. Magda would be the end of them.

But at the moment the Professor was having none of it, or so it

seemed. "What inducement is there for me to whip you? If you are content with your present Master, I see no need of this."

"Ah, sir, but it is my present Master whom I wish to serve by debasing myself before his rival."

"How does this benefit me?"

Here Magda was cagey. She worded her answer carefully. "I hold the power over she whom you most desire." She watched him glance at Lucy.

"Be blunt girl. Are you telling me that if I whip you in the manner you request, you will give Lucy to me?"

Magda smiled enigmatically.

"And if Count Dracula does not release her?"

"He has no choice, for I am the first wife and I may use the others in any manner I see fit. In exchange for this act, he has agreed to grant me any wish, and is honor bound to fulfil that promise."

"And if Lucy should not desire to leave him?"

"Lucy desires to leave him. And she obeys me. You saw her stripes when you entered and you see they have virtually healed." Magda looked coyly up through her eyelashes at the Professor. While he examined Lucy's nearly healed flesh, she said, "It was not the Count who inflicted those, but the woman you see before you. Lucy has already learned to submit to me."

The Professor seemed to consider all this. Magda had the impression that he was formulating a plan of some sort, possibly involving gaining the time to rescue Lucy from this castle and its depraved inhabitants. Or perhaps thinking this was his only possible means of escape. Possibly fantasizing about how his punishments of the fair Lucy would no longer be limited by her mortality. He would no more be limited by her frailty. And then there was the enticement of Magda's willing flesh.

"Prepare yourself," Van Helsing suddenly said.

"Tie me to this wall," Magda pleaded, "else I shall surely attempt escape."

As the Professor spread her wrists and ankles and chained them securely, the brave, provocative face Magda had shown him crumbled. What she had requested, what he had agreed to, the fact that she would gain what she most desired, all this required an immense

sacrifice, one she was not sure she could accomplish. Undead though she be, she felt pain like any mortal, perhaps more so because she was always given more. That, she knew, would be the case here.

Roughly, he tore the dress now clinging only to her hips, leaving her naked and exhibited. As he gathered her long hair and threw it over her shoulders, Magda trembled. To be whipped from head to toe until sunrise! The bullwhip would torture her with no hope of pleasure in the end; she did not know if she could stand this. She had been punished far worse by the Count in the past, yet she was not the naive girl he had taken and dominated so easily, the one who had given over her very soul.

Now she was a woman, centuries old, and altered from who she had been. She would gladly suffer this and more to be with her true love, but one can only suffer so much. Dracula always tempered her suffering by pleasuring her. Van Helsing, she knew, would not. He favored pain for the sake of pain.

The Professor hung her bullwhip back onto the wall beside her. "You... you now refuse?" Her question sounded hopeful in her ears.

He picked up his metal cane and whipped it back and forth through the air. The ear-splitting swish gave her the impression the air itself was being sectioned. The unique sound caused all heads in the room to turn, and everyone stopped what they were doing.

Van Helsing stood behind her, pressing his clothed body against her nude one, his hands against the stones beside her head, his lips close to her ear. Magda turned her head slightly. The darkness in his eyes felt intimidating, and she panted in terror. "I will give you all that you desire," he said, "and you will return the favor. And I will see to it that your debt is indeed the greater."

The sound of the rod froze her, but the blow immediately following scalded her. Her fangs pierced her lower lip and she could not stop the cry rushing from her mouth. Magda had felt nothing as brutal as this unnatural object. And this was only the start! But these thoughts evaporated as a vapor of pain engulfed her.

Chapter Forty Two

John's body felt limp from overcooking, although his cock still stood firm and on the ready. The skin of his ass had long ago numbed, but he knew the healing would be excruciating. More than anything, he was aware of his emotional state. Over the eternity he had been locked to the hot seat, he had ascended and descended emotionally a thousand times. Now he drifted in a pleasurable state, without thought, without worry.

Lucy removed the restraints holding him to the torture chair. As her cool skin brushed his, John took in the sensation like a parched man receiving water. At last she removed the blindfold. When his vision cleared, the first thing he saw was her face. The visage of a goddess. Of his Mistress.

She had never appeared so enchanting. Blonde wisps framed her pale cheeks and forehead and seemed to glow like a halo. Her violet eyes reflected the depths of a bottomless ocean. She turned her full, luscious lips, so like red plums, up into a smile and moved close, pressing them against his.

John's mouth parted in surrender to her ultimate sweetness. Her nipples, two warm red rubies, impressed themselves into his chest. Whatever she wanted, anything, he would do it for this being who held his destiny in her dainty hands.

Lucy turned abruptly at a shocking sound, and he looked in the same direction. Magda was chained naked to the stone wall, the Professor behind her with his metal rod of punishment quite active. Magda's body convulsed.

A quick glance around the room showed John a bizarre spectacle. The girl sucking Arthur—how many times must he have come by now?—had paused to watch the Professor. Arthur hung from the x-shaped cross, his inflamed cock poking through a hole, her hand still toying with it. His eyes floated up into his head and back down, again and again. Needles pierced through both nipples, now engorged from the agony they must have suffered. His face was pale but the expression bespoke bliss, much like the state John drifted in.

Against the far wall a more astonishing sight. A large woman lay sobbing across Count Dracula's knee, having her bottom well spanked by the Count's bare hand. The cheeks were the rich color of pomegranate seeds, and John felt excited. Dracula paused only a moment, then resumed his task with great vigor.

The most familiar sound drew John's attention back to the Professor and Magda. The horrible swish of metal slicing nothing then striking flesh. Magda screamed. The rod cut her shoulders again, just at the neck. Van Helsing lifted his arm immediately and swung again. This third cut looked to be on top of the last two, yet each must have been below the one before as the line of red expanded. Again and again the silver metal streaked through the air, leaving in its wake a mangled mass of flesh.

Lucy seemed particularly excited by Magda's screeching. Her hand slid down to her crotch. On impulse, John reached up and fondled her bottom and she thrust back against him, seemingly unaware of what she was doing. His hard cock pulsed with renewed energy. Her ass looked so plump and luscious to him, a ripe peach, the fruit receptive to his squeezing. He stood shakily, gaining strength as his excitement grew.

While the Professor painted Magda's back with rhythmic strokes, John pierced Lucy's cunt from behind. She bent forward to accommodate him and moaned, her fingers still working her little nub furiously.

She was an oven inside, the flesh thick and gripping, hot and juicy. John grabbed her hips and thrust hard. The thing that bound his cock and balls permitted sensation but he did not think he could ejaculate, yet he didn't mind. Lucy was such a fine hostess that he intended to stay a while.

The fleshy dark-haired girl pressed up against his back, her nipples jutting into his flesh. She slid a hand down the crack of his scorched behind until a finger entered him.

As if an unspoken conspiracy existed, all motion and sound in the room synchronized. The now wet cane, the slap of palm against tender flesh, the cries from Arthur and the screams from Magda, all of it aligned with the dark-haired girl's thrusting and John's pumping. It felt as though the universe itself had slipped into one beat that matched the beating of his heart.

As his valve of life increased its speed, so the sounds welling over and into him blended with the sensations riding his body. The fleshy girl inserted two more fingers, expanding him. Lucy opened more fully and yet her cunt gripped him hard in an exquisite embrace. He seemed to be digging deeper into her by the second.

Power and energy coursed through him, through them all, he knew. And despite the restraint around his balls and cock, he exploded into Lucy like a volcano erupting molten lava.

The cries of release cascaded around the circular chamber, echoing. They flooded through John, matching his own, and he finally, at last, understood his place in the cosmic scheme of things.

Chapter Forty Three

Quincey awoke with a start. He had slept, but had no idea for how long. His neck and wrists were still attached to the mobile stocks, making movement difficult and his muscles sore.

He opened his eyes and tried to sit up. Pain splintered his ass. He moaned and the memory of the night before crashed down on him.

The red satin dress he wore was still pinned up at the back, his bloomers down. He had lain across the Count's lap, humiliated, dressed as a woman, spanked beyond endurance, first with the Count's hand, and later with the vampire glove Lucy had given the Count. Spanked and spanked, the tiny sharp points piercing his tender flesh every time that unstoppable hand descended, until finally he had broken apart inside and cried as he had never cried before, giving himself over mind, body and spirit to Count Dracula. And now the after effects, a bottom alive with biting pain. And inside a new place had grown overnight that he had not known existed. He felt different. Liberated.

Arthur rested against the large wooden X, his crimson cock half erect, still protruding from the hole; fang marks evident along the vein in his shaft. John slept in the chair on which he had been seared like a steak. Professor Van Helsing sat on the floor against the wall. His face had changed. He was no longer in control of himself. Near him lay a pool of dried blood and the walls were flecked with a thousand dark red spots. An image of Magda flashed into Quincey's mind. Red on red. Hair dipping into the crimson fire leaking from

her back. Her mouth open, but her voice too worn out for sound to emerge. Her body jerked helplessly as Van Helsing's wet rod split the last of her flesh. Quincey shivered. He fantasized being whipped to such an extreme, and yet the state the Professor had worked himself into shocked Quincey. The man showed weakness and Quincey no longer found him appealing.

None of the women were in the room, nor was Count Dracula. Quincey wondered where The Count was, and with whom. Last night he had felt like a horse being trained. A wild stallion that had at last met his match. His will had been broken. And now he waited submissively for his strict Master to return. Eagerly he anticipated his next lesson.

Through the one window in the room, he watched the light outside the opaque glass darken. And then they floated into the room like spectres, first the dark-haired women, and finally Dracula himself. Lucy and Magda were not with them.

The Count seemed taller to Quincey, more handsome, especially compared to Van Helsing. "Get up, Professor," he ordered, "for I wish to bring your defeat to a conclusion. There is no time to waste."

Van Helsing got to his feet immediately. "Where is Lucy?" he asked, his voice dangerously less dynamic than before.

"Soothing what remains of Magda's wounds. I have come to show you that you are alone."

Dracula strode to John and hauled him to his feet. The fleshy girl moved behind John and Quincey saw her hand slip down between his legs to capture his balls.

"Name the one who must be obeyed!" Dracula ordered.

"Lucy," John answered without hesitation. He stared boldly at the Professor and Quincey could see that his eyes no longer held the regret and fear of rejection they once had. Van Helsing saw this as well.

"Your point?" the Professor said to Dracula.

But the Count was now at the crossed bars where Arthur still hung. Each nipple bore a silver ring, from the bottom of which dangled a silver wolf's head.

"You are submissive to the Professor?"

Arthur laughed bitterly. "Don't be ridiculous. He is a fool."

"Then to whom do you submit?"

The slim dark-haired beauty knelt at Arthur's feet. She opened her lips and took in his cock. "I am at the mercy of this woman you see before you. My Mistress. I submit to her blindly, for I do not even know her name." Arthur closed his eyes. He gasped and tightened his buttocks as she brought him to full erection.

Quincey froze in terror and titillation as Dracula turned on him. He strode to the bed and hauled Quincey painfully up by the fabric of his skirts until his wounded ass rose high into the air. Dracula stood behind him and within seconds Quincey felt a determined knock at his rear door. "Sir," he stammered, "I beg you—"

But now he screamed. What felt like a limb entered him deep, filling his rectum with the flesh of a man, or at least what had once been a man. His cries of pain quickly turned to moans of joy as Dracula rode him fast and hard, then harder. Within seconds that rod stiffened and pulsed and a massive quantity of hot fluid shot into Quincey's ass.

When he pulled out just as quickly, Quincey stayed where he was, savoring the sensations left by the impalement, continuing to offer his ass for the pleasure of his Master, anytime, anywhere.

"Miss, you will tell professor Van Helsing your name, and to whom you belong!" Dracula commanded.

"I am Miss Quin Morris, and I belong to you, sir, and only you," Quincey said without hesitating, a smile building on his lips.

Chapter Forty Four

As those small and experienced fingers played with John's balls, he wondered where Lucy and Magda were. Lucy, her angelic features, her stern love. He wondered what tortures and pleasures she would bestow on him tonight.

Dracula stalked Van Helsing like a feral beast intent on destroying his prey. "Should I permit you to leave?" he began.

"You are honor bound to hold to your word," Van Helsing reminded him, although the Professor's voice held no strength.

"You know nothing of honor, you who are so weak you cannot even govern your army." Dracula's hand swept the room. "More to the point, from the work you did on Magda's flesh, you cannot regulate your own passions."

"Magda requested my treatment of her at, I believe, your command."

"And did she request that you lose complete control?"

Van Helsing looked chastised by those words. John knew Dracula had planned this outcome. But hadn't they all lost control? And was that so bad? It was the nature of the beast. John shivered in anticipation of losing control. As if she could read his thoughts, the dark haired fleshy girl squeezed his balls hard, sending tremors of terror and pleasure rippling up his body.

"This is all meaningless," Van Helsing said. "I have done what was required of me, whether to your liking or not, and now Lucy is mine. These others you may do with as you see fit. None of them are

worthy." He glared at Quincey with disgust, at Arthur with menace, but for John, whom the Professor had known and punished so well, Van Helsing reserved a special look of hatred for betrayal.

Dracula crossed his arms over his chest. "You are ludicrous in your deficiency and were I capable of compassion for the vanquished I might show you some. As it stands, you have earned little but my loathing."

He spun around and yelled at the fleshy girl, "Bring Lucy here."

The girl pulled away from John as if she'd been physically yanked across the room, and hurried out the door.

"I would break you myself, Professor, but I cannot bear the sight of so defective a being. Neither you, nor your three weaklings. You will all leave here at once!"

"With Lucy."

"Magda finds her amusing, but I am finished with her. For the moment."

Dracula a man of honor?

John was startled by this turn of events. He also felt desolate. He did not know how he could live with the knowledge that his Mistress Lucy would once again succumb to the Professor's tight control and be lost to him forever. On top of that, he was to be thrust out of this pleasure palace against his will. And now that Van Helsing had witnessed his betrayal, John knew there would be no hope of even an occasional taste of his rod of punishment.

The fleshy girl ran into the room breathless.

"I told you to bring her!" Dracula said, turning on her as if he would strike her.

She cringed before him. "Master, she is nowhere to be seen. Neither she nor Magda."

Dracula strode towards the window and opened it. Cool mountain air filled the room. John watched his gaze turn inward, as if he were concentrating very hard. His face became a slab of sculpted marble. His expression twisted to black fury. He hissed, exposing those large and dangerous fangs, then turned to Van Helsing with flashing red eyes.

"We are too late Professor. Far too late."

"This is another of your tricks, and I will not have it!"

"A trick, perhaps, but not of my conjuring. It appears we have both been deceived. I sense Magda and Lucy together, perhaps for eternity." He nodded at the wall of implements where one hook stood glaringly empty. "The two of them, and Magda's bullwhip."

About The Author

Amarantha Knight is the *nom de plume* of award-winning author Nancy Kilpatrick, who has published 14 novels, about 200 short stories, and has edited eight anthologies. Her most recent works are the non-fiction *The goth Bible: A Compendium for the Darkly Inclined* (St. Martin's Press), and the dark fantasy *Outsiders: An Anthology of Misfits*, co-edited with Nancy Holder (Roc/NAL, October 2005). Under the name of Amarantha Knight, Nancy has published seven novels in the critically acclaimed Darker Passions series, which Circlet Press is reprinting. She has also edited five anthologies of erotic horror under that name. For updates and excerpts, check out her website: www.nancykilpatrick.com.

Excerpted from

The Darker Passions: Frankenstein

Evening arrived. The first of September air was cooler blowing down from the mountains, as if the wind carried change upon it. Overhead the clear sky permitted the display of an exceptional number of stars and a moon that, while still but a sliver, glowed magnificently.

I sat upon the table in the gazebo awaiting Elizabeth. The air felt refreshing as a breeze whipped through the screen. Tonight would be our last night together until December, and I intended to leave her with a strong memory of me that connected us heart to heart.

Before I saw her, I heard leaves rustling. A glow of white appeared, like a ghost coming to life. She stepped through the doorway of the gazebo.

Her golden hair hung full about her beautiful waif-face, cascading over her shoulders and falling down to her waist. Through the thin fabric of her nightgown, I saw that her nipples were firm in anticipation and her breasts rose and fell quickly with rapid breathing.

"The implement," I said.

She handed over a simple rod of bamboo, split length-wise.

Half an inch thick, five feet long, I recognized the cane from the workshop where a craftsman was reworking the veranda furniture. Her intent was as serious as my own.

"You recall the rules?" I said.

She nodded, but I repeated them for her anyway, ending with the warning, "Your wish is my command this night, and this night alone. I will give you all that you desire and no more."

"I am ready," she said.

She began to remove her nightdress, but I lifted a hand to stop her. The air was too cool and I did not wish for her to be chilled unnecessarily, although parts of her anatomy would soon be warmer than they had ever been.

Instead of the table, I directed her to a heavy, low German-style stool I'd brought with me. Ironically the square seat was made of cane. "Kneel on the edge and grasp the back of the seat," I instructed.

Once she was in position, I lifted the skirt of her dress from the hem, folding it over her head so that it was covered. I then wound the edges together and tied the corners so that she was caught from the waist up in a bag, as it were. She could hear well enough, and I could understand her, but her vision would be obscured by the cloth.

From my pocket I removed several lengths of braided sash, the type used to hold drapes apart. I tied her wrists to the legs at the back of the stool and her thighs, once I'd spread them, to the front legs.

Her delicious cunny twinkled in the moonlight, already moist with excitement. I used the rounded side of the cane to lightly pat her bottom. My strokes were short and quick. I kept my hand steady and my aim true so that the same spot might be attended to. Soon the multitude of short light strokes created a single line that stretched across the middle of her plump buttocks. Her legs began to quiver and from within the fabric I heard whimpering. Soon her bottom twitched, then twisted and turned, this way and that, desperate to avoid my perpetual strokes.

I understood what she was feeling. Elizabeth had used this very instrument one evening on my shoulders. Without the energy needed for a whip or paddle, a light spanking with this cane, if it continued on long enough, produced a terrible agony, nearly unbearable.

The whimpering turned to sobs, still I continued my easy work. "You may stop me any time," I reminded her. She said nothing, only emitted those deep sounds and kept twisting her bottom futilely...

Read more in *The Darker Passions: Frankenstein!*

Excerpted from

The Darker Passions: Dr. Jekyll & Mr. Hyde

I move through the house sluggishly, climbing the stairs that lead to the lab. I step into the room and am horrified. In the theater below, there, on my dissecting table, lies a naked female. Naked and well- whipped. This can only be the work of Hyde!

I hurry down, for my guests will be arriving shortly and for all I know this female is dead. She has long dark hair fanned out across her shoulders, and a face comely enough. Her body is the shape known as hourglass; her purple bottom sprinkled with enormous welts is propped high up, accentuating her delectable female shape. As I near I realize she is breathing deeply. I am relieved. She's asleep.

"Miss. Miss!" I shake her roughly until she wakes.

"What's that, then, Master Hyde...? Well, who might you be?" she says, an invitation in her voice.

I draw myself up to my full six feet. "I am Dr. Henry Jekyll, and you are in my laboratory. How did you come to be here?" As if I didn't know.

"Why, my Master Hyde brought me here."

Her bottom is a sight. Hyde has outdone himself this time.

"Remain on the table," I tell her. "I've a salve that will alleviate your suffering."

"Oh, there's no need for that, sir." She scurries from the table to stand before me stark naked. Her breasts are large and pendulous, the nipples firm with excitement. Embarrassed, I glance away. Certainly I have seen women and their parts before. After all, I am a physician and my vocation requires that in the course of healing the sick I must see bodies from time

to time. But this woman is not in need of my services, or so she claims.

"Turn around," I tell her. "Let me have a closer look at those wounds."

She does so willingly and quickly, bracing herself against the table. She thrusts her colorful rump at me. "Lean further over the table," I say, and she does so eagerly. Her bottom is soft and round, plump in a manner that is pleasing to most men, with flesh enough to grip. I, of course, have but a professional interest.

Her bottom is very hot to the touch and I wonder how in the world she can stand such injury. "This Hyde," I say, spreading those melon-like cheeks apart, "do you fancy him?"

"Oh yes, Dr. Jekyll. There is no man quite like him."

Her bottom hole is swollen and a far darker shade than it ought to be. Obviously his whips found this vulnerable spot. It is also distended. Clearly she has been entered here, and recently. I decide I may as well examine all of her, lest I miss a wound that needs immediate attention.

I slide forward again until my face is close to her womanly slit. The flesh here is moist and swollen, the scent sharp and sweet at once, and again that fiery color. I spread her apart and find more folds, wet and glistening like lips begging to be kissed.

Whether she has moved back or I have moved forward, I do not know, but suddenly I am tasting her moist lips. Horrified, I pull back.

I sense something in my lap and I glance down. A hand has reached between her legs and is skillfully unbuttoning the buttons at my fly. "Now, Miss Marie..."

"Oh, Doctor Jekyll, it burns so."

"Where?" I ask, full of concern for my patient and her punished derriere. Her fingers reach inside my trousers and my member is astonished by the shock of her warm flesh caressing him.

"Inside," she says. "Oh how he took me. Again and again throughout the night. Without ever once asking me if I so desired him. He thrust so hard and firmly, sir, I could not catch my breath. And when he was not keeping rhythm with his wand he kept time with the whips. Oh, Doctor Jekyll, you cannot imagine!"

Indeed, I need not imagine. She strokes my penis, which is now long and hard. I try to concentrate and spread her *labia major* further apart. The moisture seems to increase the deeper in I probe and my fingers are slick. At each touch her bottom trembles and her folds seem to open further. "And did you not find this offensive?" I manage, having great difficulty concentrating...